LOST BUILDINGS OF WORTHING

A HISTORIC TOWN AND ITS PEOPLE

ANTONY EDMONDS

AMBERLEY

To my brother

First published 2016
This edition published 2019

Amberley Publishing
The Hill, Stroud,
Gloucestershire, GL5 4EP

www.amberley-books.com

Copyright © Antony Edmonds, 2016

The right of Antony Edmonds to be identified as the Author of this work has been
asserted in accordance with the Copyrights, Designs and Patents Act 1988.

ISBN 978 1 4456 9900 4 (paperback)
ISBN 978 1 4456 5708 0 (ebook)

British Library Cataloguing in Publication Data.
A catalogue record for this book is available from the British Library.

Origination by Amberley Publishing.
Printed in Great Britain.

The cover image is an engraving of August 1858 entitled 'Worthing from the Sea, from
an original sketch by Edward Martin Esq of West Tarring'. The building that occupies
the left of the front cover, the spine, and the right of the back cover is the Royal Sea
House Hotel, which was destroyed by fire in 1901. On the right of the front cover is the
Marine Hotel, demolished in 1965.

Contents

INTRODUCTION

~

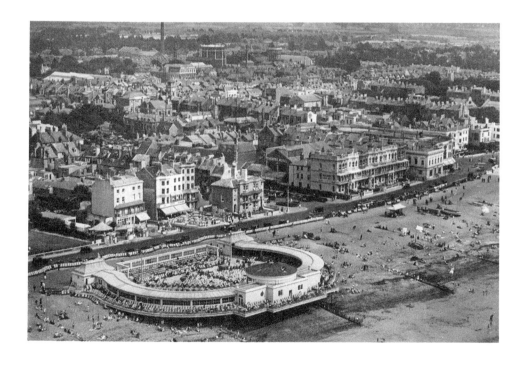

During the second half of the twentieth century, many historic British towns suffered episodes of demolition and redevelopment that were at best insensitive and at worst near-criminal. Most people have horror stories to tell about the depredations that took place in their towns over this period, especially during the 1960s and 1970s. Worthing, however, has a strong claim to have suffered more than any other town in the south-east of England.

Most of the seafront buildings seen in the photograph on the title page of this introduction, for example, are now gone. But even the many losses on Worthing seafront pale into insignificance beside the wholesale demolition at the end of the 1960s of the heart of the early nineteenth-century town centre – Market Street, the north side of Ann Street, and most of what was left of the west side of High Street.

One reason that Worthing suffered disproportionately is that the old town covered such a small area. If fifty interesting old buildings are demolished in Brighton, hundreds remain. When fifty old buildings are knocked down in Worthing, most of the historic town is lost.

Another reason that Worthing was particularly unlucky, is that, as Robert Elleray explains in his book *Worthing: Aspects of Change* (1985), the inhabitants of Worthing simply did not care. Writing about the demolition of the heart of old Worthing, Elleray says: 'It must be emphasised that the blame for the crisis lay mainly with the people of Worthing; there seemed to be complete apathy and sublime indifference to the problem.' Today proposals for inappropriate and unwelcome developments in the town generate heated discussion. In the late 1960s, however, although there were a few voices of protest, the destructive and insensitive plans for the modernisation of Worthing were all but nodded through.

Inclusions and Exclusions

The lost buildings are arranged in three overall sections, focusing on the seafront; the heart of the old town; and Charmandean and Offington. Within each of these sections, the geographical sequence is from east to west – strictly so, in the first case; as far as possible, in the second and third.

To be included in this book, a building has still to have been standing 120 years ago, the earliest 'loss event' recorded here being the demolition of Warwick House in 1896. We are thus dealing with buildings of which the longest-lost are only one generation away from living memory. There must be – admittedly very elderly – people still living in Worthing today whose parents can remember seeing Warwick House or the Royal Hotel when they were young children. Thus, although many of the buildings in this book are long lost, none are lost in the mists of time.

Those interested in still older buildings – those that stood in the very early days of Worthing and were demolished during the course of the nineteenth century – should consult my book *Jane Austen's Worthing: The Real Sanditon* (2013), which is a companion volume to the present book. It contains accounts of the town's early buildings and narratives of people associated with them, with numerous illustrations, many in colour; and the index at the end of the book is an index of buildings. My original suggestion for the book's title was *Worthing in the Age of Jane Austen*, the book being three-quarters a history of early Worthing and one-quarter about Jane Austen.

Neither Lancing nor Broadwater is included in the present book, since Ronald Kerridge's *A History of Lancing* (1979) and Ronald Kerridge and Michael Standing's *Georgian and Victorian Broadwater* (1983) already provide definitive and fully illustrated accounts of these villages. Offington and Charmandean, however, do not feature in the latter book, so are examined in detail here.

Worthing's High Street is too central – in two senses – to be omitted from this book, but the section that focuses on it is in effect a picture gallery, since those who wish to study the history of the street in detail should read Kerridge and Standing's *Worthing: From Saxon Settlement to Seaside Town* (2000) or visit the www.oldworthingstreet.com website, which derives from their book, but includes further and even more detailed research.

Those interested in surviving as well as lost buildings of Worthing will find my book *Worthing: The Postcard Collection* (2013) of interest, not least because its long central section is a building-by-building sequence of photographs of Worthing seafront from west to east, with every structure that stood in the Edwardian age depicted and commented upon.

The old cinemas of Worthing are outside the remit of this book, but are comprehensively covered in *Cinema West Sussex: The First Hundred Years* (1996), by Allen Eyles, Frank Gray, and Alan Readman, which devotes twenty pages to them. The old theatres of Sussex are dealt with in Robert Elleray's *Sussex Theatres: An Illustrated Survey and Gazetteer, 1750–2000* (2006). Those interested in Worthing's historic pubs and inns should visit the www.worthingpubs.com website, where there are numerous rare pictures and much interesting information.

In general I have tried to avoid duplication with the other books I have written about Worthing, but in a few instances this has not been possible. A small number of pictures I have previously used recur, where these are the best available of a particular building. Also, it was impossible to keep Oscar Wilde out of the present book, so there are a few passages here that repeat information that appeared in *Oscar Wilde's Scandalous Summer: The 1894 Worthing Holiday and the Aftermath* (2014).

I am not an architectural historian, and this book is not an architectural history; and in any case people associated with buildings are often of as much interest as the buildings themselves. Buildings provide structure and scenery; people provide narrative. This book therefore contains numerous accounts of famous or interesting people who lived in or visited Worthing over the last two hundred years or so. Some of the associations described are already well known, but most are not, and some of the discoveries are of particular interest – most notably, perhaps, that the great Victorian statesman Benjamin Disraeli 'sojourned for a time' at the Marine Hotel between his two periods as prime minister.

My other Worthing books have a rigid and disciplined structure. This book is looser and more informal. Most of the sections began life as articles in my 'Buildings of Old Worthing' series that featured monthly in the *Worthing Herald* from October 2012 to December 2015. Almost all the original articles have been greatly expanded, however, and at least four-fifths of the content of this book is new. A few of the articles prompted responses from readers of the *Herald* that added new and interesting information, and where I refer to these exchanges (and in a few other places) I occasionally use the first person pronoun, something writers of history generally avoid.

Although most of the information in this book derives from my own research, there are a number of sections or sub-sections where much or most of the material comes from websites or other books, and these sources are credited in the text. In addition, two individuals kindly contributed specially written passages, and I owe a debt of thanks to Lizzie Glover for her amusing account of life at Charmandean School towards the end of the Second World War and to Chris Griffiths for the erudite piece about B. W. Newton that appears in the section about the Town Hall.

I would also like to thank James Connaughton, whose roles at the *Worthing Herald* include designing and editing the retrospective section of the newspaper, in which my articles have appeared twice a month for nearly four years. He is not only a highly accomplished designer, but also the ideal editor – collegiate, patient and accommodating.

Dates

While every attempt has been made to give accurate dates, and every date has been checked and cross-checked as far as possible, it is sometimes difficult to establish the exact year in which a building was built or demolished. We are often reliant on old directories, and these frequently contain errors or inaccuracies. In addition, while it can be assumed that the directory of a given date is recording the situation that prevailed towards the end of the previous year, factoring this in is an inexact science. In some cases I have had to rely for dates on secondary sources, most often Robert Elleray's indispensable *A Millennium Encyclopaedia of Worthing History* (1998).

It can also be difficult to determine the correct year of a person's birth (other, of course, than the well documented birth dates of the famous). Early censuses recorded only a person's age on the date of the census, his or her date of birth not being given. Between 1851 and 1911, the period of most of the genealogical research for this book, Census Day was always in March or April. Since we do not know whether a given individual's month of birth was before or after Census Day, around three-quarters of the dates of birth extrapolated from original census records on websites such as www.findmypast.com – which I used for my research – will, by definition, be a year out; but we do not know which. Any date of birth that appears on a death record can, however, usually be relied upon as accurate.

The date of an engraving or a photograph, except where recorded on the original image, is always a matter for informed guesswork, and phrases such as 'in the 1880s' or 'around 1905' will often be found in the captions in this book. Many of the images come from old postcards, and in some cases a firm date for these is given. Obviously no correct date can derive from postmark evidence alone, since a postmark tells us only that the image in question was in existence by that date, not when the image was first published. The postcard might have been on a retailer's shelves for years – or in its purchaser's desk drawer for decades – before it was sent through the post. Where a precise date is given for an image from a postcard, it is because knowledge of a particular publisher's activities allow us to pronounce with certainty.

Most of the postcards of the Tunbridge Wells photographer and publisher Harold Camburn that are reproduced in this book are from the first sequence of his cards of Worthing and the surrounding villages, which bear serial numbers up to

80 or 90, and the photographs used on these early Camburn cards can be dated with certainty to 1910. The evidence for this is too complicated to be repeated here, but is set out in detail in articles I have written about Camburn for various publications. There is, however, an account of his life and work in Section 15.

Pictures

As already mentioned, many of the photographs reproduced here derive from old postcards. I decided that the captions and publisher information that appears on the front of these images should in most cases be 'cloned and healed' out of existence, because I felt that this would be an unwelcome distraction for the majority of readers. There is additional justification in the fact that all these images were, of course, photographs before they were postcards, so they have in effect been restored to their original form.

The main exception to this principle is in respect of postcards produced by the French firm of Lévy Sons & Co. and by Harold Camburn. There are two reasons for this inconsistency. The first is that these two firms made an exceptional photographic contribution to Worthing over the fifteen years from 1906 onwards – the Lévy firm between 1906 and 1914 and Camburn between 1910 and around 1921 – and thus merit special treatment. The second is that these two firms used particularly attractive and harmonious 'front styles' for their postcards, which enhance rather than detract from the image.

Numerous pictures used in this book were provided by Worthing Library or the National Portrait Gallery. All are credited in the caption below the image. In case of the library, the credit appears as © www.westsussexpast.org.uk, which should be read as the short form for the full credit 'West Sussex County Council Library Service, www.westsussexpast.org.uk'. As with previous books, I am very grateful to Martin Hayes and his colleagues at Worthing Library for their help.

I must also thank the following for providing one or more pictures: Chris Griffiths, in Section 30; James Henry, www.worthingpubs.com, in Section 8; David Nicholls, www.worthingoldphotos.co.uk, in Sections 27 and 28; Clive Purser, in Section 18; and Rendel Williams, www.sussexpostcards.info, in Section 3. In each case the source is credited at the end of the caption. In addition, I am grateful to the late Geoffrey Godden for lending me his copy of the 1895 edition of *A Descriptive Account of Worthing*, from which several pictures used here and a certain amount of information derive.

With these exceptions, all the pictures in this book come either from my own collection of photographs and postcards of Worthing – the majority – or from the long series of remarkable books about Worthing's history published under the Worthing Art Development Scheme's Worthing Pageant series between 1938 and 1955. These have also been the source of much historical information.

Among the books in this series, the following, all by Henfrey Smail, are of particular interest to those who wish to immerse themselves in the early history of Worthing: *The Worthing Road and Its Coaches* (1943), *Glimpses of Old Worthing* (with Edward Snewin, 1945), *Coaching Times and After* (1948), *The Worthing Map Story* (1949), *Notable Houses of Worthing, No. 2: Offington, Broadwater Manor, Charmandean* (1950), and *Notable Houses of Worthing, No. 5: Warwick House*

(1952). The history of Worthing's first theatre is documented in detail in three books by Mary Theresa Odell: *The Old Theatre, Worthing, 1807–1855* (1938), *More About the Old Theatre, Worthing* (1945), and *Some Playbills of the Old Theatre, Worthing* (1953). Also of interest is *Notable Houses of Worthing, No. 1: Beach House* (1947), the main part of which is anonymous. With the exception of Odell's first book, all the Worthing Art Development Scheme books were published by Aldridge Bros of No. 35 Warwick Street, Worthing and printed by Hunt, Barnard & Co. Ltd 'at the Sign of the Dolphin' in Aylesbury.

The 1879 Ordnance Survey Map

As in my other books, there are maps to assist the reader in finding the locations and buildings referred to. *Jane Austen's Worthing* includes a map of Worthing from 1814 and a conjectural map of the town as it was in 1805. *Worthing: The Postcard Collection* and *Oscar Wilde's Scandalous Summer* use extracts from the 1896 Ordnance Survey, which is very close in time to the periods on which those books focus. My original intention was to use the 1896 map again for this present book, but then I chanced upon the Ordnance Survey map of 1879 on the website of the National Library of Scotland. I had not previously seen this map, which gives an exceptionally interesting insight into what Worthing and its hinterland looked like 140 years ago, and I am confident that it will be of as much interest to many readers as it is to me. Six extracts appear here (on pages 247–52), but those who wish to study the entire map can do so online at maps.nls.uk/view/102347731.

The Author

Antony Edmonds was born in 1951 and educated at Churcher's College, Petersfield and Magdalen College, Oxford. His previous books, all published by Amberley, are *Oscar Wilde's Scandalous Summer: The 1894 Worthing Holiday and the Aftermath* (2014), *Jane Austen's Worthing: The Real Sanditon* (2013) and *Worthing: The Postcard Collection* (2013). He has published numerous articles in the *Wildean* (the journal of the Oscar Wilde Society), the *Worthing Herald*, *Sussex Life* and *Picture Postcard Monthly*.

LOST ON THE SEAFRONT

~

SECTION 1

THE ESPLANADE

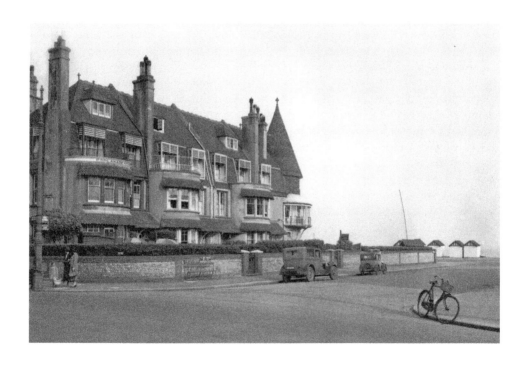

When they were built around 1881, the eight attractive houses that comprised the Esplanade – four terraced, four semi-detached – were the final buildings in Worthing, apart from a few dwellings five hundred yards to the east, close to the Half Brick Inn. Most photographs of the Esplanade are of the west-facing terrace – but the four south-facing semi-detached houses, seen on two of the illustrations in this section, were particularly impressive and unusual.

The four semi-detached houses were numbered from east to west – No. 1, The Esplanade was therefore at the eastern end – but were reallocated Brighton Road numbers around 1920. The four terraced houses, however, remained Nos 5–8, The Esplanade.

It was at No. 5, the house at the northern end of the terrace, on the corner with Brighton Road, that Oscar Wilde (1854–1900) wrote his most famous play, *The Importance of Being Earnest*, in the late summer of 1894, when the house was known as the Haven. The Haven was later turned into a boarding house, and eventually the entire terrace of four houses became the Esplanade Hotel.

It is not entirely clear when the Esplanade buildings were demolished. The 1964 *Kelly's Directory* is the last to list the four semi-detached houses – whose addresses by then were Nos 102–108 Brighton Road – so they must have ceased to exist around 1965. Esplanade Court, the modern block that replaced all eight Esplanade houses, makes its first appearance in 1972.

Puzzlingly, however, the Esplanade Hotel – formerly the houses of the west-facing terrace – still features in *Kelly's* as late as 1974. The most likely explanation is that the directory's compilers neglected to remove the entry for the hotel, and it is probable that the hotel had been demolished at the end of the 1960s and that Esplanade Court was built in 1970 or 1971.

On the wall of the new building, there is a blue plaque to commemorate the fact that Wilde wrote *Earnest* at the Esplanade. At the time of writing, however, the plaque – whose choice of position was based on the best evidence available at the time – is located on the wrong part of the building, and it is to be hoped that one day it will be moved to the north-west corner of Esplanade Court, where the Haven used to stand.

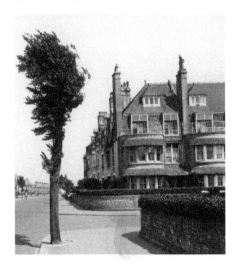

No. 5, The Esplanade, around 1920. When Oscar Wilde stayed there in 1894, the house was called the Haven.

The Summer of 1894

In 1894, the Haven was owned by a friend of Wilde's wife Constance called Miss Lord, who had gone to Matlock in Derbyshire, where the waters were believed to be beneficial for gout, from which she suffered. Constance had to take linen, crockery and cutlery to Worthing from the Wildes' house in Chelsea, and before she left London she wrote to tell her friend Georgina Mount Temple that she was busy with all the things she most detested, adding, 'I shall have to keep house for five weeks with strange servants, and my heart sinks at the prospect!' Once she arrived in Worthing on 7 August, however, Constance's anxieties seem largely to have subsided, for she reports to Lady Mount Temple: 'I like Miss Lord's dear little house and Miss Walker [presumably one of Miss Lord's servants] has made us most comfortable.' In a letter to her brother Otho Lloyd on 31 August, Constance provides a list of the occupants of the Haven at that point in the holiday: 'Our expenses are 10 guineas a week [over £1,000 in today's money], that is for Oscar & myself, Cyril and Vivian, Arthur Fenn [the Wildes' young man-servant], cook & housemaid here, & the cook's little boy.'

The stay in Worthing was a family seaside holiday, and Wilde enjoyed spending time with his sons, of whom he was very fond. Many years later, Vyvyan wrote: 'Perhaps my father was at his best with us at the seaside. He was a powerful swimmer; he also thoroughly enjoyed sailing and fishing and would take us out with him when it was not too breezy.' Vyvyan also said that Wilde 'excelled' at making complex sand-castles – 'long, rambling castles they were, with moats and tunnels and towers and battlements'.

Although he spent some of his holiday time with his sons, Wilde neglected his beautiful wife, who felt lonely and depressed. By this time he was exclusively homosexual, and he had a sexual relationship that summer with a sixteen-year-old local boy called Alphonse Conway, whom he entertained several times at the Haven to dinner and sex after Constance and the children had returned to London. He also took Alphonse to the Royal Albion Hotel in Brighton for the night.

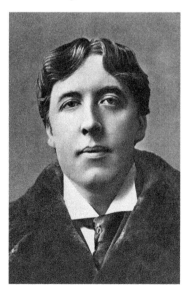

Oscar Wilde in 1892. Photograph by Alfred Ellis & Walery. (© National Portrait Gallery, London).

Eight months after leaving Worthing, Wilde was convicted of gross indecency with various youths and young men, and sentenced to two years in prison. After his release he lived in exile in France and Italy, and he died three and a half years later, aged just forty-six.

Writing *Earnest*

As I write in the introduction to this book, my intention has been as far as possible to avoid duplication with my other Worthing-related books, but in the case of the Esplanade it is impossible not to focus on the Wilde connection. The full story of the extraordinary final summer before everything fell apart is told in *Oscar Wilde's Scandalous Summer*. Here we will focus on what we know of the configuration of the house at the time of Wilde's stay and what we know of the circumstances – and indeed the room – in which *The Importance of Being Earnest* was written. This section is necessarily adapted, in part, from my earlier book, but there is also new material.

Wilde's adored but difficult and demanding friend Lord Alfred Douglas (1870–1945), always known as Bosie – who had briefly been Wilde's lover for a few months in the summer of 1892 – paid three visits to Worthing while Wilde was there, and it is from Bosie's (not entirely accurate) memories of forty-five years later

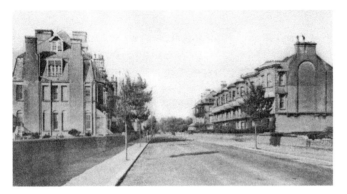

A view dating from around 1905 of Brighton Road looking west. On the left are the two semi-detached houses that comprised the eastern part of the Esplanade development. On the right is Cleveland Terrace, which still stands, and beyond it Selden Terrace, which does not.

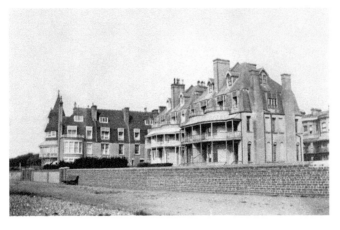

The Esplanade from the south-east. On the left is the southern end of the Esplanade terrace. On the right are the four semi-detached houses that were originally Nos 1–4, The Esplanade, but later had Brighton Road numbers.

that we have the best evidence as to which room at the Haven was where Wilde wrote his play.

In March 1939 Bosie had a conversation with Marie Stopes – the birth-control pioneer, who became a friend of his towards the end of his life – about the summer of 1894, some of which she recorded in her diary:

> He told us that they [Wilde and Douglas] were staying in rooms with a balcony in Worthing. The house was then called, I think, the Haven, and Lord Alfred had recently been down and found it, though the name of the street and the house have both been changed. ... The beautiful large room he and Wilde had, had been spoiled by partitioning, but otherwise the house was unchanged.

There are a couple of oddities here: first, Bosie's having apparently said that he and Wilde were 'staying in rooms' and, secondly, the somewhat misleading concept that the two of them 'had' a beautiful large room. These must be due either to Marie Stopes's misremembering some of the conversation when she wrote up her diary, or to Bosie's having airbrushed Wilde's family holiday of 1894 out of the picture in order to put himself at the heart of the period when *Earnest* was being written. Certainly it is inconceivable that Wilde and Bosie would have shared a bedroom at the Haven after Constance and the boys returned to London on 12 September, not least because their brief sexual relationship had ended two years earlier. Bosie, whose preference was for boys in their early teens, found sexual activity with Wilde not to his taste and Wilde, as Bosie later put it, soon 'cut it out'. Nor, for that matter, would Wilde have shared a bedroom with Constance. In the nineteenth century, upper-class husbands and wives generally slept in separate bedrooms, and in any case Wilde had ceased having sexual relations with Constance within two years or so of their marriage in 1884.

The beautiful large room with the balcony to which Bosie refers can only have been the room on the second floor, since, as can be seen from the close-up view of the Haven on page 12, this was the only room in the house with a proper balcony. The room beside it, which would probably have been Constance Wilde's bedroom while she was in Worthing, had a sort of 'Juliet' balcony.

A Victorian town house such as the Haven would normally have had the dining room on the ground floor and the sitting room on the first floor. We know from a letter Wilde wrote to Bosie before either had arrived in Worthing that the house had 'no writing-room'. The probability is that the room with the balcony was Wilde's bedroom, and that it was on a table in this room that he wrote *Earnest*. In a letter to Bosie in September 1894, when Bosie was temporarily back in London, Wilde describes how the play at that point 'lay in Sibylline leaves about the room', adding that his teenage valet, Arthur, had 'twice made a chaos of it by "tidying up"'. The room where Wilde wrote *Earnest* would certainly not have been the main sitting room at the Haven, where he would not have been able to leave his papers scattered about.

The two men's accounts of the writing of *Earnest* are contradictory. In 1897, while he was in Reading Gaol, Wilde wrote the long letter to Bosie that later came to be known as 'De Profundis'. At that time he was consumed by bitterness against Bosie, wrongly believing that Bosie had abandoned him, and much of what he wrote

was unfair, and sometimes not entirely rational – as in the case of his assertion that whenever Bosie was staying with him he never wrote anything at all:

> I am not speaking in phrases of rhetorical exaggeration but in terms of absolute truth to actual fact when I remind you that during the whole time we were together I never wrote one single line ... Wherever my writing room was, it was to you an ordinary lounge, a place to smoke and drink hock-and-seltzer in, and chatter about absurdities.

The statement in the first sentence quoted above is clearly preposterous, and Bosie later countered Wilde's claim with an equally absurd 'rhetorical exaggeration' of his own in his 1940 book *Oscar Wilde: A Summing-Up*, where he furiously rejects Wilde's assertion:

> But as in the (then) unpublished part of his letter to me from prison, 'De Profundis', he makes the amazingly and fantastically untrue statement that I interfered with his writing and that he never wrote anything while I was with him, I must again put on record the fact, which is susceptible of absolute proof, that from the time our close association began till the day he died he never wrote anything at all except when I was with him; generally I was actually staying in the same house and often sitting in the same room with him while he wrote. He wrote the whole of *The Importance of Being Earnest* at a house in Worthing where I stayed with him, and most of it while I was sitting in the same room with him.

At about the same time as he was writing *A Summing-Up*, Bosie gave Marie Stopes a similarly Bosie-centric account of the composition of *Earnest*, telling her that he was personally with Wilde, staying with him and in and out of his study all the time he was writing the play, and that a number of the jokes were based on his own 'repartee'.

The truth almost certainly lies somewhere between Wilde's and Bosie's accounts. It is entirely likely that Bosie was, as Wilde says, sometimes a distraction and a hindrance during the composition of *Earnest*. On the other hand, some of the play's lines perhaps did indeed, as Bosie suggests, originate in badinage between the two of them, for Bosie was an amusing conversationalist. Indeed earlier that year Max Beerbohm, himself one of the wittiest men of the age, wrote to their mutual friend Reginald Turner: 'Dear Bosie is with us. Is it you who have made him so amusing? Never in the summer did he make me laugh so much, but now he is nearly brilliant.'

SECTION 2

WORTHING COLLEGE / BEACHFIELD / THE CATHERINE MARSH CONVALESCENT HOME

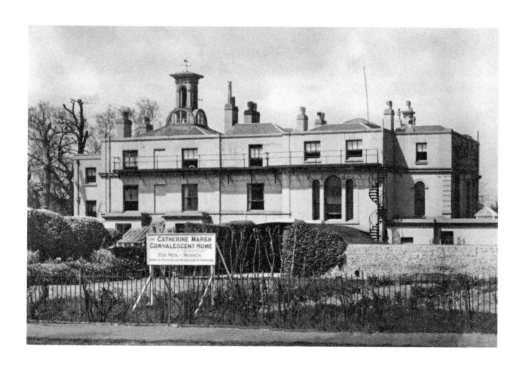

Until the Esplanade was built, the first notable building seen by those approaching Worthing from the east was a handsome house that served as a school for most of the nineteenth century and as a convalescent home for much of the twentieth. The building in question, which stood on the south side of Brighton Road, just to the east of where the Splashpoint swimming pool stands today, is generally referred to in Worthing as Beachfield. However it was first given this name in 1899, and this was its primary name only from 1899 to 1901 and then again from the Second World War until the building's demolition in the 1960s.

Originally a four-roomed cottage built by a brick-maker called Page, the house was acquired in the 1840s by a schoolmaster named Williams, who enlarged it. Until then, his school – Williams's Academy – had been located at College House (later Park House) on Warwick Street, today the Ask pizza restaurant. The school had been founded in 1783, but not necessarily by Williams or in Warwick Street.

Later headmasters (all clergymen, as was often the case in the nineteenth century) were Revd Balfour, Revd Helm, Revd Shields, and Revd Jones. The school then closed for a while, before being acquired, around 1860, by Colonel George Burnand (1802–91), a wealthy London stockbroker who had retired to Worthing, and Revd Francis Piggott. Piggott was the new headmaster, while Colonel Burnand was the principal investor in the project. The building was enlarged again, into what would be its final form, and the distinctive bell turret was added.

The 1861 census records those living at College House in Brighton Road as Piggott and his wife and young son (also Francis, who later became a barrister); two unmarried assistant masters in their twenties; three servants; and thirteen boy boarders, ranging in age from seven to eighteen. The 1861 census was taken on 7 April, which must have been during the Easter holidays – indeed that year Easter Sunday fell on 31 March – so the thirteen boys in residence were presumably boys whose parents were abroad in the service of the British Empire and had nowhere else to go. In term-time the full boarding contingent was much larger (in 1895, for example, there was accommodation for a hundred boys), and there were probably day pupils as well.

The extent of George Burnand's wealth can be gauged from the fact that in 1861 he was living at a house called Casina, at No. 12 Montague Street, with his youngest son Lewis, then twenty-two years old (Burnand was a widower by then) – and no fewer than seven resident servants: a butler, a footman, a housekeeper, a housemaid, a cook, an under-housemaid and a kitchen maid. Ten years later, by now living in a house in York Terrace, later to be occupied by Warne's Hotel (see Section 6), Burnand was making do with just six servants, although again they all lived on the premises, in the case of his new butler, Joseph Heasman, with a wife and four young children.

Soon after Burnand came to live in Worthing – which was at some point in the 1850s – his eldest daughter, Ellen, was involved in a notorious divorce case that had a Worthing dimension. Ellen, who was born in 1830, had married a wealthy merchant called James Morton Bell in 1851, when she was twenty years old. Less than seven years later, however, she began a scandalous affair with the twice-widowed Henry Paget, 2nd Marquess of Anglesey, a man more than thirty years older than her. The Marquess had Worthing connections – he and his son Alexander were the original patrons of the Worthing Cricket Club, founded in 1855 – so it may have been in the town that Ellen met him. Either way, it was while she was staying with her father in Worthing in October 1858 that she suddenly absented herself not only from No. 12 Montague

Street but also, permanently, from her marriage to Bell. She travelled to London and signed in at Lillyman's Hotel in Lower Brook Street, where she was joined by her personal maid, and where the Marquess visited her every day. Before long they were living as man and wife in lodgings in Piccadilly, and in due course the cuckolded Bell sued for divorce. The case came up before the distinguished divorce judge Sir Cresswell Cresswell on in December 1859 and the jury awarded Bell the sum of £10,000 (about £900,000 today) in damages. The following year, Ellen married the Marquess. She was still only twenty-nine, and her new husband was sixty-two. He died nine years later in 1869. Ellen died in Worthing in 1874, and is buried in Broadwater Cemetery.

The College

During its time as a school, the building was known variously as College House, Worthing College or simply the College. A promotional article in the 1895 edition of *A Descriptive Account of Worthing* – a seventy-six page book consisting mainly of somewhat unctuous articles paid for by the owners of the establishments featured (schools, hotels, and shops) – tells us that the school had recently been taken over by a new principal, Charles Hemingway. The vice-principal was Albert Bonéfant, and his wife was the matron. 'In Mrs Bonéfant – an English lady – the pupils have a kindly and sympathetic matron,' says the article, 'who well sustains the harmony and home-like feeling which is a noticeable and distinctive feature of the College. A liberal table is supplied, the cuisine leaving nothing to be desired.'

The article also tells us that the rooms were 'large, lofty and light' and 'the ventilation and the sanitary arrangements' were 'in every degree perfect'. The 'chief school-room' was a 'spacious apartment running the entire depth of the building'. The facilities included 'a chemical laboratory', 'a private skating rink', 'a well-kept kitchen garden from which a considerable portion of the garden produce necessary for the table is obtained', and 'a special room where pupils engaged in the mysterious art of amateur photography'. The author of the article says that the facilities, together with 'the evidence of solicitation for the pupils' comfort one sees on all hands', made it easy to understand 'the expressions of content seen on the several faces met in the house' during his visit.

In reality, the school was in terminal decline. Although Hemingway, according to the article, had 'a long and honourable record as a private coach', he did not last long at Worthing College, and by 1898 Revd E. J. Cunningham was the headmaster. His stay too was brief, and the college closed a year or two later. Cunningham continued to live at the house for a couple of years – it was he who renamed it Beachfield – before becoming vicar of St Paul's church in Chapel Road and moving to Ambrose Place. Then, in 1901, the former school building was acquired by the trustees of the Catherine Marsh Convalescent Home.

Catherine Marsh

Catherine Marsh (1818–1912) was a remarkable Victorian philanthropist and a devout Christian – the two almost always went together in those days. She was sufficiently celebrated to feature, along with three other notable women including Florence Nightingale, in a book published in 1890 in Cassell's series *The World's*

Workers. In spite of the rather curious series title, this sequence of some twenty books focused mainly on great and famous people of the century, including Charles Dickens, Abraham Lincoln and General Gordon.

The section on Catherine Marsh tells us that her father, Dr William Marsh, was 'an earnest evangelical clergyman of singular beauty and purity of life, and of great practical benevolence'. She grew up and lived most of her life in Beckenham in Kent, where she did most of her good works, and indeed the book's author, Lizzie Alldridge, describes her, somewhat hyperbolically, as 'the great and good woman who has made Beckenham a household name wherever the English language is read or spoken'. By 1890 Catherine no longer lived in the village, but the author went there and met an elderly villager who remembered how much the local navvies took to Catherine. She went to see them again and again, he said, 'until she won from them the exclamation, "We know you cares for our souls!", until she brought many and many a one to Christ, until she was able to show to all the world that a British navvy could be in very deed and truth a Christian and a gentleman'.

Catherine not only devoted her life to good works, but also, mainly during the 1850s and 1860s, wrote numerous short books of an inspiring nature. One of the most famous was *The Victory Won: A Brief Memorial of the Last Days of 'G. R.'*. 'G. R.' was a doctor by the name of Reeve, who came to Miss Marsh's attention when he was dying of consumption. He had refused to see any clergymen, and it was thought he had only a few days to live. He had even been tempted to end his life with poison. The book is an account of how Miss Marsh eased him towards death, helping him to overcome his despair and reinforcing his faith.

Catherine Marsh's best-selling book was *Memorials of Captain Hedley Vicars*, a biography of a serious-minded young soldier, much given to prayer and good works, who was killed in 1855 at the Siege of Sebastopol, during the Crimean War. The book sold 78,000 copies in its first year of publication, and a second, cheaper edition sold 30,000 copies on the day of publication. The book was also translated into French, German, Swedish and Italian. *English Hearts and English Hands, or The Railway and the Trenches* was her account of her work among the navvies. A letter in praise of Catherine Marsh published in the *Spectator* on 10 September 1910 tells us that she had been 'the first to take up the cause of the navvies, then a neglected and dreaded class'. *Light for the Line, or, The Story of Thomas Ward, a Railway Workman* told the story of her friendship with a railway worker who had his left arm wrenched off in a railway accident that was to prove fatal. Miss Marsh sustained him as he was dying and nurtured his faith, with the satisfying result that his last words were, 'My blessed, blessed Saviour. World without end, Amen. Blessed, blessed Jesus.' Other books with more or less self-explanatory titles included: *Death and Life: Records of the Cholera Wards in the London Hospital*; *Brave, Kind and Happy: Words of Hearty Friendship to the Working Men of England*; and *Midnight Chimes, or, The Voice of Hope*.

There was also, in 1871, a book of truly terrible poems, called *Memory's Pictures*. The first poem in the book, 'My Childhood's Days', begins:

> Do I remember the days gone by?
> Yes! And their memory is a sigh.
> Happy my infancy was and gay,
> Sunny and bright as mornings in May.

Catherine Marsh never married, and there are accounts in a 400-page biography, *The Life and Friendships of Catherine Marsh* (1917), of passionate friendships with a number of other women, but it is unlikely that these had physical expression. That was not generally the way in those days. A flavour of these friendships is found in a letter of 1862 from a (married) female friend who wrote to her, 'My Katie, you were mine in 1842, and you have been twenty times more mine every year since.'

Catherine, who was what would today be called an accomplished networker, knew many of the most influential people of the day, not least that other committed Christian and philanthropist, William Gladstone. She was not afraid to intervene in political matters and on 18 April 1893, during Gladstone's fourth and final period as prime minister, Catherine wrote to him, 'from the depth of a heart that has poured forth prayer for you for seven and twenty years past', earnestly advocating that he withdraw the Government of Ireland Bill 1893 because she was convinced that Irish Home Rule would lead to 'the horror of civil war'. In his reply, Gladstone, who had been an advocate of Home Rule for some years, indicated that, while he valued her prayers, she could hardly expect him to make political decisions based on such a submission. In the event the bill was passed by the House of Commons, but vetoed by the House of Lords.

The Catherine Marsh Convalescent Home

The convalescent home that was eventually to occupy the former Worthing College building had its origins in the London cholera epidemic of 1866, which killed almost six thousand people. Miss Marsh initiated two enterprises in response to this disaster. One of these was an orphanage at Beckenham for seventy-seven children orphaned by cholera. Six years after the orphanage came into being, Miss Marsh was writing,

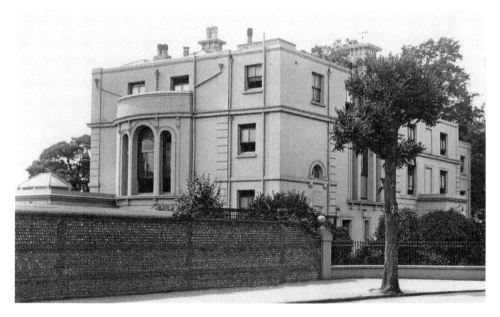

The Catherine Marsh Convalescent Home, seen from Brighton Road around 1925.

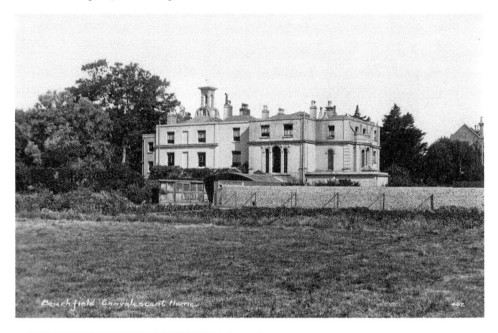

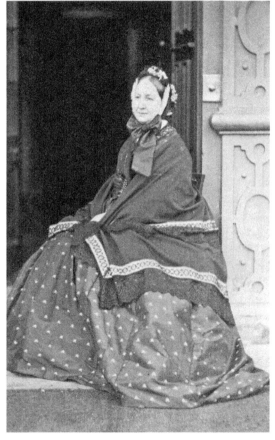

Above: On this Harold Camburn postcard view of the south frontage around 1920, the building is described as 'Beachfield Convalescent Home'.

Left: Catherine Marsh in 1865. Photograph by John Patrick. (© National Portrait Gallery, London)

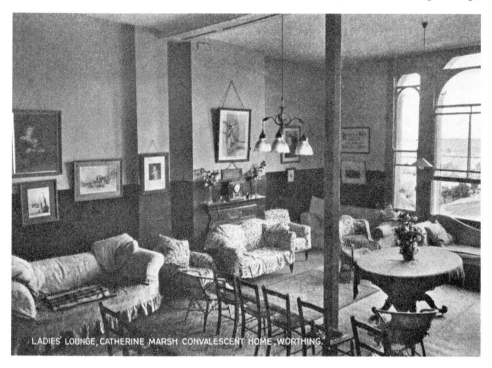

The Ladies' Lounge at the Catherine Marsh Home.

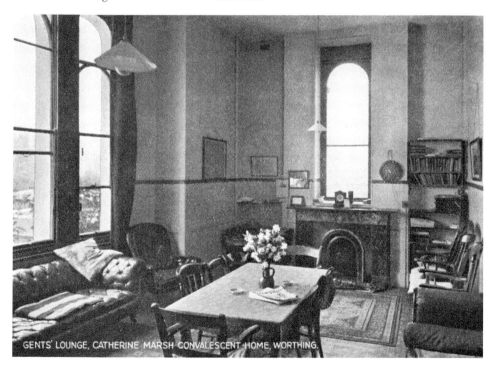

The Gents' Lounge – considerably sparser than the Ladies' Lounge.

'The sunshiny happiness of their daily life in the home has even surpassed our hopes.' Needless to say, pointing the children in the direction of God was as important to her as creating 'sunshiny happiness' and, when one of the girls who had been in the orphanage later wrote to tell Catherine she was thinking of becoming an actress, Catherine replied:

> Dear child, I am sorely grieved to hear of this temptation. Of course, I can understand that its gaiety seems bright and charming to you, but it is a path of danger, which might end in misery and shame for you. If you come to the Lord Jesus, He will make you happy in His love, not with the happiness you think you will find in music and dancing, and gay dresses and tinsel and paint, but with letting you be His own dear little friend, and giving you His Holy Spirit.

The girl duly abandoned her plans.

Miss Marsh's other big project during the cholera epidemic was to establish a convalescent home to help back to health some of those who had been weakened by the disease. The home began life in a block of cottages on the Leytonstone House estate of Sir Fowell Buxton, later to be Governor of South Australia. Once sufficient funds had been raised, the Catherine Marsh Convalescent Home moved to permanent premises at Blackrock (today Black Rock), on the eastern side of Brighton. By the turn of the century, however, the encroachment of the sea made it necessary to find a new location for the home – much of the cliff in front had fallen away – and in 1901 the former Worthing College buildings were purchased. Although the recently acquired name Beachfield did not go out of use, it receded into the background, and the building was generally known for the next forty years or so simply as the Catherine Marsh Convalescent Home.

By the time of the move to Worthing, Catherine Marsh was too old to take an active role in the home, but she regularly visited. On her final visit in 1904, when she was 86, the large central room – which had been the main schoolroom in Worthing College days – was filled with patients, staff and friends of the home, and Miss Marsh gave a short devotional address and 'poured out her heart in prayer for them all'.

Although the home had been founded for those recovering from the cholera epidemic, its role soon became more general. The listing in the 1917 edition of Herbert Fry's *Royal Guide to the London Charities* indicates that its purpose was 'to receive convalescents needing change of air'. Anyone who paid a subscription of two guineas could 'recommend' two patients for three weeks at a charge of 5s 6d for men and 3s 6d for women, while for 'non-subscribers' the cost was 12s 6d for men and 10s 6d for women.

The Catherine Marsh Convalescent Home seems to have closed either just before or during the Second World War, and Beachfield was then converted into nine flats. However this final incarnation was short-lived, for by 1957 the building was unoccupied, and it was demolished around 1961 to make way for the Aquarena swimming pool. This opened in 1967 and closed in 2013, to be superseded by the new Splashpoint pool immediately to its west. The former Beachfield and Aquarena site is now occupied by the controversial Bayside development, which includes the first high-rise block on Worthing seafront.

SECTION 3

THE CHILDREN'S PLAY AREAS

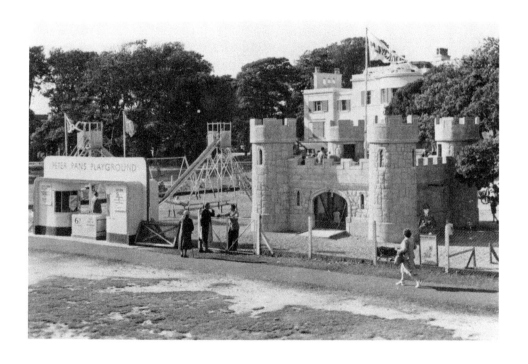

Peter Pan's playground from the south-east in the early 1970s, with Beach House in the background.

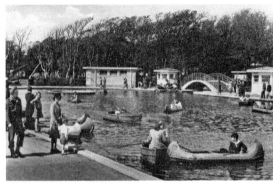

The boating pool from the south-east, in the late 1940s (from a Wardell postcard).

At Worthing, as in many seaside towns, the seafront buildings are close to the shore, meaning that there is little recreational space on the seafront. Only east of Splash Point does the land widen. The only potential 'amenity land' on the seafront – other than Marine Gardens and Steyne Gardens – has therefore always been the area between Splash Point and the recently built Splashpoint swimming pool.

A hundred years ago, the eastern section of the land in question consisted of the gardens of Beach House and the fields between Beachfield and the sea. The former were acquired by Worthing Council in 1927 and the paddling and boating pools on the eastern side of the land opened ten years later, with Peter Pan's Playground following in 1951.

The postcards reproduced here give a good idea of how these three sites were located in relation to each other, with Beach House and Beachfield serving as helpful 'locators'.

When, in 2010, the area was designated for the new indoor swimming pool, it was initially hoped that a new location could be found at least for Peter Pan's Playground, but sadly this proved impossible. The playground and the paddling pool closed for the last time at the end of September 2010. The boating pool, which had already been unused for some years, had been grassed over in 2008–09.

Alfred William Wardell

Three of the photographs in this section comes from postcards published by the notable Sussex publisher, Alfred William Wardell, formerly of Brighton and later of Worthing. His name appears on so many twentieth-century postcards of Worthing that it is of interest to say something about him – not least because at the time that

these three photographs were taken he was living just three-quarters of a mile east of the children's paddling pool, in Heatherstone Road.

All the information that follows derives from the section about Wardell on Rendel Williams's Sussex Postcards website – www.sussexpostcards.info – and is included with his permission.

Bill Wardell, as he was generally known, was born in 1878 at Newport in Monmouthshire. By the time of the 1901 census he was living in a boarding house in Weston-super-Mare and working as a piano tuner, this having also been his father's profession. It was, however, in his birth town of Newport that he married his wife Flora in 1903. Soon after their marriage, Bill and Flora moved to Brighton, where Flora gave birth in 1906 to twin boys, Charles and William. The following year she died of tuberculosis, aged only twenty-nine, soon followed by her infant son, Charles; Wardell's father also died around the same time. Seven months later, in November 1907, Wardell married his second wife, Grace, with whom he had three sons and two daughters.

1907 was a momentous year for Wardell, for not only was there a wedding and three funerals, but he also started publishing postcards. However, his primary occupation remained that of piano tuner until he was called away from Brighton by the First World War. Late in 1915 Wardell joined the Army Service Corps as a motor transport trainee driver, and within a year or so he was in France, conveying ammunition, food, and supplies to the soldiers on the Western Front. However, he then contracted scabies and, after a spell in hospital, was transferred to the Army Printing and Stationery Services at Amiens. He had probably been assigned to photographic duties because of his experience in that field.

Pike's 1917 Brighton Directory lists Wardell as a stationer at No. 39 West Street and a confectioner at No. 26 Queens Road, but it must have been his wife Grace who ran these shops while he was away. She may also have engaged in other activities in his absence, for Bill and Grace's marriage did not long survive his return from war service. Wardell was demobilised in March 1919, and by June 1920 Grace had left the family home. She had fallen in love with a married man called Frank Teague, seventeen years older than her. The pair eloped to Australia, taking with them just one of her five children – six-year-old Grace.

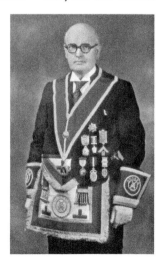

Bill Wardell wearing his masonic regalia, around 1950.
(By courtesy of Brett Jeffery and Rendel Williams,
www.sussexpostcards.info)

The others were left behind in Brighton with Bill. In July 1921, the divorce court granted Wardell a divorce and ordered Teague to pay him £1000 in damages.

Again, Bill Wardell did not remain unmarried for long, and early in 1922, by then forty-three years old, he married his third wife, Sadie, a woman sixteen years younger than him, with whom he does not seem to have had any children. His business, meanwhile, continued to prosper and expand. By the mid-1930s he had three shops in Brighton – a toy shop, a stationer, and a 'fancy goods dealer' – and he was publishing more and more postcards. His early postcards had been of Brighton, but in due course his reach extended as far west as Arundel and as far east as Eastbourne. By the end of the Second World War Wardell was sixty-six, and around this time he and Sadie moved to Worthing, where they lived at No. 3 Malvern Close, Heatherstone Road.

Over the years the 'publisher credit' on the back of Wardell's postcards had a number of different variants. When Bill first moved to Worthing, this credit became 'Copyright by A.W.W., Brighton and Worthing', from which Rendel Williams deduces that Wardell initially retained business premises in Brighton. This is the credit that appears on the backs of all three Wardell cards reproduced in this section, and the earliest postmark found on cards with this credit is 1947. By August 1949, however, the formula had become simply 'A.W. Wardell, Worthing', so Wardell had seemingly severed his links with Brighton by this point. New Wardell cards were still appearing in the early 1960s, but Williams suggests that it is unlikely that Bill was still active in the firm at that stage, and that in all probability one of his sons was running the business.

Bill Wardell died at No. 18 Winchester Road, Worthing – still a care home today – in May 1962 at the age of eighty-three. His estate was valued at £9,614, a considerable sum in those days: you could, for example, have bought three four-bedroom detached houses in Worthing for that money. Bill Wardell had done well for himself.

The paddling pool from the south in the early 1950s, looking towards Brighton Road (from a Wardell postcard).

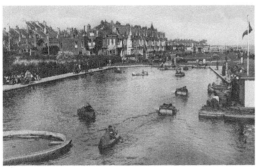

The eastern end of the boating pool in the late 1940s, with New Parade behind (from a Wardell postcard).

SECTION 4

The Gardens of Beach House

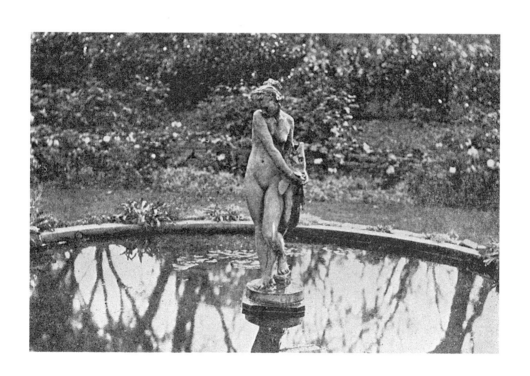

Gardens are demonstrably not buildings but, as indicated in the introduction to this book, we are in a few places taking a slightly cavalier approach to its title, and the lost gardens of Beach House have an important story to tell – and indeed one that offers the opportunity to say something about the connection between the Loder family and Worthing. (There is more about one of the Loders in Section 20.)

Either side of the entrance to Beach House there is a blue plaque. One commemorates its ownership between 1917 and 1923 by the homosexual playwright, Edward Knoblock (1874–1945), the author of *Kismet*. The other reads as follows: 'Edward VII (1841–1910) stayed in Beach House 1907 – 1908 – 1909 & 1910'.

This form of words indicates a minimum of four stays – at least one in each of the years given. Elsewhere I have seen several variants of the information about Edward VII's visits to Beach House – everything from 'he spent more than a month staying with [the Loders] in 1908' and 'he twice stayed here during his reign', and 'he came

Sir Robert Loder, who bought Beach House in 1878.

Sir Edmund Loder, eldest son of Sir Robert and his principal heir.

no less than six times', to 'he spent the summers between 1907 and 1910 at Beach House'.

As far as I am aware, however, the only source for the belief that Edward VII stayed at (rather than merely visited) Beach House is a sixty-four page book entitled *Notable Houses of Worthing, No. 1: Beach House – Beach House* for short – published in the Worthing Pageant series in 1947. It is in this book that the pictures of Beach House gardens seen here first appeared, although they date from the Knoblock period rather than the reign of Edward VII.

This book is something of a curiosity, not least in that, uniquely among books in this series, it is mainly anonymous. It starts with a three-page preface by 'J. G.', and ends with a two-page postscript, 'Beach House Today', by Antony Dale, a distinguished author and the founder of the Regency Society. The main part of the book, however, consists of ten pages of anonymous text, together with forty-one pages of photographs. This ten-page central section is written in a curious style, and is certainly not the work of either 'J. G.' or Antony Dale.

The anonymous author, for example, imagines Mr Helmes, the man who built Beach House in 1820, saying to himself when he first finds the location: 'Here is the quietude I seek, unbroken save for the singing of the birds, the music of the gentler breezes and the passions of the gales, the gentle lapping of the waves, and the roll of the tide tossed shingle.' Those that remember Fotherington-Thomas in the Molesworth books by Geoffrey Willans and Ronald Searle – 'Hello trees, hello sky!' and so on – will be familiar with this sort of writing, but it is rarely found in books of social or architectural history. *Beach House* is therefore a very different offering from, for instance, Henfrey Smail's superb books about other historic Worthing houses, published in the same series.

Seven of the ten pages of the main section of *Beach House* relate to the period when the house was occupied by Edward Knoblock, and it is possible that the book's shy author was a friend – or perhaps a former boyfriend – of the playwright. Even in respect of the Knoblock era, however, the book does not always seem reliable. The author makes the highly improbable claim, for instance, that the novelist and playwright J. B. Priestley stayed at Beach House during Edward Knoblock's ownership. Knoblock did indeed collaborate with Priestley on a dramatised version of

Beach House and its lawn from the south-east around 1920. The fish pond seen on the title page of this section was on the west side of the house.

The playwright Edward Knoblock, who owned
Beach House from 1917 to 1923.

the latter's novel *The Good Companions* in 1931, by which time Priestley was a
celebrated writer. However it is unlikely that the aesthetically inclined homosexual
American playwright and the bluff pipe-smoking Yorkshire socialist would have met,
let alone become friends, before the latter became famous. In 1923 – the final year
of Knoblock's ownership of Beach House – Priestley, although by then twenty-eight
years old, had only recently graduated from Trinity Hall, Cambridge, which he had
attended as a mature student after service in the First World War. He was an obscure
jobbing writer in London, and his first novel would not be published for a further
four years. In all likelihood, therefore, the author of *Beach House* simply forgot
the chronology, and extrapolated from the fact that Knoblock and Priestley had
collaborated on a play in 1931 that Priestley had been one of the literary visitors to
Beach House between 1917 and 1923.

Edward VII

There are two passages in *Beach House* about Edward VII's association with the
house. (The book, it should be remembered, was first published thirty-seven years
after the king died.) The first passage reads as follows:

> King Edward VII visited here on two occasions in the winter of 1908. In 1909 and
> again in 1910 Sir Edmund [Loder] was again honoured with visits from His Majesty.
> These visits led to rumours that the King intended to purchase the Beach House
> property, but there was no substance in the reports. It was a favourite resort of the
> King for these brief holidays, affording him the rest and privacy which he could
> rarely find elsewhere.

The author of *Beach House* goes on to say that several townspeople 'remember
having seen the king strolling and resting in the sheltered grounds'. This, of course,
does not itself prove an overnight stay. Nonetheless, although 'visits' are not
necessarily 'stays', 'brief holidays' certainly does imply a stay of several nights. Beach

Edward VII with his favourite dog, Caesar, probably in 1910. Photograph by Thomas Heinrick Voigt. (© National Portrait Gallery, London)

House, however, would have been a very modest house for stays by a king who loved the high life, even for a 'brief holiday'; and indeed Worthing (to be blunt) would have been a rather dull location.

The other reference in *Beach House* to Edward VII's visits to the house is a passage in which we learn that Winifred Loraine, second wife of the actor-manager and First World War flying ace Robert Loraine, spent her honeymoon there in 1921. Robert Loraine was a friend of Edward Knoblock, who lent him the house. The author of *Beach House* quotes a long passage from Mrs Loraine's memoir of her husband, published after his death, which in passing includes the information that Edward VII had 'often week-ended' at the house. We do not know the source of Winifred Loraine's information – which must have been, at best, third-hand – nor, of course, to what extent the story may have been amplified before it reached her, but this hearsay testimony is not reliable.

A difficulty we are faced with in this investigation is that in the main we are dealing not with hard information but with absence of information. Absence of information can, however, be telling – and neither the king's supposed good friend Sir Edmund Loder, nor Worthing, nor Beach House, are mentioned in Jane Ridley's recent 600-page biography of Edward VII (2012) or Sir Sidney Lee's massive two-volume biography, 1,600 pages in total (1925–27). Likewise, Alfred Pease's 356-page biography of Sir Edmund Loder, *Edmund Loder, Naturalist, Horticulturist, Traveller and Sportsman: A Memoir* (published in 1923, three years after his death), includes no reference either to the king's visits to Beach House or even to Loder's having been a friend of his. This is a surprising omission if the two men were indeed closely enough acquainted for the king to have stayed with Sir Edmund a number of times. The sole reference in *Edmund Loder* to the (future) king is to his having been

at Whittlebury, the estate of Robert Loder, Edmund's father, on 21 October 1887, to play real tennis during the Whittlebury Tennis Week, organised every year from 1883 until 1888 by two of Edmund Loder's younger brothers, Alfred and Gerald.

It should also be pointed out that Beach House was never Edmund Loder's main home.

Edmund's father, Robert, had been an immensely rich man. In 1871 he had inherited from his own father a fortune of £2.5 million (over £2 billion in today's money), and he had extensive estates in Russia and Sweden as well as in England. In 1873, Robert Loder – who was made a baronet only in 1887, the year before his death – purchased the Whittlebury Lodge estate in Northamptonshire, which was to be his main home for the rest of his life.

Five years later, Robert Loder bought Beach House, presumably primarily because he had political ambitions in Sussex – he was MP for New Shoreham from 1880 till 1885 – and, although he was at Beach House when he died in 1888, it was to Whittlebury that his body was taken for burial. Edmund Loder, who was now, following his father's death, Sir Edmund, inherited both the Whittlebury Lodge estate and Beach House, but had no long-term use for either. Indeed Sir Edmund disliked Whittlebury, which he regarded it as a white elephant, and it remained a problem for him for most of the rest of his life, as, with some difficulty, he sold the estate bit by bit.

The year after his father's death Sir Edmund bought Leonardslee, near Horsham, from his father-in-law, while his widowed mother, Lady Loder, lived at Beach House until her own death in 1907. After Lady Loder's death, Beach House was in effect surplus to requirements. A house at the Sussex seaside was of little use to someone who lived just nineteen miles away. Nonetheless Sir Edmund continued to own Beach House for a further decade – money was not a problem for the Loders – just as he had retained Whittlebury for many years. If, however, he had been a good enough good friend of Edward VII to have the king to stay for the weekend on several occasions, this would surely have been at his main residence, Leonardslee, with its fabulous gardens and lakes, its vast collections of plants, and its gazelles, beavers, kangaroos and wallabies?

Charles Stamper

A second relevant book in which there is no reference to overnight stays by Edward VII at Beach House is *King Edward as I Knew Him: Reminiscences of Five Years Personal Attendance upon His Late Majesty King Edward the Seventh*, by Charles Stamper, who was the king's motor engineer between 1905 and 1910. The book, which was published by Mills & Boon – originally a general publisher rather than a purveyor of romantic fiction – came out three years after the king's death.

In the early days of motoring, cars were unreliable, and whenever Edward VII travelled anywhere by car Stamper was with him, in order to be available if mechanical problems arose. Stamper says that he never drove the car himself, but rather sat in front beside the driver, who was always a police constable.

Such references as there are in Stamper's book to Beach House and to Worthing relate only to day-visits or stop-offs when the king was being driven west from

Brighton, a town where – like his great-uncle, the Prince Regent (later George IV) – he often stayed. There is, for example, a detailed account of a visit to Worthing on 12 December 1908, when the king was unwise enough to go for a walk on the pier and was mobbed by his devoted subjects (see Section 10).

The first reference in Stamper's book to a visit by the king to Beach House is a brief passage relating to an occasion early in 1909:

> On 21 February he motored to Beach House, Worthing. This stands on the shore of the sea on the skirts and to the east of the town. The owner was away, but he had, I was told, asked to be allowed to place the garden at His Majesty's disposal. This was a very fine one, running right down to the sea, with only a wall between it and the waves, while the privacy it afforded was absolute. His Majesty was very pleased with the pleasaunce [grounds], and we brought him there two or three times.

Several interesting points arise from this passage. First, the implication of the extract is that the various visits Edward VII made to Beach House were solely to make use of the grounds – and the owner's being away would not be surprising since the owner in question actually lived at another house just nineteen miles away. Secondly, the fact that the owner is not mentioned by name implies that he was not a particular friend, but rather an acquaintance who was happy to oblige the monarch – and indeed there is no indication that Stamper either knew or cared who the owner was. Thirdly, had the king previously stayed at Beach House, this would surely have been mentioned on the occasion of this visit, both by the king in the car and by Stamper in his book. Fourthly, the date 1909 is the second year given for the king's 'brief holidays' at the house in the account in *Beach House*, and in this respect the two accounts simply do not cohere.

In view of the fact that it was on 12 December 1908 – when the Beach House arrangement was not yet in place – that the king was mobbed on Worthing pier and the first visit to the gardens of Beach House was on 21 February 1909, it is likely that it was following the event on the pier that the king's aides were asked to find a location in the area where the king could enjoy sea air in peace, and made enquiries about the prominent house on the eastern approach to Worthing – and that Sir Edmund Loder was more than happy to oblige his monarch by offering him use of the grounds.

I wrote to Jane Ridley to ask whether she had any memory of having, while doing the research for her biography of Edward VII, come across any reference to Sir Edmund Loder or to Beach House. She kindly went back to her notes, and replied as follows: 'The king spent quite a lot of time in Brighton in the winters of 1908, 1909 and 1910. He usually stayed with the Sassoons at 8, Kings Gardens. He would go for drives with Stamper along the coast, and get out of the car for a brief wheezy walk – he was trying to shake off his bronchitis. My notes from his diary show him staying in Brighton 8–12 December 1908, 19–23 February 1909, and 10–15 January and 7–14 February 1910. My notes are pretty brief, but February 1910 does include a visit to "Lady Loder's garden". It is possible there may be references to the Loders' garden on the other dates in the diary. I think it unlikely that he stayed with the Loders, as he could easily reach Worthing from Brighton by car.'

A tree-lined walk on the east side of the grounds of Beach House in the spring of 1922 or 1923.

This evidence is very telling – not least, indeed, because it would have been very strange for the king, while spending a few nights with his close friend Arthur Sassoon, suddenly to have abandoned Kings Gardens for Beach House; and there is clearly no record in his diary of any such event. Very persuasive, also, is the reference Professor Ridley found in the king's diary to visiting 'Lady Loder's garden' – not the phrase he would have used had Sir Edmund been a friend, or if the king had stayed the night at Beach House. Indeed the 'Lady Loder' referred to in the diary is almost certainly not Sir Edmund's wife but his mother, who, as we have seen, had lived at the house from 1888 until her death in 1907. Sir Edmund himself never lived at Beach House, and therefore the house, which was generally left empty, would still have been thought of as his deceased mother's rather than his. The king's use of the phrase 'Lady Loder's garden' also coheres with Stamper's account of its having been the garden – rather than the house – that was made available for the king's use when he was passing along the south coast. Professor Ridley, after reading the article on which this section was based, wrote: 'I think you have conclusively nailed the myth about Beach House.'

Even without overnight stays, however, the connection between Edward VII and Beach House remains an interesting one – and a minor historical truth is preferable to a mid-sized historical myth.

SECTION 5

Eardley House

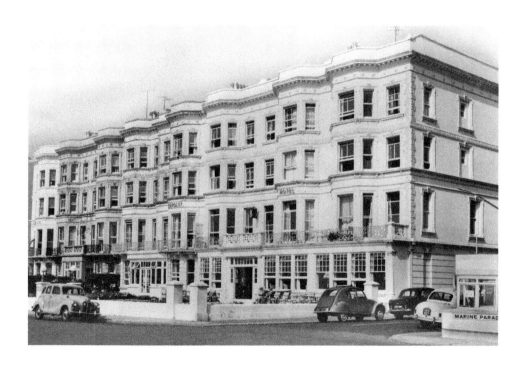

Unlike many of the Victorian terraces on Worthing seafront, the terrace that stood for 140 years at the eastern end of Marine Parade, almost opposite Splash Point, was not given a name when it was first built in 1868.

This unnamed terrace consisted of eight houses, most of which were being run as boarding houses by the end of the nineteenth century.

Jane Butler

In 1881 an energetic and enterprising woman called Jane Butler (1846–1936), who had previously run Giddinap House School in Selden Terrace – where she taught, among other things English, music, modern languages and drawing – established a boarding house at No. 3 Marine Parade, the house at the eastern end of the terrace.

In 1885, Miss Butler named her establishment the Eardley House Boarding Establishment. By 1893 she had expanded into Nos 4–5, but there was no further expansion until 1959. During those six and a half decades other small hotels traded in the more westerly houses of the terrace. However, even in the days when Eardley House occupied just three houses, it was a substantial concern, with thirty-six bedrooms.

In 1895 a promotional article in *A Descriptive Account of Worthing* made a virtue out of the establishment's being 'situated near the eastern extremity of the Marine Parade' since this meant it was 'sufficiently out of the line taken by the general run of trippers to make its locality pleasantly select'. 'Winter and summer there is always

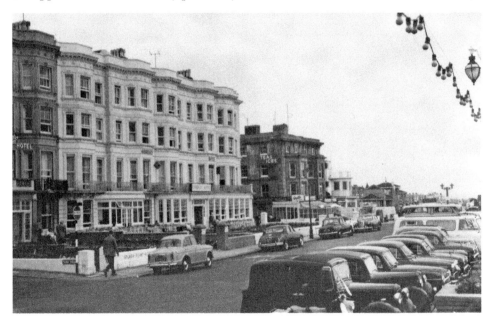

A view of the Eardley Hotel in the early 1960s. Beyond is Gravel Terrace – formerly Greville Terrace – the only old building between Steyne Gardens and Splash Point that survives. The Eardley Hotel did not acquire the three houses at the western end of its terrace until 1973, these having been occupied by various other small hotels during the first three-quarters of the twentieth century.

more or less of company at Eardley House,' the article continued, 'and Miss Butler, the proprietress, is a lady who thoroughly knows how to adapt her establishment to the fitness of things. The household duties are performed in orderly methodical style, and the domestics are most attentive to the individual wants of visitors.'

Jane Butler seems to have had a special friend called Sarah Morgan, who at the time of the 1891 census was also living at Eardley House. She is listed as a 'boarder' and 'living in own means'. Although the term 'boarder' was used also for guests staying in the hotel, in census terms it simply meant someone resident at a dwelling who was neither a servant nor related to the householder. Sarah is recorded as having been born in Scotland and thirty-nine years old. In 1891 Jane Butler was forty-five.

By 1901 Jane and Sarah are living at No. 6 Ambrose Place – Sarah is again listed as a 'boarder' – and have a fifteen-year-old servant called Jessie Marsh. This time Sarah's place of birth is given as Merionethshire, Wales, a more probable location than Scotland for a woman named Morgan. Jane is now recorded as 'boarding-house keeper (retired)'. This is puzzling, since by the time of the 1911 census Jane's residence for census purposes was again Eardley House, and she is no longer retired but is once again a boarding-house keeper. Sarah Morgan, however, is not listed at the Eardley in 1911, nor indeed elsewhere in Worthing, although she died in the town in 1920.

It is perhaps mischievous to construct a narrative out of these simple facts, but a plausible explanation for these oddities is that Jane and Sarah had, at some time in the 1890s, decided to retire to a life of domestic contentment at Ambrose Place, with Jane leaving the running of Eardley House to a manager – but that the friendship came to grief at some point in the subsequent decade, with the result that Jane returned to managing as well as owning the Eardley.

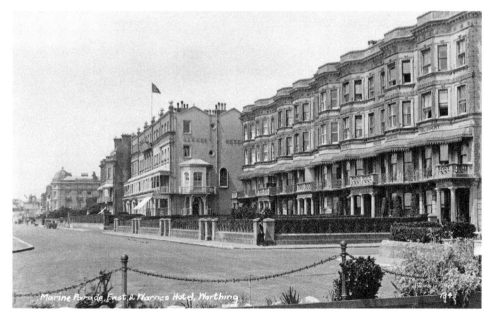

A Harold Camburn postcard dating from just before the First World War. At that time the Eardley House Boarding Establishment, as it then was, occupied the eastern half of the terrace on the right. Beyond is Warne's Hotel.

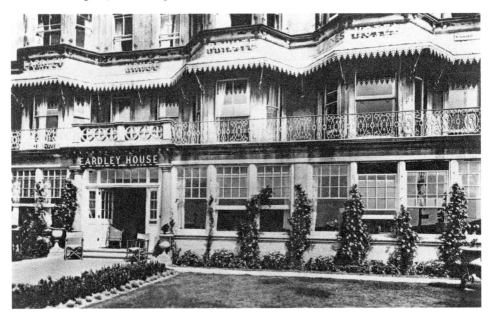

The entrance to Eardley House, probably in the early 1950s.

Frustratingly, Jane Butler makes no appearance in the 1921 or 1931 censuses – old censuses, sadly, are full of omissions and disappearances, and it is impossible to interpret these accurately – but she certainly remained the proprietress of Eardley House until 1930, although she had presumably by then for a second time retired as manager. She was ninety years old when she died on 19 September 1936 at her house in Ambrose Place.

Jane Butler left £100 in her will for cigarettes and tea for inmates of the nearby Humphrys' Almshouses, which at that time occupied premises in Portland Road as well as Humphrys Road. The charity still has almshouse flats in Humphrys Road today, but in houses that were rebuilt in 1971. In the 1960s the income from Jane Butler's bequest was being distributed at Christmas and in 1972 it was amalgamated with the almshouse charity. In 1975 it paid out £4.80, which cannot have represented a lot of tea and cigarettes, even at 1970s prices.

Men Behaving Badly

During the Second World War, Eardley House was requisitioned for use by the military, and in February 1944 the British Army's 4th Armoured Brigade set up its headquarters there in preparation for the D-Day landings. The brigade brought two hundred tanks to Worthing, and troops were billeted in and around Steyne Gardens.

After the war, Eardley House continued to occupy just the three houses at the eastern end of the terrace until 1959, when it acquired Nos 6 and 7. Finally the three houses at the western end, Nos 8–10, were added in 1973. However, the hotel occupied the entire terrace for only fifteen years, for it closed in 1988 and became a Crown Agency training centre.

There was, however, a postscript to Eardley House's time as a hotel when, renamed the Groyne View Hotel, it featured in episode forty-one of the television comedy series *Men Behaving Badly*, broadcast on Boxing Day 1998. The International Movie Database offers the following plot summary:

> Gary (Martin Clunes) is attending a security conference in Worthing and invites the others along, though they all end up sharing a cramped hotel room. On the first night the lads steal a huge ornamental fish, which they hide in the room and have to keep bribing the chambermaid to keep quiet about. After Dorothy (Caroline Quentin) has told her she is pregnant, Deborah (Leslie Ash) is horrified to see Gary kissing Wendy (Amanda Drew), another delegate with whom he has fallen in love, and asks Tony (Neil Morrissey) to do something to break them up. Tony's answer is to date Wendy, though they are caught by Gary, which leads to a fight on the crazy golf course [this was created at Splash Point for the purposes of the programme] and Gary realising where his heart really lies – with Dorothy.

The Crown Agency training centre vacated the Eardley building in 2006. It was regarded as not commercially viable to repair the existing building or turn it back into a hotel – the façade needed major repairs due to damage to the lime mortar brickwork, and the foundations needed underpinning – and in the summer of 2008 the old terrace was demolished.

Happily, however, the building that has been built in its place is a handsome structure closely modelled on the original terrace. At the International Property Awards 2012 the new Eardley won the awards for 'Best Development Multiple Units, West Sussex', 'Best Apartment, West Sussex' and 'Best Apartment, United Kingdom'. Jane Butler would doubtless be pleased and proud to know that the name she chose for her boarding house over 125 years ago has survived, and on such a fine building.

Bob Monkhouse

In his 1993 autobiography, *Crying with Laughter*, the comedian Bob Monkhouse (1928–2003) records that, when he was a child in the 1930s, his family almost always spent its fortnight's holiday at the Eardley House Hotel; and in this connection he has a remarkable story to tell.

The year after Bob was born, his parents acquired a black cat called Sam, to whom Bob became devoted. Generally Sam was looked after by friends when the family went on holiday, but in the summer of 1935 – when Bob was seven years old – no one was available for the purpose, so Sam accompanied them on the sixty-mile trip to Worthing. On the way they stopped for tea, as they always did, at Clematis Cottage.* Sam had a saucer of milk and, Monkhouse writes, 'the kindly old lady who ran the place remarked on how handsome she thought Sam and made friends with him'.

* This was probably Clematis Cottage at Washington, in those days a well-known tea room a couple of hundred yards west of the London road. The A24 ran through the east side of Washington village until the bypass was built in 1964.

During the holiday Sam shared a room at Eardley House with Bob and his brother, occasionally going out onto the balcony – the photographs that illustrate this section suggest they must therefore have had a first-floor room – or into the garden, but never much further. Then, on the last day of the holiday, Sam suddenly and inexplicably disappeared. Bob's father delayed the family's departure from two o'clock until the early evening, but in the end there was no alternative but to drive back to the family home in Beckenham, with Bob in floods of tears.

Bob continued to be upset about Sam's disappearance, wondering where he was and who was feeding him. Eventually his parents thought the best thing would be to try to make Bob accept that the cat was dead. So, one day in October, they sat him down and told him that they were sure Sam must have been killed by a car, and offered to get him a new kitten. However the thought of Sam's being 'squashed under a wheel' was too much for Bob to bear, and he took out the snapshots of that summer's holiday in Worthing and started tearing them up.

When Bob got up the next morning, he saw from his bedroom window a very thin black cat in the garden, and he went down to give it some food. The cat was so emaciated and unkempt that at first Bob did not recognise him, but then, as he puts it, suddenly the cat looked into his eyes and his heart jumped. It was indeed Sam, who had somehow found his way back from Worthing to Beckenham.

The next summer, Bob and his family went again to Eardley House, this time leaving Sam with neighbours, and as usual they stopped at Clematis Cottage for tea:

> The proprietor recognised us, as she did every year, and asked me, 'How is that handsome cat of yours?'
> I said he was fine, thank you.
> 'He passed through here last autumn,' she said. 'I gave him some fish and a little milk, and then he was gone again.'

The holidays at the Eardley House Hotel were not, as it turned out, the end of Bob Monkhouse's association with Worthing. When the Second World War broke out, his father thought it would be safer to take the family out of London, and from 1939 until 1942 they lived at No. 4 Douglas Close, West Worthing, and Bob attended Goring Hall School.

SECTION 6

WARNE'S HOTEL

For most of the twentieth century Warne's Hotel* was the only location in Worthing that was known nationally, and indeed internationally. It is probably not an exaggeration to say that it was the fame of Warne's Hotel more than anything else that put Worthing on the map during that period – certainly until the men's bowls national championships arrived in Worthing in 1974 (before defecting to Leamington Spa after 2013).

To many people who are now in their eighties or nineties, the name of Warne's Hotel evokes the era of raffish young – or not-so-young – men driving women who were not their wives down to the south coast in open-top sports cars. And while Worthing may never have been as popular a location as louche and animated Brighton for illicit liaisons, it was little further from London than Brighton by the route used in those days. For a motorist starting at Vauxhall Bridge, the journey to Worthing following the A24 was only four miles longer than the fifty-two mile journey along the A23 to Brighton. Neither was as close to central London as Southend-on-Sea, the nearest of the east coast resorts, but no man who wanted to impress a girl would take her to Essex for the weekend.

Like a number of other hotels in twentieth-century Worthing – such as the Esplanade (see Section 1), the Eardley (see Section 5), the Chatsworth and the Berkeley, now Travelodge – Warne's Hotel developed gradually and organically out of a nineteenth-century terrace, in this case York Terrace, built in the early 1820s. Warne's expanded as more houses were acquired, until finally the hotel occupied the entire terrace, as well as a previously separate building called Steyne House, immediately to its west.

The hotel was named after its founder, George Hilbery Warne (1864–1916), an entrepreneur from Brighton, who owned and managed it for the first seventeen years of its eighty-six year existence. Like many successful enterprises, the success of Warne's Hotel owed partly to energy and partly to luck. The element of luck was that less than two years after Warne's opened in July 1899, the Royal Hotel (see Section 13), which had been Worthing's largest and most famous hotel for the previous three-quarters of a century, was destroyed by fire.

At that stage Warne's was still small, but gradually Warne acquired the space to make his new establishment the town's leading hotel. We can follow the trail of his acquisitions in old directories. By the turn of the century the street address of York Terrace, the five Georgian houses that were to form most of the hotel, was Nos 11–15 Marine Parade. Marine Parade had been rationalised and renumbered in 1881, and the old terrace names had gradually gone out of use. Warne started his hotel in No. 11 Marine Parade, the house at the eastern end of the terrace. He had acquired No. 12 by 1901, No. 13 by 1905, and No. 15 by 1908. The 'missing link', No. 14, followed a year later. Finally, Steyne House, the building at the corner of Steyne Gardens, became part of the hotel around 1926, ten years after Warne's death, with much of its ground floor being fitted out as the Old England Bar.

It appears from an entry in the *London Gazette* on 17 December 1918 in the 'Notice of Intended Dividends' section – this term relates to the sharing out of available funds after bankruptcy – that George Warne went bankrupt in 1914, two

*In the early days of the hotel, the with-apostrophe form 'Warne's' was almost always used. Later – perhaps after George Warne's bankruptcy in 1914 or his death in 1916 – the apostrophe was generally omitted; but we use the earlier form throughout.

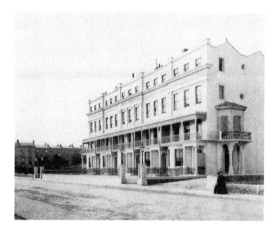

This rare, though not very high quality, photograph of around 1880 shows York Terrace as it looked before it was occupied by Warne's Hotel.

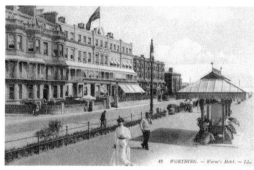

A Lévy Sons & Co. postcard of Warne's Hotel, first published in 1907, using a photograph taken the previous summer.

years before his death. The process of dealing with his bankruptcy took some four years, so it must have been slow and difficult, and indeed would have complicated by Warne's dying in the meantime. In view of his bankruptcy, the hotel presumably passed out of Warne's hands in 1914.

By the 1980s Warne's Hotel was in decline. There was now an over-supply of accommodation in British seaside towns, with cheap package holidays abroad providing a tempting alternative. In Worthing, scores of small hotels and guest houses closed, and several larger ones, including, as we have seen, the Esplanade and the Eardley. By the 1980s Warne's was old-fashioned, and there is a limit to how much modernisation can be done within a structure dating back over 150 years. The hotel closed in 1985, and the following year the building and its contents were sold at auction. In October 1987 the empty building suffered a serious fire, which was attended by at least fourteen fire engines. Originally, it had been hoped to preserve the hotel's façade, but in the event the entire building was demolished in 1992, and the present impressive but incongruous block of flats was erected on the site.

Motoring at Warne's

George Warne was an enthusiastic early motorist, and his hotel was the first in Britain to have a garage with a trained mechanic to attend to the temperamental cars of those early years. The garage, which opened in 1900, only a year after the hotel, was situated behind the hotel, with an entrance on York Road. Warne advertised

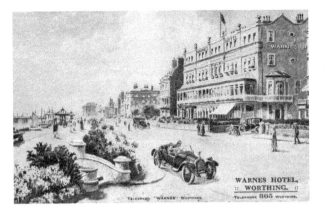

A charming postcard produced for its guests by Warne's in the early 1930s. On an earlier, colour version of this card, dating from just after the First World War, the cars seen are of an older type. The artist replaced these with new models when the card was reprinted.

his hotel as 'the mecca for motorists', and on 29 May 1909 *Autocar* assured its readers: 'Mr G. H. Warne, the urbane host of Warne's Hotel, Worthing, the motorist's house par excellence of the South Coast, spares no effort or expense to serve the many clients who visit his well-appointed hotel from far and wide.' Incidentally, the journey from London to Worthing in those days took motorists through the middle of Findon, where the Local Government Board had instituted a 10 mph speed that the Mr Toads of the era found very frustrating.

Warne's interest in motoring was reflected in a special song called 'The Warne Motor Ride', written by the hotel's musical director, Walter Wells, which was performed at orchestral concerts held in the hotel. Guests were encouraged to join in the chorus, which went:

> Away goes the motor,
> Off we go for a ride
> Through rustic lanes and villages
> Down the hills we glide.
> The hooter gives the signal
> Look out! Clear the way!
> We're off to Warne's Hotel, my boys,
> For that's the place to stay.

The cover of the orchestral programme reproduced on the facing page, which probably dates from around 1905, has 'Headquarters A. C. G. B. & I' on it. These initials stood for the Automobile Club of Great Britain and Ireland, which was founded in 1897, and the following year incorporated the wonderfully named Self-Propelled Traffic Association. In 1907, the club, under the patronage of Edward VII, another enthusiastic early motorist, changed its name to the Royal Automobile Club – today's RAC. The claim on the programme that Warne's Hotel was the club's headquarters is puzzling, however, since the club was always based in London. Warne's Hotel can at best have been a local headquarters, for Sussex or the southern counties.

In 1902 Warne organised a 'motor trial' from Crystal Palace to Worthing, for which his hotel served as the lunch stop. The event attracted about two hundred and fifty competitors. A second event, held on Easter Monday in 1905 – the Worthing Decorated Motor Carnival and Battle of Flowers – was even larger. Over three hundred cars and

motorcycles attended, and fourteen prizes were offered for the best decorated cars and motorcycles. The car competition was won by Hector Morison, a stockbroker and prominent Liberal, who stood as the party's candidate for Lewes in the 1906 General Election and for Eastbourne in the two elections of 1910, and finally served as MP for Hackney South from 1912 to 1918. All the cars were richly decorated with flowers, but Morison's also had an outsized swan on top of the engine.

According to Tony Gardiner, in his book *The Brighton National Speed Trials*, George Warne's initiatives of 1902 and 1905 may have been the inspiration for Brighton to organise its own trials, the first of which was held on July 19–22, 1905, three months after Warne's Motor Carnival. If so, it would appear that the London to Worthing run of 1902 was the original event of its kind, and that the London to Brighton run, still held today, was in effect an act of automotive theft.

The cover of an 'Orchestral Programme' of around 1905. The hotel's orchestra under Walter Wells played light classical music three times daily: from 12.45 p.m. until 2.30 p.m., from 3.40 p.m. until 5.10 p.m., and from 7.20 p.m. until 9 p.m.

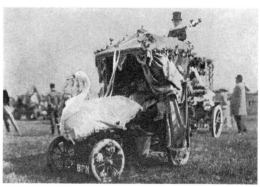

The car that won the first prize at the Decorated Motor Carnival organised by George Warne in 1905. It was owned by Hector Morison, a stock-broker and later a Liberal MP.

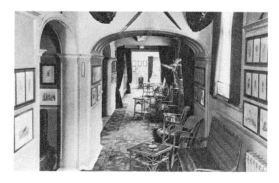

A view of the so-called 'Corridor Lounge' at Warne's in the 1920s, which according to the information on the back of this postcard contained 'many curios', including 'the famous Mermaid', original drawings of Dickens's characters by Kyd, and an Armada chest.

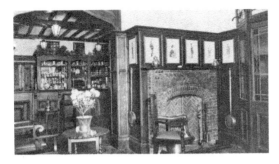

The Crush Bar at Warne's in the 1940s.

The dining room at Warne's in the 1920s. The information on the back reads: 'The three palms, Kentia Fosteriana, flourishing in the dining-room since 1908. The finest specimens of their kind in Great Britain.'

William Kenny, VC

Warne's had many famous guests over the years, but also, in the early 1930s, a notable doorman – William Kenny (1880–1936), an Irishman from Drogheda, who had been a drummer in the 2nd Gordon Highlanders during the First World War. Kenny was a man of many medals, including the Queen's South Africa Medal and the King's South Africa medal (for service in South Africa in 1899–1901); the 1914 Star; the British War Medal; and, for some reason, the Russian Cross of St George, 2nd class. Most notably, however, he was awarded the VC for his heroism on 23 October 1914, during the Battle of Ypres, when he rescued five wounded men under heavy fire. Kenny also served at the Somme in 1916, and a full account of his war service appears in Gerald Giddon's 1997 book, *VCs of the First World War: 1914*. After being discharged from the army in 1919, Kenny joined the Corps of Commissionaires, a body founded after the Crimean War to provide jobs for ex-servicemen, which still functions today. For many years he worked in Bond Street in London, and towards the end of his relatively short life – he was only fifty-five when he died in 1936 – at Warne's.

In July 1935 Kenny gave an interview to the *Daily Express*, which was printed under the headline 'Irish V.C. tells of how he saw himself buried'. It was 1917. Kenny was digging a grave for a dead soldier, and there was another grave close by that had just been filled in. The Brigadier passed by and said to the man who had just filled in the other grave, 'I see you have lost your Drum Major Kenny then?' 'Ah yes, sir,' the man replied, 'that's his name there on the cross.' 'No, no, it's not true,' interrupted Kenny. 'I am not dead, I am no corpse. Here I am.' 'But we have just buried you,' said the other man. 'There is your identity disc to prove it.' The Brigadier and the other gravedigger took some convincing, but in the end Kenny was able to persuade them that the soldier who had been killed had accidentally picked up Kenny's shirt and identity disc in the bathhouse earlier in the day.

In the 1930s professional postcard photographers patrolled British beaches offering their services to holiday-makers and day-trippers. The photographs were printed off the same day, at postcard size and with proper postcard backs. In this case someone has helpfully written the date 5 June 1938 on the back of the card. There is another example of this type of card on the title page of Section 7.

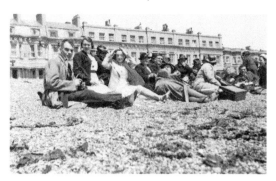

John Logie Baird

The blue plaque on the block that occupies the site today records that the distinguished people who stayed or dined at Warne's Hotel during the nine decades of its existence included King Edward VII, King George V, Emperor Haile Selassie and his family, Winston Churchill, General Montgomery, General Eisenhower, and the great American composer John Philip Sousa. Details about most of these visits are hard to come by, and in some cases they were probably for lunch or dinner rather than overnight. It would be fascinating to have sight of the hotel's guestbooks.

The most celebrated of these associations is, however, well documented. Haile Selassie, Emperor of Abyssinia (later Ethiopia) from 1930 until he was deposed in 1974, a year before his death, stayed at Warne's with his family for several weeks – possibly six – in 1936. This was at the start of Selassie's five-year exile in England after Benito Mussolini's Italian army occupied his country. Selassie was a major world figure for almost half a century, and is today the figure at the heart of the Rastafarian cult, which holds that he was the reincarnation of Jesus.

Five years before Haile Selassie stayed at Warne's, the hotel was the location of the first date that John Logie Baird, the television pioneer, had with his future wife, a young South African pianist called Margaret Albu. She was twenty-four and Baird (1888–1946), still a bachelor, had just turned forty-three. The account that follows derives from information in Russell W. Burns's 2000 book *John Logie Baird: Television Pioneer*.

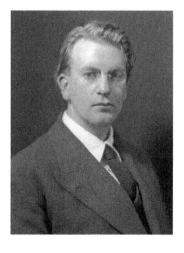

John Logie Baird in 1928, three years before he took his future wife, Margaret Albu, to dinner at Warne's on the day he first met her. Photograph by Lafayette Ltd. (© National Portrait Gallery, London)

A friend of Margaret Albu's by the name of Grace had been invited to tea with Baird one afternoon in August 1931. She asked if she could bring a friend with her, and the friend she chose was Margaret. The two women were taken by car to Baird's house at Box Hill in Surrey, and it was only when the driver got lost and had to ask directions that Margaret realised that it was this celebrated man who was to be their host.

After tea Baird said to the two young women, 'Will you two girls give me the pleasure of coming down to Worthing for dinner? The chauffeur will drive you straight home afterwards.'

They duly drove the thirty-five miles from Box Hill to Warne's Hotel. The dinner was evidently a great success, and afterwards Baird said to Margaret and Grace, 'I wish I was returning with you two girls instead of spending the weekend here.' As they were about to be driven away, Baird ran down the front steps of the hotel to ask Margaret for her telephone number. Later he telephoned a friend and said, 'I'm going to marry this young woman.' He was as good as his word. Not long afterwards he proposed to her over the telephone from New York. Margaret flew out to America, and she and Baird were married at the Half Moon Hotel on Coney Island on 13 November 1931 – only three months after they had had their first dinner together, at another hotel three thousand miles to the east.

T. S. Eliot

Another famous guest at Warne's was T. S. Eliot, who stayed at the hotel in 1959 with his second wife Valerie. Eliot is widely regarded as the greatest poet of the twentieth century, and his long and often obscure poem *The Waste Land* as the century's greatest poem. In a lighter style, Eliot also wrote *Old Possum's Book of Practical Cats*, on which the Andrew Lloyd Webber musical *Cats* was based.

It is not clear how long Eliot stayed at Warne's in 1959, but we know from his scrapbook-cum-diary that on the evening of 27 July he and his wife went to see the Agatha Christie play *Appointment with Death* at the Connaught Theatre, sitting in seats E19 and E20. Eliot noted that the play 'was admirably done by the local Rep – no West End production could have been better'. There is something pleasingly incongrous about an author best known for dense and intellectual poetry enjoying a Christie whodunnit on a summer night in Worthing sixty years ago.

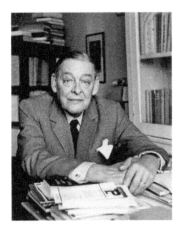

The poet T. S. Eliot in 1959, the year when he and his wife Valerie stayed at Warne's and went to see an Agatha Christie play at the Connaught Theatre. Photograph by Ida Kar. (© National Portrait Gallery, London)

SECTION 7

STAFFORD'S LIBRARY AND REBECCA HOUSE

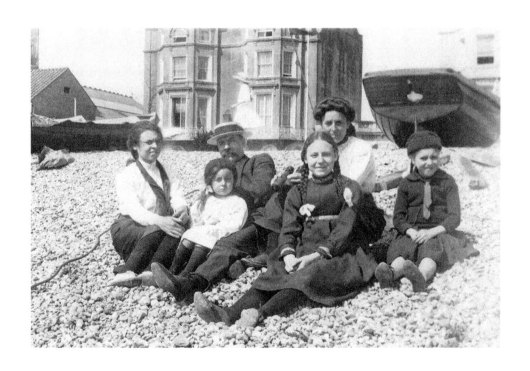

The small building that stands immediately to the west of the southern end of the Chatsworth Hotel was always of one storey. It was the Steyne Baths from 1886 until 1903 and then became the premises of the Worthing Sailing Club. The next building, however, which today also consists of just a single storey, was originally a handsome four-storey structure, as the illustrations here show.

Its architect was John Biagio Rebecca, the greatest of all Worthing's architects, who designed many fine buildings in and around the town, including the Chapel of Ease (later St Paul's Church), Beach House and Castle Goring, all of which survive; and the Sea House Hotel (later the Royal) and Marlborough House, which do not. When it was first built, around 1809, the eastern half of our building was called Rebecca House, and it is possible that John Rebecca lived there himself. The western half served as a new home for Stafford's Marine Library.

We know the date of the building because it does not appear in a print of 1808 that shows the Steyne Hotel (built in 1807), but it does appear in a print of 1810. Both prints are reproduced in my book, *Jane Austen's Worthing*. In *A Topographical Description of Worthing* (1824), John Shearsmith says that the building had been erected twelve or fourteen years before he was writing, but the evidence of the prints suggests that fifteen is more accurate.

Stafford had opened his library – the first in Worthing – in Marine Place in 1797. Then, in 1802, Edward Ogle built the Colonnade terrace, which included a fine new library on the corner of Warwick Street and High Street. Stafford's premises in Marine Place now fell some way short of the competition, hence the move to the new location a few years later.

By 1824 the library was being run by Mrs Stafford, so Stafford himself had probably died by then. Shearsmith says that the library's 'internal arrangements'

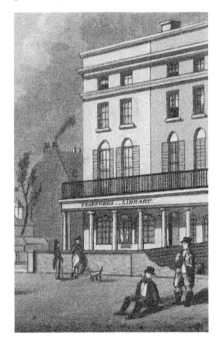

Stafford's Marine Library and Rebecca House in 1810, only a year or so after they were built.

were similar to those of the Colonnade Library 'with the exception of not possessing a distinct reading room'. Nonetheless Stafford's Library claimed 'an equal degree of respectability'. Shearsmith also tells us that, being directly on the seafront, 'in point of situation it is less retired than the Colonnade Library', and that therefore it is 'the admiration of the gay', while the Colonnade Library is 'preferred by the grave'.

The library seems to have closed about 1845. John Rebecca died in 1847, and by 1865 the former Rebecca House was known as Landsdown House and the former Stafford's Library as Clarendon House. The building's original simple Georgian façade had, like that of the Steyne Hotel next door – now the southern part of the Chatsworth – been replaced with a bow front.

By the end of the nineteenth century most of the buildings on Worthing seafront were hotels or boarding houses, and this building was no exception. It was now a single unit known as the Clarendon House Boarding Establishment. A promotional article in the 1895 edition of *A Descriptive Account of Worthing* tells us that, while 'some boarding-houses are as busy and bustling as an ordinary hotel', Clarendon House – which had twenty-four bedrooms – 'is as much like a well-appointed private home as possible, and nothing is neglected by Mrs E. T. Bush, the enterprising proprietress, to provide the comforts, refinements and bright surroundings of a genuine home'. The piece goes on to say that Clarendon House is situated 'almost opposite the pier' and that it adjoins the baths and is close to the tennis courts,

At the time of this 1895 photograph the building was known as the Clarendon House Boarding Establishment, although the second word of its name does not appear on the board above the entrance.

to which the guests have 'the right of entrée'. These were the grass tennis courts which at that time occupied the northern end of Steyne Gardens. 'The cuisine,' the piece continues, 'is of the very best and the sanitary arrangements are certified as perfect by an official certificate from the Corporation' – although the mention of the proximity of Clarendon House to Steyne Baths suggests that bathing facilities were not available at Clarendon House itself.

For most of the twentieth century the building was again two separate units. The western half continued as a small hotel. The eastern half passed through various hands, and after the Second World War was converted into flats. Finally the whole building was acquired by the Southdown Bus Company, but the upper floors fell into disrepair and in 1978 the building was taken down to a single storey.

Curiously, the Clarendon House Boarding Establishment had an exact namesake in Australia, in the Blue Mountains, west of Sydney. It is listed under that precise name in a guide of 1907 issued by New South Wales Railways. Perhaps it was set up by a citizen of Worthing who had emigrated to the Antipodes.

SECTION 8

THE WELLINGTON INN / THE PIER HOTEL

The Royal Sea House Hotel, the Marine Hotel and the Wellington Inn, probably in the 1850s (photograph provided by James Henry, www. worthingpubs.com). The very pale section at the bottom right-hand edge of the photograph is a single-storey building located on the opposite corner of Marine Place. By the time the photograph on the title page of this section was taken in the late nineteenth century, the Pier Hotel, second from left, had acquired a third storey, and the façade had been altered.

The Pier Hotel, which stood just to the west of Marine Place, had three incarnations: first, from 1816, as an inn converted from a seafront cottage; secondly, from around the middle of the nineteenth century until 1937, as a small three-storey hotel; and thirdly, from 1938 until 1965, as a four-storey art deco structure.

The Wellington Inn

The original two-storey building on the site, which was known as Marine Cottage, dated back to the eighteenth century. It was in 1816 that the cottage was converted into an inn. The previous year the Duke of Wellington had defeated Napoleon at the Battle of Waterloo, and the new inn was, like many buildings and streets all over England, named after the great general.

One of the inn's early landlords – probably in the late 1820s or early 1830s – was a man called Robert Little, who was originally from Dorking. Little had become an entrepreneur in Worthing, where he was a shipowner and a coach proprietor as well as an innkeeper. The ship-owning business seems to have failed about the same time as Little left the Wellington Inn, however, for he is subsequently described only as a coach proprietor.

Little relocated to Marine Place, where he lived at Bedford Cottage, which still stands today. He then fell on even harder times, because his next address was the King's Bench debtors' prison. After his release, Little returned to Dorking, where he set up as a dealer in tea and coffee with a man called John Irving. However this business too came to grief. In 1836 Little was back in prison, and on 14 June that year the

London Gazette announced that a 'petition' from him was to be heard at the Court for the Relief of Insolvent Debtors at the courthouse in Lincoln's Inn Fields on 7 July.

At some point, perhaps around the middle of the nineteenth century, the Wellington Inn was restructured, the frontage being altered and a third storey added. In 1862 Worthing Pier – just a simple narrow walkway over the sea in its early days – was built, and the following year the inn was renamed the Pier Hotel. The reason for the new name was probably as much to serve as a convenient geographical marker as to commemorate the new pier. The decision to remove 'Wellington' from the name would not have been a difficult one to make, since in the later part of his life the hero of Waterloo, who had died in 1852, had become a deeply unpopular politician, noted for his reactionary views. Between 1830 and 1832, and again briefly in 1834, Wellington had been prime minister, and during his period of office Apsley House, his London residence, was twice attacked by mobs of demonstrators who smashed many of the windows. Wellington's nickname 'the Iron Duke', incidentally, related not to his prowess on the battlefield but to his inflexibility as prime minister.

Ezekiel Osborne

Around 1870 the Pier Hotel was acquired by Ezekiel Osborne. The 1895 edition of the promotional publication *A Descriptive Account of Worthing* describes Osborne as having been 'well known in connection with Squire Gratwicke of Ham Manor near Angmering' – a wonderful euphemism, since he had in fact been Squire Gratwicke's butler. Gratwicke was a successful racehorse owner and breeder, whose horses *Frederick* and *Merry Monarch* won the Derby in 1829 and 1849 respectively. Oil paintings of the horses hung for many years in the smoke room of the Pier Hotel.

In an article in the *West Sussex Gazette* in February 1907 Ezekiel Osborne was described as 'a man of venerable appearance, who afterwards proved a model landlord of the Pier Hotel at Worthing'. The exact extent of this venerability is in doubt, however, because the 1861 census (when he was still a butler) has him born in Essex in 1813, while the 1871 and 1881 censuses (when he was at the Pier Hotel) have him born in 1820 in Sussex.

In Osborne's time, and for a while afterwards, the hotel was known as Osborne's Pier Hotel. Osborne died in 1891 and his wife Mary Ann, whom he had married in 1872 when she was already forty-seven, in 1894. The 1871 census shows them as having a one-year-old daughter, also Mary, born when her mother was forty-four. Sadly, however, it seems she died young, as many children did in the nineteenth century, since she is missing from the 1881 census.

The Thirties Incarnation

It is often assumed that the 1930s incarnation of the Pier Hotel seen in the later photographs was the result of a similar process to the 'art-deco-isation' of the Beach Hotel (see Section 21) – in other words, the original structure remained, but was given a comprehensive makeover with, in the case of the Pier Hotel, an extra storey added.

Following an article in the *Worthing Herald* in February 2014 in which I repeated that assumption, however, I was contacted by John Melser, whose grandfather – and

then his parents – ran the Pier Hotel for many years, until the early 1960s. John, who grew up at the hotel and was later the manager of the Parade Wine Lodge (see Section 19), told me that the old Pier Hotel was in fact demolished totally in 1937, and that the art deco structure that replaced it was an entirely new building. Interestingly, a temporary building was erected in the forecourt to maintain the continuity of the licence while the new hotel was being constructed in 1937–38.

In 1965 the new Pier Hotel was in its turn demolished, at the same time as its immediate neighbour the Marine Hotel. They were replaced by the oblong building seen on the third photograph on this page. At its western end was a branch of Bejam, the frozen food retailer that was later taken over by Iceland, while the main part of the building was occupied by the Marine public house. Within thirty years or so, however, this building too was gone, and today a less slab-like structure occupies the site.

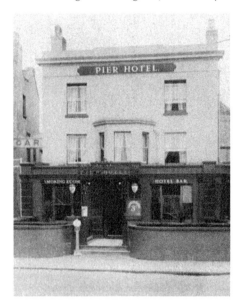 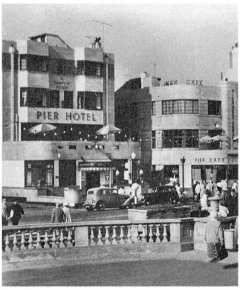

Above left: The Pier Hotel around 1930 (photograph provided by James Henry, www. worthingpubs.com).

Above right: The Pier Hotel in the late 1950s.

An early 1970s view of the building that occupied the former site of the Marine and Pier Hotels for thirty years or so.

SECTION 9

THE MARINE HOTEL

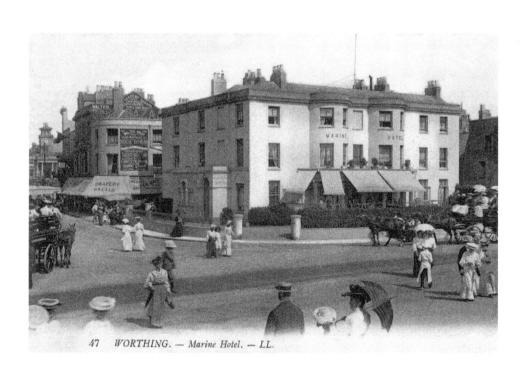

47 WORTHING. — *Marine Hotel.* — LL.

The Marine Hotel and its predecessor, the New Inn, stood immediately to the west of the Pier Hotel. As the pictures here show, the Marine was a charming building, and its demolition in 1965 was a great loss to the central section of Worthing seafront. The present building, on the ground floor of which there is a pub currently known as the Cow Shed, is the second to have occupied the site since then.

At the end of the eighteenth century, when Worthing was little more than a village, Worthing's three main inns were all in South Street.

Halfway down the eastern side was the Nelson Inn, which still stands. Today it is the southern half (No. 40) of the shop that occupies Nos 40–42 South Street. It still has its attractive original curved bay windows on the first and second floors, while the windows of No. 42 are more angular.

At the south-west end was the Sea House Inn, and at the south-east end the New Inn.

Worthing rapidly grew in size over the first few decades of the nineteenth century, and the Sea House Inn and the New Inn soon seemed rather old-fashioned, especially in comparison with the Steyne Hotel (now the southern end of the Chatsworth), which opened in 1807. It was during the ten-year reign of George IV, formerly the Prince Regent, that both of the hotels at the end of South Street were replaced by new buildings. In 1826, the Sea House Inn was rebuilt as the Sea House Hotel, later the Royal Sea House Hotel, and subsequently simply the Royal (see Section 13); while the Marine Hotel had replaced the New Inn a year or so earlier.

The Marine was one of the town's leading hotels throughout its 140-year existence, and civic or commercial events were often held there. On 10 August 1838, for example, 'at 12 precisely', an important auction took place at the Marine. There were four lots 'comprising the manor of Tarring in the County of Sussex, in which the fines are arbitrary, with courts baron, manorial rights, royalties, and quit-rents, extending over various farms, houses, and other properties, together with a genteel residence called the Rectory-house, and five neat and newly-erected cottages in the village of Sompting and [over twenty-seven acres] of exceedingly rich meadow and arable land surrounding the same'.

This auction led to an expensive and protracted dispute. Lot One – the most important lot, the manor of Tarring itself – was bought by a man called James Cuddon, who afterwards complained that some of the 'fines' were not arbitrary but fixed, a difference with significant financial implications. This complicated matter finally went, on appeal, to the House of Lords, where the case was heard on 18, 19

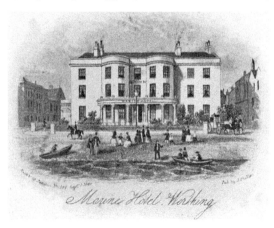

The Marine Hotel in 1849.

and 22 January 1842. The account of the case occupies thirty-five pages in *Reports of Cases Heard and Decided in the House of Lords on Appeals and Writs of Error, during the Sessions 1831–1846*, Vol. 1 (1872).

Mrs Harriette Smythies

There was clearly an association of some kind between the Marine Hotel and a now forgotten but once popular Victorian novelist called Mrs Harriette Smythies, née Gordon, since important episodes in two of her early novels are set in the hotel. There is no evidence that Mrs Smythies ever lived in Worthing – she was born in Margate and spent her early life in Kent and her later life in London – but she clearly knew both Worthing and the Marine Hotel. The two novels in which the hotel features were early ones, so perhaps she and her family spent holidays there when she was a girl or a young woman. Either way, Mrs Smythies needs to be added to the list of notable writers who had a connection with Worthing.

There is uncertainty about the year when Harriette Gordon was born. 1813 is the year most often given, but census and other records give a variety of dates – the 1851 census has 1817, the 1881 census 1811, and her death certificate (she died in 1883) has 1809. She seems to have got older as she got older! The reason for the earlier dates was perhaps that, if she was born in 1809 – and the death certificate is probably the most reliable source – she was an embarrassing seven or eight years older than her husband, a fact she perhaps kept from him. (The years given for his death vary too. Either 1816 or 1817 is probably correct, with 1810 a rogue date.)

This husband was the Revd William Yorick Smythies, a Church of England clergyman, whom she married in 1842 and by whom she had five children. He was a feckless individual, constantly in financial difficulties, and Harriette left him in either 1860 or 1864 (again sources vary) and moved with her children to London. By then her own financial situation had deteriorated. Her novels had been successful and lucrative through the 1840s and 1850s, and she also published numerous articles and stories for periodicals. As literary tastes changed, however, Mrs Smythies' work went out of fashion. In 1862, she suffered two financial blows, when her publisher and the journal for which she most regularly wrote both went bankrupt. Four of her five children suffered from tuberculosis, and she spent large amounts of money trying to restore their health by sending them to warmer countries. By 1882, all had died.

In her prime, Mrs Smythies was known as the 'Queen of the Domestic Novel' – although apparently this title was sometimes applied to other novelists too – and she was a far from negligible writer. The *Dictionary of National Biography* offers the following summary: 'While her work has often been dismissed for its melodrama and didacticism, it is notable for its keen satire and sensitive renderings of the economic and sexual dangers besetting young and working women.'

Fitzherbert: or, Lovers and Fortune-Hunters

It was in 1838, the same year as the ill-fated auction of the manor of Tarring had taken place at the Marine Hotel, that the first novel by Harriette Gordon – as she then was – was published under the title *Fitzherbert: or, Lovers and Fortune-*

A busy late nineteenth-century scene on Marine Parade, with the Marine Hotel just left of centre. At the far left is the County Club, and just to its east is the corner of the Royal Hotel. (© www.westsussexpast.org.uk)

Hunters. Mrs Smythies' name did not appear on her early novels, and *Fitzherbert* was published as 'by the authoress of *The Bride of Siena*' (an unsuccessful epic poem that had been her first book).

Two of the central characters in *Fitzherbert* are a plain, middle-aged heiress called Ann Matthews and an unscrupulous fortune-hunter called Thomas Shuffle, whom she marries without realising what his true nature and motives are. It does not, however, take Mrs Matthews Shuffle – as she now styles herself – long to discover what kind of man he is, matters coming to a head during their honeymoon at the Marine Hotel.

One morning, about a week after the wedding, Mrs Shuffle is sitting 'in a splendid dressing-room facing the sea' at the Marine, wearing 'a richly embroidered robe-de-chambre'. Breakfast is being prepared. Ann's French maid, Olympe, is heating up chocolate in a saucepan over the fire and an Italian pageboy is preparing the coffee, while the breakfast table 'announced by its variety and profusion of dishes the gluttony and epicurism of the two'. Shuffle has been for a walk on the pier to get, as he puts it, 'a mouthful of air', and is now ready for his breakfast. He is 'dressed, with the assumption of ease the vulgar are so fond of, in a gaudy dressing-gown' and has 'a large leghorn hat on his frightful head'.

His first words on entering the room are addressed not to his new wife but, flirtatiously, to Olympe, the 'neat, trim little French maid', who 'looks archly up' at him with her 'bright black eyes' as she pours his chocolate and tells him, in French, that after his walk on the pier his complexion has the freshness of a rose. Mrs Shuffle tells Olympe to shut up and leave the room, and the maid 'lightly glides off, with an arch smile at her hideous master'.

Mrs Shuffle suggests to her husband that it would have been more appropriate that his first greeting on entering the room should have been to his bride. At the same time she slowly moves 'her substantial form' to the breakfast table, where she sits beside her husband, 'emulating his vigorous attack on the substantial breakfast'. At first Shuffle does not even bother to reply:

> Shuffle, too happy in his deep draughts of chocolate to be inclined for a love-quarrel, which must delay him, nodded without looking up; and it was not until the protracted repast was ended that, flinging himself back in his chair, he said, 'And so,

Mrs Matthews Shuffle, you're jealous of my speaking to ma'amselle! Now let me tell you, once for all, I'll speak to whom I please. I'm no hen-pecked husband, I'll show you; so none of your sneers and airs with me; they won't do. Ma'amselle is young and pretty and you, old girl, are rather the worse for wear; so if I choose to say a civil thing to her I expect no wry faces, ma'am.'

There follows a protracted quarrel, at the end of which Shuffle falls asleep and Mrs Matthews Shuffle goes off with Olympe to the baths and libraries. In due course, however, this unappealing pair make up and become accomplices, joining forces to fleece others.

The Matchmaker

The second novel by Mrs Harriette Smythies that features an important scene at the Marine Hotel is *The Matchmaker*, which was published in 1842 – the year of her marriage – this time as 'by the author of *Cousin Geoffrey*'.

Two of the principal characters in *The Matchmaker* are Comte Alphonse de Villeneuve and his mistress Zelie, an aspiring opera singer, whom he presents as his sister. Another of the book's main characters, a young man called Julian Lindsay, has met Zelie and Alphonse in Paris. In Chapter VI we learn that Zelie is staying with Alphonse in Worthing, 'laid up with a cold, caught, of course, from breathing our odious fogs'. Later, Julian, who is staying at a house his father has taken for the winter in Brighton, decides to visit them in Worthing; and at the start of Chapter IX we meet Zelie and Alphonse for the first time:

'Bonjour, belle Zelie,' said Julian, entering a drawing-room at the Marine Hotel at Worthing, where a young and foreign-looking girl lay on a sofa near the window – a soft September breeze blowing freshly from the sea, and a bright September sun sending through the crimson curtains a glow like that of health on the complexion of a young sufferer. 'How are you this morning,' he added, kindly taking her hand; 'still feverish, I fear – I came to lure away your brother for this evening, but I fancy you are not well enough to be left alone.'
'If he can bear to leave me, I can bear to be left, Monsieur Jules,' replied Zelie, while her colour rose and tears filled her eyes.

A moment later Alphonse de Villeneuve enters from an inner room:

He was attired in a flowered satin dressing-gown, antique slippers curved up at the toes, his long black cap was surmounted by an Apollo cap, and his beard and moustachios might have belonged for length and thickness to an itinerant vender of 'old clo', but for the care evidently bestowed upon their gloss and perfume.

This description would have left the Victorian reader in no doubt that the Comte de Villeneuve was a wrong 'un, and indeed showy dressing gowns seem to be the garment of choice for Mrs Smythies' more dastardly characters when staying at the Marine – as we saw in *Fitzherbert*, Shuffle wore a 'gaudy dressing-gown' at the

breakfast table. A vender of 'old clo' (old clothes), incidentally, was a Jew making his living from the rag trade.

Alphonse and Zelie have had a lovers' quarrel, and its nature is so obvious to the reader that it is surprising that Julian remains unsuspecting of their true relationship. Alphonse tells Julian about the quarrel, adding, rather chillingly, that 'nothing secures pardon between those who love, like a brief absence. Repentance is the offspring of solitude, and I am sure, when I am gone, she [that is, Repentance] will whisper something to Zelie's heart.'

Zelie, however, is appalled by the idea of being left alone at the Marine. She bursts into tears, and says, 'I have repented, Alphonse; do not leave me alone in this drear place, with nothing to look at but the sea, one wave supplanting another, all monotonous and selfish as mankind – I am not well, oh do not leave me.'

Alphonse, however, is unyielding, and leaves the room to dress in his outdoor clothes. In his absence Julian tries to cheer Zelie up by suggesting that she will soon be a famous opera singer. This thought improves Zelie's mood, and, forgetting her troubles for a moment, she seizes her guitar and 'poured her rich and wondrous voice into an Italian air, the excitement of the moment lending such inspiration to her talent that Julian actually trembled with admiration'. Zelie now says she is happy to be left alone at the Marine, and Julian and Alphonse walk the eight miles to Brighton, deep in conversation.

The story ends badly, as such stories usually do. Although Zelie is Alphonse's mistress, he arranges for her to marry the elderly, rich and miserly Earl of Gripeall, an unappetising-looking individual with filmy blue eyes, a red-brown face, and cheap ill-fitting false teeth that have turned yellow with age. The expectation is that the earl will die soon, and the two schemers will be rich. In the meantime, however, Alphonse has turned his attention to a pretty but naïve Scottish girl called Annie Maxwell, 'a hoyden of fifteen, blooming and fresh as her native heather', who is more dentally appealing than the Earl of Gripeall, having 'the whitest teeth that ever glistened through the coral lips of a highland lassie'. Annie becomes infatuated with Alphonse, but it is clear that he will have to wed her if he is to bed her. (Between 1823 and 1929 a girl as young as twelve could marry without parental consent.) Alphonse duly marries her, but, in dastardly fashion, has the ceremony performed by a Catholic priest, knowing it will thereby be invalid because Annie is not a Catholic. Annie is not as naïve as she looks, however, and has secretly converted to Catholicism a week earlier, so she is now indeed the Countess de Villeneuve. All this comes to light in front of poor Zelie, who shrieks and collapses into Alphonse's arms, with blood pouring out of her mouth. She has broken a blood vessel in her lungs. The Earl of Gripeall has no interest in tending to his dying wife, so Alphonse nurses her on her deathbed and then, heartbroken and full of remorse, kills himself with his own pistol.

Queen Victoria

We return from this distressing Victorian fiction to sober Victorian fact, and indeed to the person who gave her name to the age.

We know of only two occasions when Queen Victoria passed through Worthing, and on both occasions the Marine Hotel featured in the royal progress.

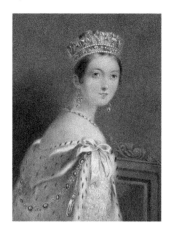

Queen Victoria in 1838, four years before she first passed through Worthing, on which occasion the town band played the national anthem for her in front of the Marine Hotel. Reduced copy by W. Warman, after Thomas Sully. (© National Portrait Gallery, London)

The first visit was in 1842, an event documented in a forty-eight page book published that year called *The Royal Visit to Portsmouth, 28 February, 1842*. The queen set off from Brighton early in the morning, and at every town she passed through there were 'demonstrations of loyalty'. The 'inhabitants of Shoreham hailed the royal cortege with hearty huzzas'. Then Victoria continued on her journey west:

> About half-past eight o'clock the Queen passed through Worthing, where her Majesty was greeted with similar marks of loyalty and attachment. The town band played the national anthem on the platform fronting the Marine Hotel, and the royal travellers were escorted by a loyal cavalcade as far as Broadwater. From the towers of Castle Goring were displayed a variety of flags, the colours of all nations, and a royal salute was fired. In nearly all the houses and cottages some signal was put up to welcome her Majesty in that neighbourhood.

The second time the queen passed through Worthing was three years later. Henfrey Smail describes the occasion in his 1948 book *Coaching Times and After*:

> In 1845 Queen Victoria and the Prince Consort drove through Worthing on their way to Arundel Castle and changed horses at the Marine Hotel. The date was the 17th February; the day was bright but bitterly cold – the coldest, it was said, for sixteen years – and snow lay thick on the ground. The Royal couple did not leave their carriage and their stay in Worthing was of only a few moments' duration, for the art of unharnessing four tired horses and putting in a fresh team had been brought to a remarkable pitch of perfection. As the Royal carriage drove up to the front of the Marine Hotel the new horses – four beautiful bays – were brought out and harnessed, and in about seven or eight minutes the journey was resumed amidst the cheers of a large crowd which had assembled. The postillions on this stage were Thomas Town and Nathan Long, both employed by Mr Hillman, the landlord of the Marine Hotel; while James Town helped to harness the horses.

James Town, who was eighteen or nineteen at the time – Thomas Town was his father – was later an important figure in Worthing and, as Smail puts it, 'his business became one of the leading job-master's and livery stable-keeper's establishments in the district, employing latterly some thirty men'. He died in 1912, aged eighty-six.

Benjamin Disraeli

Although Queen Victoria did not linger much longer at the Marine Hotel in 1845 than she had done in 1842, Benjamin Disraeli (1804–81), her favourite among her many prime ministers, stayed at the hotel around a quarter of a century later. We know of this visit from Revd Frederick Arnold (1833–91), who in 1889 published a somewhat Pooterish memoir under the title *Reminiscences of a Literary and Clerical Life*. In the book he cites two examples of the way public men drop their guard when unobserved and then rapidly pull themselves together when they know they are being watched:

> A public man cannot afford to be ill; he resents the suspicion of it. I remember very well, many years ago, being in the lobby of the House [of Lords] when it was entirely deserted, and Lord Palmerston happened to come by. He looked intensely weak and weary. You might have taken him to be a hundred years old. Directly he saw that he was somewhat intently observed, he gathered himself together and showed an almost military precision. He died a few months later.
>
> Many years later, I was staying at Worthing when Disraeli was sojourning for a time at the Marine Hotel. He kept himself very quiet, would hardly show himself, and would see no visitors. Just in front of the hotel is the pier, which at the dinner-hour is ordinarily deserted. I was sitting there, having a quiet time, when I observed opposite to me Mr Disraeli and Lady Beaconsfield. I have special sympathy with all bronchial patients. Disraeli seemed weary and depressed, and, indeed, very feeble. He reminded me of the last time that I had seen Lord Palmerston. And, like Lord Palmerston, he drew himself up to his height [when he saw Arnold looking at him] and at once discarded all appearance of languor. Of course I took a close observation of him; but my coming to the pier-head was purely accidental.

Arnold was an inveterate name-dropper, so it is no coincidence that that these anecdotes relate to two of the most famous statesmen of the Victorian age. He is, however, careful to note that it was purely by chance that he saw Disraeli on the pier, since he does not want his readers to think that he would be so vulgar as deliberately to put himself in the paths of the famous. Nonetheless, it might be

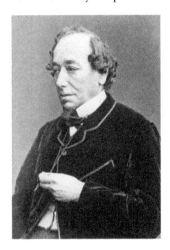

Benjamin Disraeli in 1868, a year or two before he 'sojourned for a time' at the Marine Hotel. Photograph by W. & D. Downey. (© National Portrait Gallery, London)

pointed out he shows no embarrassment at 'somewhat intently observing' or 'taking a close observation' of these two distinguished men, which might be regarded as rather intrusive behaviour.

Arnold does not give a date for his sighting of Disraeli on the pier on Worthing, but the event cannot have been earlier than December 1868, because Arnold refers to the couple as Mr Disraeli and Lady Beaconsfield, and it was on 30 November 1868 that Disraeli's wife was ennobled.* Equally, the Disraelis' visit to Worthing cannot have been later than 1872, because Disraeli's wife died in December of that year.

Disraeli was prime minister twice – for most of 1868, and again from 1874 to 1880 – so his stay in Worthing was during a period when he was in opposition. He was born in 1804, so he was in his mid-sixties on the day when Revd Arnold observed him on the pier looking weary, depressed and feeble. He died in 1881, at the age of seventy-six.

Lord Alfred Douglas

The next Victorian celebrities to be associated with the Marine Hotel were Oscar Wilde and his friend Lord Alfred Douglas ('Bosie'), the Marine being just one of the four buildings in Worthing that we know Wilde spent time inside when he stayed in the town for two months in the summer of 1894 while he was writing his most famous play, *The Importance of Being Earnest*. The other buildings, all also now gone, were the Haven, the house where Wilde and his family stayed (see Section 1); the Assembly Rooms in Bath Place (see Section 14); and the old southern pier pavilion (see Section 11).

During the first of Bosie's three stays in Worthing that summer, he and Wilde got into the habit of taking out a hired sailing boat, and one day around 20 August a sixteen-year-old boy called Alphonse Conway and a younger boy called Stephen helped drag their boat down the beach. Wilde invited them to join him and Bosie on their outing, which was repeated the following morning, and afterwards Wilde entertained Bosie and the two boys to lunch at the Marine Hotel – so, half a century after a fictional Alphonse stayed at the Marine, a real Alphonse ate there.

The Marine was probably also the hotel where Wilde, Alphonse and Stephen sought refuge, warmth and brandy three weeks later, on 9 September. That morning, the three of them had sailed the seven or so miles to Littlehampton, bathing on the way, but then got caught in a severe gale. It took them five hours to get back, reaching Worthing only at eleven o'clock at night. Wilde calls this as 'a dangerous adventure' and says that all the fishermen were waiting for them at the pier. In a letter to Bosie – who was not in Worthing at that point – Wilde describes how he, Alphonse and Stephen then 'flew to the hotel for hot brandy and water'. The Marine was situated immediately opposite the pier, and Wilde's use of the term 'the hotel'

*Queen Victoria wished to ennoble Disraeli in 1868, but he preferred to remain in the House of Commons, so the queen made his wife Viscountess Beaconsfield. The title was created on 30 November of that year, the day before Disraeli's short first term as prime minister ended. Later, in 1876, Disraeli did accept ennoblement, and was created Earl of Beaconsfield.

suggests an establishment that he and Bosie had previously patronised, so on both grounds the Marine is the obvious candidate. Either way, the proprietor had to give rather than sell them brandy because it was past ten o'clock on a Sunday night. Wilde reported to Bosie that the absurdity of English licensing laws had – no doubt with encouragement from himself – turned Alphonse and Stephen into anarchists.

Wilde also tells Bosie that he found there a letter for Bosie from a friend of theirs, which the hotel had forgotten to forward and which he now enclosed. This letter would not have been addressed to the hotel unless Bosie had earlier stayed there, and for a period long enough for him to use it for receiving correspondence. It would appear from this that during the first of Bosie's visits to Worthing that summer, when Wilde's wife and children were at the Haven, Bosie had stayed at whichever hotel provided brandy on that night in September – which, for reasons already given, was probably the Marine.

 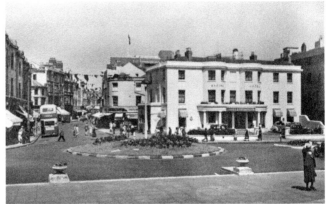

Above left: Lord Alfred Douglas in 1894, the year he certainly lunched at – and probably stayed at – the Marine Hotel.

Above right: The Marine Hotel in the late 1950s.

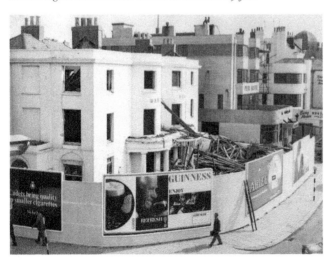

The Marine Hotel undergoing demolition in 1965, with the Pier Hotel to its east awaiting the same fate.

SECTION 10

THE PIER KIOSKS

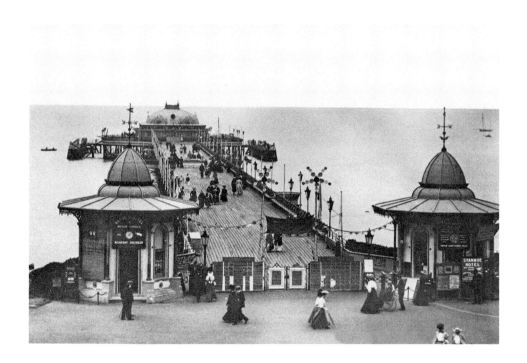

The original version of Worthing Pier had been built in 1861–62, and the first major enhancement was the two attractive kiosks that were added at the land-end at the start of the 1880s.

The date usually given for their erection is 1884. However, they appear in a long pull-out image of the seafront dated 16 May 1882 that appears in a nineteenth-century book of engravings entitled *An Album of Worthing Views*. They must therefore have been built at least a couple of years earlier than generally thought. The kiosks replaced the simple plain toll house that had stood at the northern end of the pier till then. The western kiosk served as the new toll house – people had to pay to go onto the pier in those days – while the kiosk on the eastern side sold newspapers and souvenirs.

The kiosks remained in place for not much more than forty years. In 1920 Worthing Corporation purchased the town's pier for £18,978, and five years later the characterful 'lemon-squeezer' kiosks were demolished, and work started on the building that occupies the site today.

This was a new pavilion, in complementary style to the original pavilion at the sea-end, which was to be destroyed by fire in 1933 (see Section 11). For many years the new building was known as the Pier Pavilion, the New Pavilion or the Music Pavilion, but today it is called the Pavilion Theatre. The new pavilion – which cost £40,000 and had seating for a thousand people – opened on 26 June 1926. It became the permanent home for the new Worthing Municipal Orchestra, one of the first full-time all-year-round orchestras at a seaside resort. In the immediate post-war period the orchestra played seven days a week, sometimes three sessions a day, but it was disbanded in 1978 and replaced with the Worthing Symphony Orchestra, still a major musical presence in the town today.

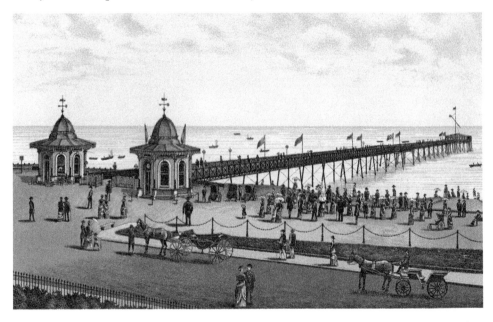

A view of Worthing Pier from *An Album of Worthing Views*. This book was first published in 1882, indicating that the kiosks were erected at least two years earlier than usually thought.

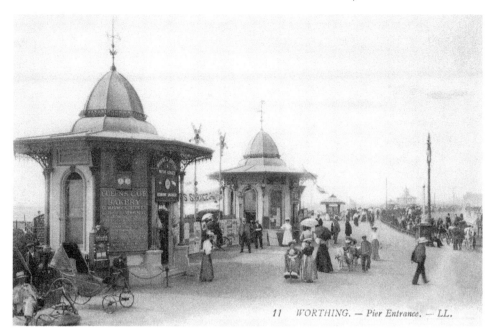

11 WORTHING. — Pier Entrance. — LL.

The pier kiosks from the west on a Lévy Sons & Co. postcard first issued in 1907, but using a photograph taken the previous summer.

Alphonse Conway

The easterly kiosk, at which newspapers were sold, featured briefly in one of the most famous trials of the nineteenth century. In the spring of 1895 Oscar Wilde unwisely sued the Marquess of Queensberry for libel after Queensberry had left at Wilde's club a visiting-card with the notorious message, 'For Oscar Wilde, posing somdomite [*sic*]'.

Like a number of other boys and young men with whom Wilde had been involved, Alphonse Conway, with whom Wilde had had a sexual relationship in Worthing the previous summer, gave a statement to Queensberry's solicitors. The boys had little choice but to cooperate since, as the law stood at that time, they could themselves have been imprisoned for involvement in homosexual acts. Alphonse's statement must have included the information that at some point he had a job selling newspapers at one of the kiosks at the pier. Edward Carson QC (later Sir Edward), defending Queensberry, found it convenient to assume that Alphonse had had this job during or prior to Wilde's stay in Worthing, but Wilde said he had never heard of it, so it is more likely that Alphonse acquired the job after Wilde left Worthing.

Today, the aspect of a relationship between a man of thirty-nine and a working-class boy of sixteen that would cause most concern would be the difference in their ages, but Carson's primary focus was not on the boy's age so much as his class. This was a period when, although any homosexual activity was illegal, a girl was free to marry without parental consent at the age of twelve, so the age of a sexual partner was not a major issue.

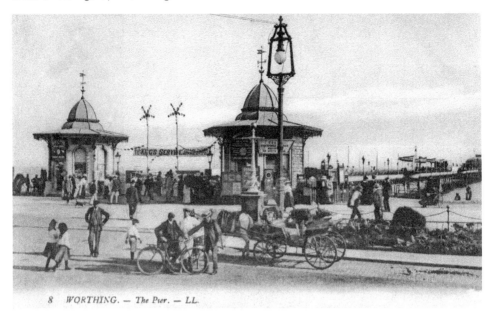

8 WORTHING. — The Pier. — LL.

The pier kiosks seen from in front of the Royal Hotel. Another Lévy card from the 1906–07 set.

Carson needed to prove that Wilde's association with Conway was sexual in nature, and therefore he wanted to demonstrate that there could be no other motive for their friendship. Within seconds of introducing Alphonse into his questioning of Wilde at the Old Bailey on the afternoon of 3 April 1895, Carson was homing in on the boy's humble employment at the pier kiosk:

CARSON: He sold newspapers on the pier at Worthing?
WILDE: No, never to my knowledge.
CARSON: What?
WILDE: Never.
CARSON: Or at the kiosk?
WILDE: No, never.

Then, only a few moments later:

CARSON: Did you know or have you ever heard that his previous occupation had been selling newspapers?
WILDE: Never in my life.
CARSON: Would it astonish you to hear that he had so much industry?
WILDE: I think it would.
CARSON: Was he a literary character?
WILDE: Oh, not at all. (*Laughter.*)

Carson would not let the matter drop. A little later he asked, 'Would you be surprised to hear that the only occupation that he ever had was this selling of newspapers?' On the surface this was a pointless question, but Carson's motive for asking it was

to remind the jury of Conway's humble status just before he then forced Wilde to admit that he had given Conway an expensive walking stick. This allowed Carson to exclaim: 'For a newspaper boy. Just look at that! He was a newspaper boy out of employment.'

When, the following day, Sir Edward Clarke QC, prosecuting Queensberry on behalf of Wilde, questioned Wilde about Conway in less hostile terms, Wilde had his quip ready:

CLARKE: Did you ever hear of his having been employed as a newspaper boy?
WILDE: No, I had no idea; no, certainly not. I never heard of it, nor had any idea that he had any connection with literature in any form. (*Laughter.*)

Amusing though Wilde's response was, it played into Carson's hands, since it reinforced Carson's case that that Wilde and Conway had nothing in common.

Edward VII

A few years after Alphonse Conway's association with the pier kiosks, King Edward VII found himself in an awkward situation in immediate proximity to them, an incident described in *King Edward as I Knew Him: Reminiscences of Five Years Personal Attendance upon His Late Majesty King Edward the Seventh*, by Charles Stamper, the king's motor engineer.

As we saw in the section on Beach House Gardens (Section 4), Edward VII visited Worthing several times towards the end of his reign, driving over from Brighton,

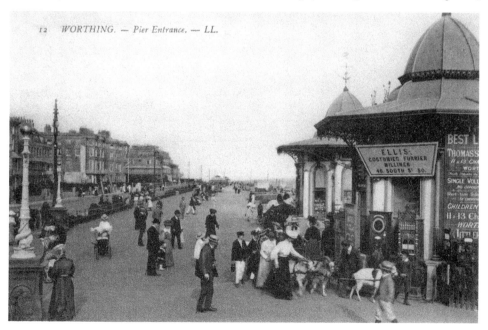

The pier kiosks from the east. Again a Lévy card from 1906–07.

where he often stayed with his friend and confidante Arthur Sassoon. At Brighton there was nowhere for the king, who suffered from bronchitis, to enjoy the sea air without being mobbed, and Sir Edmund Loder made the gardens of Beach House available for him.

The episode on Worthing pier took place on 12 December 1908. The arrangement with regard to the gardens of Beach House gardens seems not yet to have been in place at that stage – Stamper's book indicates that the first visit to the gardens was in February 1909 – and indeed the arrangement may have been created as the result of the incident we are about to describe.

As the king was being driven along the seafront, he noticed that the pier was almost deserted, and he asked that they stop there. The king and his party paid the tolls in the usual way and walked onto the pier. Only a couple of people had seen the king arrive, but news spread rapidly and soon a large crowd had gathered, and when Arthur Sassoon left the others sitting at the far end of the pier and came back to the gates to ask the gateman to get two newspapers for the king, he had to thread his way through a mass of people. By this time a senior policeman had arrived, and, at Sassoon's suggestion, he told the tollhouse-keeper not to admit any more people. The crowd outside, however, kept on growing.

The gateman seemed incapable of carrying out Sassoon's request to buy the newspapers. Stamper, who had remained in the street with the king's car and had now joined Sassoon at the kiosk, attributed this 'either to the overpowering excitement under which he was labouring, or to his fierce determination not to miss a chance of another glimpse of His Majesty'. So Stamper went in search of them.

He was easily able to obtain a copy of the *Telegraph* – presumably at the other kiosk – but had to drive to the railway station for a copy of the *Times*. When he got back, the crowd had become enormous, and Stamper had to fight his way back onto the pier. As he passed through the gates, he saw the king approaching, accompanied by the senior policeman and a constable, who were trying to keep the people back. A way was cleared, but the crowd closed in behind the king, and two of the party were cut off. After seeing the king into the car, Stamper had to return and ask the crowd to let the king's friends through. The party then drove out of Worthing, stopping once they were clear of the town so that the king and his friends could stroll on the shore in peace.

SECTION 11

THE SOUTHERN PIER PAVILION

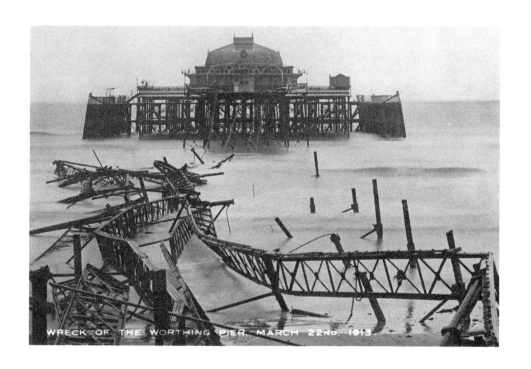

WRECK OF THE WORTHING PIER, MARCH 22ND, 1913.

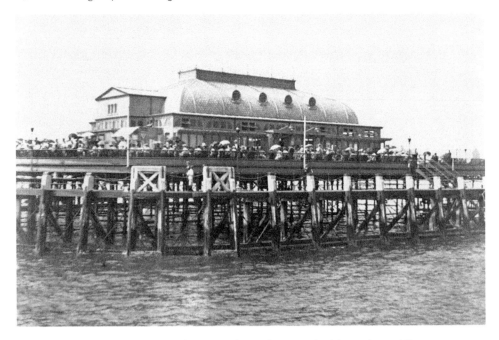

The landing stage and the sea-end pier pavilion, photographed from the paddle steamer *Princess May* in August 1898.

When Worthing's pier first opened in 1862, it was a simple structure, little more than a walkway across the sea. The kiosks at the land-end were in place by the spring of 1882 (see Section 10), and in 1888–89 the width of the decking was doubled and a pavilion was built at the sea-end, together with a landing stage where paddle steamers stopped. The pavilion, which had a capacity of 500 or 600 (accounts vary), was used for concerts and entertainments.

Oscar Wilde and the Venetian Fete

On 13 September 1894, Oscar Wilde made a speech inside the pavilion when he gave away the prizes after the so-called Venetian Fete that was held that year. The main feature of this lamp-lit water carnival was a procession of almost twenty illuminated boats. They assembled opposite Warwick Buildings and, after a rocket was fired from the pier-head as a signal for the start, proceeded westwards in a single line. It was a beautiful night, and the spectacle was witnessed by thousands of people on the parade, the beach, and the pier itself. Voting cards were issued to the spectators 'with the request that each voter might give his or her opinion' as to which were the three best-decorated boats. The votes were then counted by the organising committee. Mr Ramsay's boat was declared the winner, Mr Ralli's boat came second and Mr Marshall's was third.

Afterwards there was a concert in the south pavilion, at the end of which Wilde presented prizes to the owners of the three winning boats, and made his short speech. As was usual in those days, the *Worthing Gazette* printed Wilde's remarks

The pier pavilion and a goat-cart, photographed in 1903.

in reported speech, and the version that follows is a reconstruction I prepared for a visit to Worthing by the Oscar Wilde Society in August 2012:

I congratulate Worthing on the extremely beautiful scene of this evening. Worthing has already arranged some extremely pretty shows. I have been much struck at the Regatta, at the Lifeboat Demonstration, and other festivals with the beauty and grace of everything I have seen. There was, however, there was one thing that marred the Regatta. There was a sailing boat, not belonging to Worthing, but coming from some wicked, tasteless spot [probably the rival resort of Brighton], bearing a huge advertisement of a patent pill. I hope that boat will never be allowed to enter Worthing again. I cannot help feeling the change that has taken place this year in the town, and expressing the great pleasure it gives visitors to return. I consider that such a charming town will become one of the first watering places on the South Coast. It has beautiful surroundings and lovely long walks – which I recommend to other people, but do not take myself. As for the excellent water supply, I am told that the total abstainers who visit Worthing are so struck with the purity and excellence of the water that they wish everybody to drink nothing else. [Wilde's comment about the water was a gracious reference to the fact that Worthing's water supply was again safe to drink after the previous year's typhoid epidemic, which had caused 188 deaths.] Above all things I am delighted to observe in Worthing one of the most important things, having regard to the fashion of the age – the faculty of offering pleasure. To my mind few things are as important as a capacity for being amused, feeling pleasure, and giving it to others. I hold that whenever a person is happy he is good – although, perhaps, when he is good he is not always happy. There is no excuse for anyone not being happy in such surroundings. This is my first visit, but it will certainly not be my last.

Sadly Wilde's intention to revisit Worthing never came to fruition. Within eight months he was in prison, and after his release in 1897 he left England for the Continent, never to return to Britain.

The Storm of 1913

Over the Easter weekend of 1913 there were terrible storms on both sides of the Atlantic. On Good Friday – March 21 – tornadoes across Mississippi, Georgia, and Alabama killed forty-eight people, and on Easter Sunday tornadoes across Nebraska and Iowa killed at least 168. On the evening of Easter Saturday the storms hit Britain, and just before midnight two hundred yards of Worthing Pier were swept away, leaving the south pavilion marooned in the sea.

The following Wednesday's edition of the *Worthing Gazette* told the dramatic story at length. The headline 'The Pier Washed Away', was followed by four subheadings: 'A Midnight Collapse', 'Remarkable Spectacle for Holiday Visitors', 'Havoc on the Front' and 'The Total Damage Estimated at Nearly £15,000'. Inside a box to the left of this multi-part headline was printed – for some reason in Gothic print – the further headline 'Eastertide Storm of Exceptional Violence'.

The *Gazette* reported the climactic moment, which occurred at about half-past eleven, as follows:

> Then came a startling incident of this memorable storm. The electric manhole at the corner of Bath Place and Marine Parade blew out, and a big flash of light ascended into the air. The Parade was plunged into darkness, for the moon had once again been temporarily hidden behind a cloud. Most of those in the vicinity of the pier rushed across to see what damage had been done, and then it was that the great disaster occurred.
>
> While their backs were turned, Worthing was deprived of its pier, and many thousands of pounds had been sent to the bottom of the sea! And the remarkable thing is this, that the crashing of the iron work when the structure gave was not heard by those immediately to the west of the toll-house; but it is said that it could

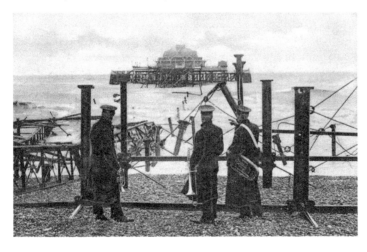

The pier pavilion after the storm of March 1913.

be distinguished on the east, and one eye-witness said that it was 'just like the firing of a Gatling gun'.

'The pier's gone!' was the startled cry that ran along the front, and soon the large assembly of people that had gathered round the shelter watching the work of the sea there rushed to the pier-head to find that the statement was only too true.

After the damage had been done, the moon shone out again, and some idea was then given of the magnitude of the disaster. The pavilion at the sea end stood there as sturdily as one of the stately old castles of England, the landing stage still resisting the buffeting of the tide, whilst the main part of the structure was at the bottom of the sea.

There were, however, some commercial benefits arising from the disaster, and a column of fifteen snippets of storm-related news, which was printed beside the main report under the heading 'Stormlets', mentioned several of these. 'The Railway Company did particularly well on Sunday', for example, while 'Monday was a record day for a local restaurant keeper. It is an ill wind that blows nobody any good!'

A further 'Stormlet' informed readers that the town's photographers had 'been quite unable to keep pace with the demand for pictorial postcards. (Local firms such as Edwards & Son would have had postcards on sale within a day or two.) Finally, a well-loved Sussex paddle steamer visited the scene:

> *Worthing Belle*, which makes calls regularly at the pier during the season, brought over a large number of people to see the result of the gale on Monday morning. She came as close as was safe, and then carried her human freight back to Brighton.

The *Gazette* also reported that the local MP, Major W. R. Campion, sent the mayor of Worthing, Alderman Piper, a – somewhat perfunctory – telegram of sympathy: 'Deeply regret to hear of storm havoc.'

In those days a seaside town's pier was too important an asset to the holiday trade not to be quickly restored to use, and within less than a year the central structure had been rebuilt. The pier reopened – with a parade through the town and much fanfare – on 29 May 1914. However an even greater disaster was to strike less than twenty years later.

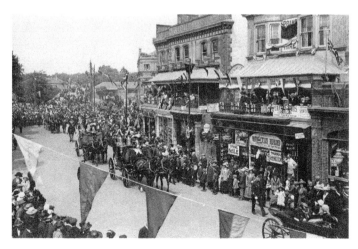

The procession passes along Chapel Road on 29 May 1914, the day the rebuilt pier was reopened.

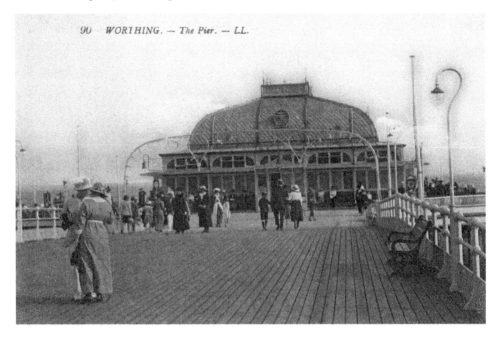

The south pavilion, photographed for Lévy Sons & Co. in 1914, after the pier was repaired.

The Fire of 1933

On the afternoon of Sunday 10 September 1933 the sea-end pier pavilion caught fire. It was a windy day, and the blaze quickly took hold. By the time the fire brigade arrived it was too late to save the building. The national press estimated the damage at £30,000, but this was apparently journalistic exaggeration, the true cost of the damage being £10,000.

The *Worthing Gazette* again reported the disaster in detail, under the main headline 'Southern Pier Pavilion Destroyed by Fire' and the subheadings 'Burnt Out in an Hour', 'Awesome Sunday Afternoon Spectacle' and 'Damage Estimated Between £10,000 & £15,000'. As in the case of the storm, the *Gazette*'s headlines highlighted both the 'spectacle' and the cost of the damage. The report began:

> The fire provided a thrilling spectacle for the thousands of holiday makers and townspeople who rushed to the front and crowded on to the beach as soon as the word went round that the pier was on fire.
>
> It was just after half-past three that people on the beach saw smoke coming from underneath the pier head. Someone called out that a speedboat was alight, but half-a-minute later a great cloud of smoke had begun to envelop the seaward end of the pier, and it was obvious that the Southern Pavilion was on fire.
>
> Then the watchers on the beach to the east of the pier saw flames underneath the south-eastern corner and heard the wail of the fire alarm siren and, a minute later, the clanging of the fire engine bells as the Worthing Brigade dashed down South Street to the pier entrance.

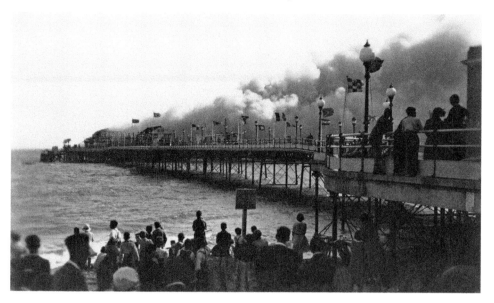

The end-of-the-pier show – the fire of 10 September 1933.

The firemen had a hose out to the Pavilion in a few moments. Meeting them as they ran with it were holiday makers and members of the pier staff dragging out a grand piano, chairs, tables, automatic machines and the like.

'We haven't a chance!' exclaimed a fireman and, as if to prove the truth of his words, the whole front of the pavilion flashed into flames, and a minute later the whole building was enveloped. The flames ran in such a curious way that for the moment the pavilion was outlined in red, rather like the main [land-end] pavilion seen from a distance at night time.

An angler who was fishing from the west landing stage gave this account to a '*Gazette* representative':

I had just thrown over my line, when one of my friends remarked that something was burning.' Another one turned and jokingly called out: 'It's only the pier on fire; carry on, boys.' Then I turned and saw smoke pouring out from under the pavilion. 'By gum,' I said, 'you're right. The pier is burning.' And I hauled in my line and grabbed my coat. In the half-minute it took me to do that we were enveloped in smoke, and by the time we got round the stage on to the deck the side of the pavilion where we had been was a mass of flames.

Although, as the report in the *Gazette* indicates, the fire brigade were on the scene very soon after they were alerted, there was a fatal delay of between ten and twenty minutes – witness accounts varied – before the fire brigade had been called. Had the call been made at once, the pavilion might have been saved.

Inevitably there was speculation that the fire had been caused by arson, but both Chief Fire Officer Jones and Reg Paine, the pier master, were in no doubt that the cause of the fire was a discarded cigarette end.

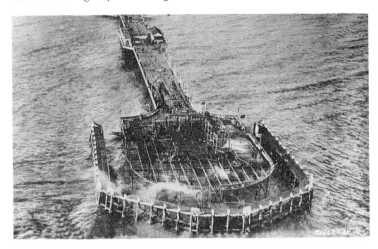

The pier pavilion from the air after the 1933 fire.

Three people were slightly injured: a visitor from Rochester and two unnamed Worthing residents, from Northcourt Road and Stanley Road respectively. Otherwise there were no casualties, although a 'young lad' called Ronald Clarke, who lived in Dominion Road, Broadwater, fell fifteen feet into the sea through a hole in the planking. He was in a chain of people passing articles from hand to hand and did not notice that the area of planking just behind where he was standing had been torn up by the firemen. He was picked up by a motor boat, and, after receiving First Aid at the St John Ambulance First Aid Station, 'was none the worse for his ducking'.

Perhaps the person who had the worst day was a visitor by the name of Nash, who was a partner in a timber yard at Redhill. When he returned home that evening after watching the Worthing pier fire, he found that his own business premises had been completely burnt out during the course of the day.

As in the case of the storm of 1913, the point was made that disasters have financial benefits, in this case in a letter to the *Gazette* from someone who signed himself 'Nearly a Socialist'. The pseudonymous correspondent set out a sophisticated economic argument. He said that the firemen would have earned extra money, much of which would be spent in the local shops; that the day after the fire more than double the usual number of national papers were sold in Worthing and that indeed the *Gazette* would presumably be printing more copies than usual; that journalists and photographers were kept busy for an hour or two and would be 'the richer for it'; and that aeroplanes that would otherwise probably have remained idle had been commissioned to fly over the site. Finally, he said that the rebuilding of the pier would 'provide work for a number of men at a critical time' – this was at the height of the Great Depression – with the cost being borne by insurers 'whose business it is to meet such contingencies and who will not lose by it'. 'What it boils down to,' the near-socialist concluded, 'is that a certain amount of frozen capital will be released. And a very good thing too, in these hard times!'

After the fire, it did not take long to set in motion a programme of repair and replacement, and a new pavilion in art deco style opened at the sea-end of the pier in July 1935. The building survives today, and, although the outside has a somewhat utilitarian appearance, the interior is one of the most splendid of any building in Worthing.

SECTION 12

WORTHING BELLE

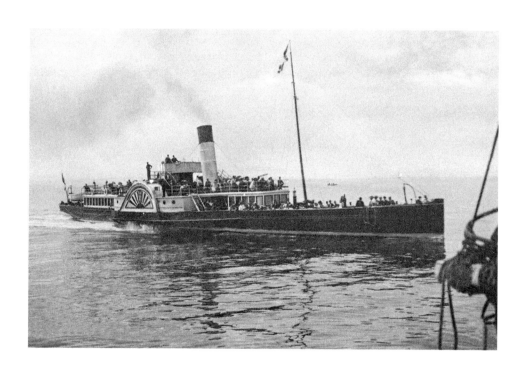

While a ship is certainly a structure, not all structures are buildings. In this section, therefore, we are being generous in our interpretation of the title of this book. Nonetheless, it would be a pity not to include a brief history of the paddle steamer that for almost one-third of its forty-one year life was known as *Worthing Belle*, and was held in great affection in the town after which she was named.

This section is printed after the section about the sea-end pier pavilion because it was at the landing stage there that *Worthing Belle* docked when it stopped at Worthing. Most of the information comes from Tom Lee's paddle steamer website, website.lineone.net/~tom_lee/index.htm, and is printed with his kind permission. He, in his turn, had much of his material from the late Phil Hayden, grandson of William Reid, who was the owner of *Worthing Belle* for five years before the the First World War.

Worthing Belle was built at the Glasgow shipyard of Barclay, Curle & Co. in 1885 for the North British Steam Packet Company. Originally called *Diana Vernon*, she was one of a number of paddle steamers built for the company over a five-year period. She measured 180 feet in length and was coal fired. Others in the fleet included *Meg Merrilies*, *Jeanie Deans* and *Lucy Ashton* – all, like *Diana Vernon*, named after characters in the Waverley novels of Sir Walter Scott.

Diana Vernon served in the upper reaches of the Firth of Clyde, sailing from Craigendoran – now a suburb of Helensburgh – into Gare Loch and Holy Loch. Then in 1899 she was replaced by the newly built *Waverley*, and two years later she was sold to Mr J. Lee of Shoreham-on-Sea, who renamed her *Worthing Belle*. Her 'home port' then became Brighton's West Pier, from where she was employed on trips west to Worthing, Littlehampton and Bognor, and east to Eastbourne and Hastings, as well as on short excursions into the Channel.

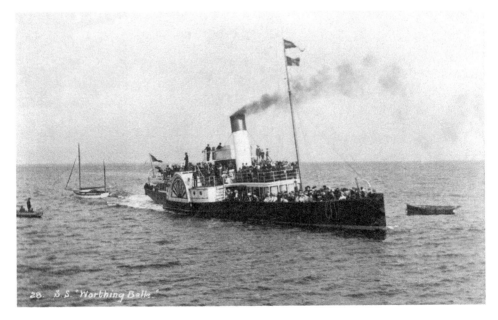

A Harold Camburn postcard of *Worthing Belle*, photographed in 1910.

In 1909 *Worthing Belle* was acquired by William Reid, who continued with the same schedules and added occasional trips to Boulogne. During the whole period of her service on the South Coast, *Worthing Belle* was commanded by Captain John Trenance. She was the last privately owned steamer to remain in competition with the paddlers operated by the large Bristol firm of P & A Campbell, whose fleet before the First World War consisted of around twenty steamers.

Tom Lee helpfully provided me with a paragraph of general information about the uses to which paddle steamers were put in their heyday:

> Paddle steamers were first extensively used in Scotland, where they served numerous functions; and this originally applied on the south coast of England too. Several of the South Coast steamers acted as ferries as well as being used for pleasure trips; and there was fierce competition for the Royal Mail franchises, carrying post and parcels to the Continent. Some paddle tugs, normally used for towing, would do 'trips around the bay' and so on during the summer season. *PS Lord Elgin*, originally a pleasure steamer, was later converted to carry cargo, and was even used to carry the elephants and big cats to the Isle of Wight when the circus went there. In and around the large liner ports like Southampton, the paddlers were often used as tenders to the liners, ferrying out passengers and supplies. Presumably this was cheaper than paying port dues. They also had distinguished service in both world wars. Latterly the better-known boats of the south coast, like *Worthing Belle*, were almost exclusively pleasure steamers. However a poor weather season reduced revenues so much – and refurbishment and maintenance costs were so high – that the paddlers gradually all disappeared.

At present, the only seagoing paddle steamer in use anywhere in the world is *PS Waverley*. This is not the paddler that elbowed aside *Diana Vernon* in Scotland in 1899, but a later steamer of the same name, launched in 1946. The original *Waverley* was converted into a minesweeper, and was sunk off Dunkirk in May 1940. The new *Waverley* usually does excursions on the South Coast in September of each year. Her most easterly port of call is Portsmouth, but special buses go from Worthing Pier to the pier beside Portsmouth Harbour railway station where *Waverley* docks.

Belle Goes to Turkey

Just before the First World War, *Worthing Belle* finally succumbed to the powerful competition provided by the P & A Campbell steamers, and she was sold in March 1914 to new owners in Turkey, who renamed her *Tuzla*. (This name is sometimes transliterated as 'Touzla'; but 'Tuzla' is preferable.) *Tuzla* is the name of a city in Bosnia, at that time part of the Ottoman Empire, of which Turkey was the mother country. The name meant 'place of salt' in Ottoman Turkish. It seems odd for *Tuzla* to have been named after a land-locked city nine hundred miles north-west of her base in the Dardanelles, so perhaps the choice of name was in part a reflection of the fact that she plied her trade over salty waves.

Tuzla was sunk by a British warship on 30 August 1915, during the ill-fated Gallipoli campaign, while she was lying empty at Akbas Liman, a tiny harbour on the European side of the Dardanelles. ('Liman' means harbour.) It has been suggested

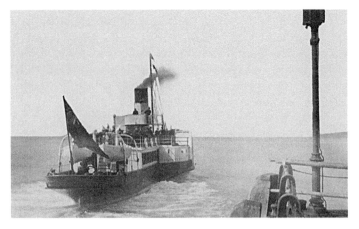

An Edwardian view of *Worthing Belle* from the rear.

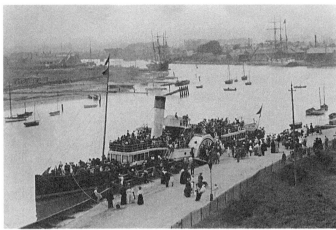

Worthing Belle at Littlehampton harbour around 1910.

that *Tuzla* served the Turks as a gunboat in the First World War, but a thread on the message board of the www.paddleducks.co.uk website indicates that this is incorrect. A paddle steamer historian called Alistair Deayton reported that he had made an enquiry of a fellow expert, who was categorical that *Tuzla* was never a gunboat – not least because there is no mention of her in *The Ottoman Steam Navy* by Langensiepen and Guleryuz. The theory that *Tuzla* had been a gunboat during the war probably derived from the fact that a British warship went to the trouble of sinking her. However the British Navy, which itself suffered heavy losses during the Gallipoli campaign, doubtless regarded any vessel moored at an Ottoman harbour as a legitimate target.

Tuzla was in due course refloated and repaired, and then resumed service as a Turkish ferry, before finally being scrapped in 1926.

SECTION 13

THE ROYAL SEA HOUSE HOTEL

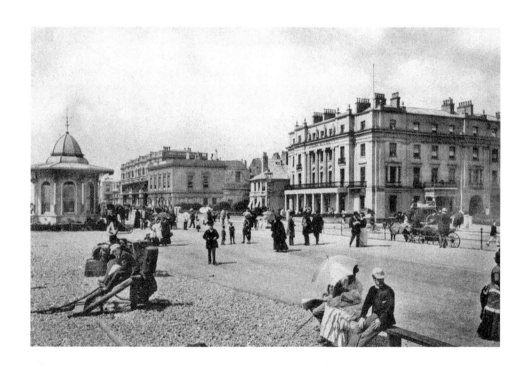

At the start of the eighteenth century the shoreline at Worthing was two or three hundred yards to the south of where it is now, and a number of buildings stood on land that today is under the sea at high tide. One of these buildings, a simple inn that stood roughly opposite Bedford Row, was the first of three Worthing inns or hotels to bear the name 'Sea House'. This inn was still there as late as 1777, because on 5 August of that year Tom Lindup, a local ferryman, married Mary Summer of Coombs, who worked at the inn. As the sea advanced and the shoreline retreated, however, the old Sea House had to be abandoned, and a new inn of the same name was built at the south-west corner of South Street. This was probably in the late 1780s or early 1790s.

The new Sea House Inn was briefly Worthing's largest and best inn – two attractive watercolours are reproduced in my book, *Jane Austen's Worthing* – but it did not hold that title for long, because Worthing's first modern hotel, the Steyne (now the southern end of the Chatsworth) opened in 1807. By the 1820s both the Sea House Inn and the New Inn, which stood opposite it on the south-east corner of South Street, had become unacceptably old-fashioned; and both were demolished. The Marine Hotel was built on the site of the New Inn, and in 1826 the splendid new Sea House Hotel opened.

The new building was designed by the greatest of Worthing's architects, John Rebecca, who also built numerous other buildings in and around the town, including the Chapel of Ease (now St Paul's Centre) and Castle Goring. For the next seventy-five years it was Worthing's leading hotel.

The 1859 edition of *Murray's Handbook for Kent and Sussex* carried an advertisement for the Sea House Hotel, which, rather curiously, is described as 'in a direct line from the station'. This was, as the crow flew, more or less true, but the hotel omitted to mention the more relevant information that the station was the best part of a mile away. Heat and light were both extras. A fire in your sitting room – at even relatively modest hotels in those days guests could, if they wished, have a suite consisting of a sitting room and a bedroom – cost 1s 6d per day, and wax lights (candles) were 1s. A charge of 1s 6d was made 'for the attendance of servants'. This meant that you had to pay this small sum if your own servants – whether billeted in the hotel or in more modest accommodation elsewhere – looked after you during your stay.

The hotel also offered a referral service for those who needed more ample accommodation: 'Parties who require Houses or Apartments will obtain every information at the above Hotel.' The owners of the flats or houses in question presumably paid the hotel a commission for these referrals. Those who went for the

A dramatic engraving from the 1830s, during the period when the Sea House Hotel was owned by George Parsons, who renamed it after himself. (© www.westsussexpast.org.uk)

Another engraving of the hotel from the Parsons era, this time looking east. A choppy sea and a sailing-boat again feature.

self-catering – or, more likely, servant-catering – option were, however, encouraged to use the Sea House Hotel as a kind of off-licence: 'Families taking Houses or Apartments in the Town, requiring Wines, Bottled Ales, Porter, etc., of the first quality, will find the Wholesale Prices of this establishment worthy of their notice.'

Civic and Legal

As we saw in the context of the Marine Hotel (see Section 9), there were no dedicated civic buildings in Worthing until the Town Hall was built in 1835, and during the first few decades of the nineteenth century the town's principal hotels often housed events that today would take place in courtrooms or council buildings. The hotel most often used for these purposes was the Nelson Hotel in South Street, the structure of which still survives, but the Marine, the Steyne and the Sea House were all used from time to time.

On 28 July 1829, for instance, the oddly named 'Commissioners in a Commission of Bankrupt' met at the Sea House Hotel at ten o'clock in the morning to 'distribute the estate and effects of James Cooper of Lancing, in the County of Sussex, Grocer, Dealer and Chapman [merchant], when and where the Creditors, who have not already proved their debts, are to come prepared to prove the same, or they will be excluded the benefit of the said Dividend'. The term 'dividend' referred to the distribution of a bankrupt's money after the sale of his effects.

Indeed, even the erection of the Town Hall did not mean the end of the town's leading hotels being used for civic and legal purposes. On 17 September 1842, for instance, the 'Provincial' section of the *Illustrated London News* carried a brief report, deriving from the *Sussex Advertiser*, of an inquest recently held at the Sea House Hotel:

MELANCHOLY SUICIDE. – An inquest was held before J. L. Ellis, Esq., coroner, on Friday, at the Sea House Hotel, Worthing, on the body of Mr. Richard Parker, aged 62, formerly of Arundel and West Tarring, and since of this town. It appeared he was generally cheerful and pleasant in his disposition; that, owing to recent misfortune, he was without house or home – a wanderer in the town, and destitute; also, that as one of the trustees of a benefit club, he had appropriated £2 5s of a sum directed to be deposited by him in the savings' bank, and had to meet the members on the Tuesday evening, or about that day. This circumstance, it was thought, might have contributed to the distress of his mind. Verdict, 'Temporary Insanity'.

A Complaint of Street Minstrelsie

The Sea House Hotel features prominently in a humorous article published in the 1 May 1831 issue of the *New Monthly Magazine and Literary Journal*. The piece's author was John Poole (1786–1872), a prolific English nineteenth-century playwright and early exponent of farce. A play called *Paul Pry* was considered Poole's most successful work, and the 1831 article was published as 'by the author of *Paul Pry*'.

The author, as we shall see, is not kind to Worthing, which he describes as 'the stupidest place that ever had the assurance to call itself a town', its 'lady patronesses' being dullness and boredom. He suggests that 'if you possess one spark of feeling, or fancy, or imagination, or intellect, and desire that it should be extinguished', you should spend a week in Worthing.

Worthing seems to have had a great reputation in the first half of the nineteenth century for its dullness, and Poole had probably read Horace Smith's satirical article 'Select Society; or, a Week at Worthing', published nine years earlier in the same journal. Long extracts from Smith's warm-hearted but unflinching account of the boredom of a week in Worthing appear in the final chapter of *Jane Austen's Worthing*.

Although 'A Complaint of Street Minstrelsie' was published only in 1831, the events described took place in the summer of 1826, the year in which the Sea House Hotel opened. As in the case of Horace Smith's tale, there is much exaggeration for comic effect, and indeed the account clearly owes as much to the imagination as to the memory.

The theme of Poole's article is his loathing of street musicians and his desperate attempts to escape them. He tells us that he has tried the resorts of Ramsgate, Cheltenham, Harrogate, Tunbridge Wells and Hastings without success, but there remains one possibility: 'Being assured at length that Worthing was, beyond all comparison, the quietest place in the empire, Worthing was the retreat, or, more properly speaking, the refuge determined on.'

Poole explains that 'the most imperturbable of my tormentors was a little imp of a Savoyard' – that is, a boy from Savoy, today a territory in the south-east of France, but in those days part of the kingdom of Sardinia. The boy's 'weapon' was 'a small, shrill organ, capable of but one tune'. The tune in question was 'Partant pour la Syrie' (Leaving for Syria), a French song of around 1807 inspired by Napoleon's

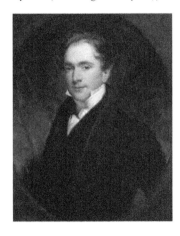

John Poole in 1827, four years before he published 'A Complaint of Street Minstrelsie', a satirical article in which the Sea House Hotel featured prominently. Painting by Henry William Pickersgill. (© National Portrait Gallery, London)

campaign in Egypt and Syria in 1798–1801. It is available on YouTube. Anyone who goes there to listen to it will agree that, pleasant though it is, 'Partant pour la Syrie' is not a tune one would want to hear repeated indefinitely.

On the morning of Poole's departure for Worthing, the infuriating Savoyard is, needless to say, outside his London house playing the tune, and as Poole sets off for Worthing the boy walks beside his carriage. Initially the London traffic makes progress very slow, and Poole's tormentor keeps up with him. As the carriage speeds up, however, the boy and the tune are left behind. Poole spends the night at Horsham, and mercifully the boy is nowhere to be seen, although Poole keeps hearing the tune in his head and indeed thinking that he glimpses the boy.

The next day Poole reaches the town that he has chosen as his 'refuge', and is at once struck by how quiet and empty it is:

As we drove through Worthing, I observed a notice in every window of 'This house to let,' or, 'Apartments to let', and could not help thinking how much trouble would have been saved, had they posted one notice at the entrance to the town of – 'Worthing to let'.

'Mr. P-rs-ns,' said I, as I entered the S**-H**** Hotel, 'is Worthing full?'

'The fullest season we have had for years, sir.'

This information was perfectly true; for, upon after-inquiry, I found there were nine families who had actually taken houses for a month – to say nothing of two others who were there for the night (on their way to other places), and eleven, or, according to another report, fourteen, single gentlemen.

'Can I have a quiet room here?'

'Quiet as a mouse, sir.'

'Is Worthing much infested by...'

But I had not courage to utter the word.

'Not in the least, sir,' was mine host's reply; fancying, no doubt, that I intended to add 'robbers'. However, I chose to avail myself of the benefit of the consequence of my own hesitation, and was happy.

(Shortly after the first appearance of this paper, the worthy hotel-keeper, whom we have now so mysteriously alluded to, took the trouble of journeying all the way from Worthing to Brighton for the purpose of assuring the Editor of the *Brighton Gazette* – one of the best-written, cleverest, and most intelligent, of the newspapers published out of London – that, to the best of his recollection, this and the following circumstances here narrated had never occurred! If our Savoyard boy be still in existence, we call upon him to come boldly forward and vouch for our veracity. So, haply, shall he obtain our forgiveness!)

It is notorious that Worthing is the stupidest place that ever had the assurance to call itself a town. Its lady patronesses are Dulness [*sic*] and Ennui [boredom]; and I was satisfied, by my first evening's inspection, that no organ-grinder who exercised his art with a view to patronage and profit would ever set foot in it. Its public promenades are of no earthly use, except as places where you might practise archery or pistol-firing, without fear of hurting anyone: and, for its places of amusement! I entered one of the libraries, where four elderly ladies had been for two hours waiting in hopes of a fifth, to complete a five-shilling loo [loo was a popular card-game of the

time] for a ninepenny needle-case; and, at the other, there were three old gentlemen who had for two hours and a half been eagerly watching for an opportunity to seize hold of the Morning Post, which a fourth had all that time been poring over.

The 'greatest house' of the season was expected at the Theatre, for an eminent London actor was to perform. His terms were (as usual) that he should take as much as he pleased of the whole receipts, and, afterwards, share equally with the manager whatever might remain over and above that. Expectation was not disappointed, and the manager could not but have been satisfied: it was the fullest house of the season, and the gross receipt was £2 9s 6d.

If you possess one spark of feeling, or fancy, or imagination, or intellect, and desire that it should be extinguished, pass a week at Worthing. Such, altogether, is the place, that certain I am that if ever, by some wonderful revolution, Botany Bay should become the capital of the British Empire, Worthing is the spot to which its convicts will be transported.

My bed-room was a paradise – it was as quiet as the cell of a Trappist. Save the low murmuring of the sea, not a sound was to be heard. Beneath my window was a spacious lawn, enclosed within an iron fence, which seemed to promise protection from all manner of noise. Not even the rattling of a wheel-barrow could assail me. In the proud consciousness of security I composed myself to sleep. No dread of the morrow embittered my midnight hour, for, at length, a morning was to dawn for me, in whose ineffable soundlessness I might lose all memory of the agonies of the time past.

'Twas eleven o'clock when I awoke. The sun was pouring his glorious rays full into my room. I arose. I approached the window. There was a palpable – I would say a *living* quiet in the air – it was exquisite. Not a human being was within sight.

I looked again – yes – there was ONE! O Jupiter! 'Twas he! – the thing! – the fiend! There he was, with organ at his back, and marmot [a species of large squirrel] on his shoulder, clambering over the fence. He observed me and approached – and grinned – and took his station immediately beneath my window – and slowly, slowly drew his organ round to his side – and placed his hand on the winder – and paused – yes, for a moment the demon paused, and grinned again – O, that moment ! – the power of respiration forsook me – the blood stood still in my veins – his hand began to move – it was inevitable – it came – the same, indubitable, incontrovertible, undeniable, 'Partant pour la Syrie'. The window was small, and would not allow the passage of a chest of drawers which I would have hurled down upon his head: – tables – chairs – all were too large. I fled the house – the town. I went to Lancing – to Little Hampton – to the most sequestered places in the neighbourhood, but in vain. Wherever I went, thither did he follow me, never allowing me four-and-twenty hours the start of him.

Five years have passed away since then, and – Ha! here he is!

Queen Adelaide

In 1849, Queen Adelaide (1792–1849), the widow of William IV (1765–1837, reigning from 1830) famously – at least as far as Worthing is concerned – stayed at the Sea House Hotel for two weeks.

Like most British kings and their consorts at that time, Adelaide was German. She was the daughter of the Duke of Saxe-Meiningen, and her maternal grandmother was Prince Christian of Hohenlohe-Langenburg. Her marriage to William in 1818 was an

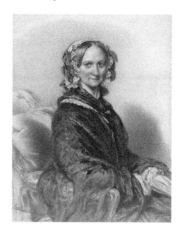

Queen Adelaide in 1849, the year she and her entourage stayed at the Sea House for a fortnight. After her visit the hotel was renamed the Royal Sea House in her honour. Portrait by Richard James Lane, after Franz Xaver Winterhalter. (© National Portrait Gallery, London)

arranged marriage: she had first met him just a week before the wedding. William, fifty-two years old and until then a bachelor, was second in line to the throne, the only legitimate child of his elder brother, the Prince Regent (later George IV), having died the previous year. This was Princess Charlotte, who had stayed at Warwick House in Worthing in the summer of 1807. The Prince Regent's wife, Caroline of Brunswick, was now past childbearing age and, in any case, was estranged from her husband and living in Italy. Therefore, not only would William in due course become king if he outlived his elder brother, but any children William had would accede to the throne even if he himself was never to reign. The reason for his marrying the twenty-five-year-old Princess Adelaide was therefore dynastic. Healthy heirs to the British throne were required.

Sadly, however, Adelaide failed in this respect. Her first child, Charlotte, born in March 1819, survived only a few hours, and a second pregnancy ended in a miscarriage later the same year. Another daughter, Elizabeth, was born in December 1820, but died less than three months later, and twin boys were stillborn in April 1822. William IV therefore died without any living legitimate children, and was succeeded on the throne by his niece, Victoria. Ironically, however, he was survived by eight of the ten illegitimate children he had had by the Irish actress Dorothea Jordan, with whom he had cohabited for twenty years until 1811. David Cameron, prime minister from 2010 to 2016, is a direct descendant of one of these children, Lady Elizabeth FitzClarence, and is therefore a distant cousin of Elizabeth II.

It was a dozen years after her husband's death that Queen Adelaide, a kind and modest woman who was very popular with the British people, stayed at the Sea House Hotel. She arrived in Worthing by train on 28 May 1849, and she and her entourage occupied forty of the hotel's rooms for a fortnight. After her visit the hotel was renamed the Royal Sea House Hotel. In due course it became simply the Royal, breaking the historic link with the two earlier Sea Houses. Queen Adelaide was more directly commemorated in other places, most notably in the Australian state of South Australia, whose capital city is named after her.

Queen Marie Amélie of France

Twelve years later there was a second royal visitor to the Royal Sea House Hotel. This was Queen Marie Amélie of France (1782–1866), the widow of the French

Marie Amélie Thérèse, Queen of France, in the early to middle 1860s. In the summer of 1861, she and her party of eighty-five occupied the Royal Sea House Hotel for six weeks. Photograph by François-Marie-Louis-Alexandre Gobinet de Villecholle Franck. (© National Portrait Gallery, London)

king Louis-Philippe. Louis-Philippe had come to the throne in 1830, the same year as William IV, but abdicated after the revolution of February 1848. He and Marie Amélie then went into exile in England, where Queen Victoria lent them Claremont House near Esher, where Louis-Philippe lived till he died two years later, while his widow remained there until her own death in 1866.

It was in August 1861 that Marie Amélie and her entourage took over the Royal Sea House Hotel for six weeks. With numerous servants and the whole of her family accompanying her, the party apparently consisted of a total of eighty-five people. On 8 September a courtier by the name of Luigi Odorici, who was not among those who stayed in Worthing, recorded in his diary that the queen's holiday was seemingly proving beneficial (the entry is translated from French):

> Since 24 August Her Majesty has been at Worthing, a bathing-place, which has undoubtedly been of much benefit to her, for I am assured that she is in the best of health; and, although she is almost eighty years old, she still has the strength of character that has sustained her through all life's vicissitudes.

The Fire

Disastrous fires in major buildings are rare today, but they used to be common occurrences. In Worthing, the Colonnade was all but wrecked by fire in 1888 (see Section 25) and the sea-end pier pavilion burnt down in 1933 (see Section 11). However, the greatest loss by fire in the town's history was that of the Royal Hotel in 1901. For some reason the date almost always given for the fire is 21 May, but it in fact occurred on the morning of Friday 24 May.

The cause, according to the report in the following week's *Worthing Gazette*, was probably a portable stove being used by workmen who were involved in working in what the report in the paper refers to as 'the north-west wing of the establishment'.

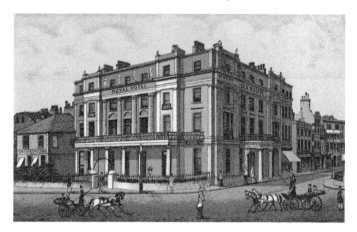

In this engraving from *An Album of Worthing Views* (1882), the south façade of the hotel has 'Royal Hotel' and the east façade 'Royal Sea House Hotel'.

The fire was discovered by the hotel's manager, Reinhardt Datz, who was woken just after four o'clock in the morning by the smell of smoke. At first he thought that the workmen had already started and that the smoke was to do with their work, but he glanced over to the clock on the pier toll house opposite and realised it was too early for this. The report in the *Gazette* continues:

> Opening his bedroom door, Mr Datz was almost overpowered by the inrush of a volume of smoke, and realising at once the gravity of the situation he directed his attention to the safety of the inmates of the huge establishment. One of the waiters was dispatched in hot haste, clad in the scantiest of clothing, to the Fire Brigade Station to give the alarm, and meanwhile a garden hose was brought into use at the seat of the outbreak, though the fire had already gained so great hold as to render such efforts completely futile. Almost simultaneously with Mr Datz's discovery, the outbreak had been seen by Miss Coleman, the manageress of the bars at the Theatre Royal, who occupies apartments at No. 1, Bath Place, and whose rooms [which were at the back] overlooked the hotel. Chancing to wake at this time she saw that the hotel was in flames, and she and Mrs Fenoulhet, with whom she resided, ran to the front of the house and gave an alarm, and had the satisfaction of finding a passer-by promptly act upon the startling information thus conveyed to him.

What the *Gazette* describes as 'one of the most exciting incidents of the morning's operations' was when the Fire Brigade's chief officer, Captain Crouch, learning from Datz that two guests, Mr and Mrs Rosher, were still inside the hotel, in a room on the first floor, bravely went into the building and 'brought the lady down on his back through the blazing staircase into the street'. He was awarded the Silver Medal of the Royal Society for the Protection of Life from Fire for his courage.

Captain Alfred Crouch (1847–1927) was a notable figure in the town in the late nineteenth and early twentieth centuries. He was a builder from London, who moved to Worthing in 1870 for the benefit of his health. He built the pier kiosks (see Section 10) in the early 1880s, and in 1909 was in charge of the extensive refurbishment of the New Theatre Royal (see Section 14) in Bath Place; and he became Overseer of the Borough. However, he was best known in the town as the head of the Worthing Volunteer Fire Brigade, in which capacity he served

from 1887 to 1901. He had five daughters, but only one son, Allen, born in 1883. Allen, who married in 1914, died in Mesopotamia in 1918 of wounds sustained in a gun accident and is buried in a war cemetery in Baghdad – just one of the countless personal and family tragedies that arose from the First World War.

Once all the guests and employees of the Royal Hotel had been evacuated, 'the attention of the rescuers was directed to the score or so of horses that occupied the mews, belonging to Mr J. Town, at the rear of the hotel, and after some slight difficulty the affrighted animals were removed to a place of safety'. For a while it looked as if the fire's 'ravages' might affect neighbouring properties such as the theatre and the County Club, and there was, indeed, a 'slight outbreak' at No. 2 Bath Place, but this was quickly dealt with. However, the ironmonger's shop of Mr B. S. Hiscock immediately next to the hotel was badly affected and it was here that the 'next greatest destruction was witnessed'.

At half-past five Datz telegraphed to Brighton for assistance, and the Volunteer Fire Brigade, 'travelling at a rapid pace', reached Worthing by road within fifty minutes. Meanwhile Captain Crouch had contacted Brighton's Railway Brigade, whose fire engine came to Worthing on a special train that arrived within twenty minutes of leaving Brighton Central. The train was shunted into the South Farm Road siding, where the fire engine was 'horsed', and driven to the fire, which it reached about twenty past seven. The Worthing brigade had by this time got the fire under control, but the extra help was much appreciated, and the crowd 'lustily cheered the new arrivals'.

However, the building was damaged beyond repair – and so ended the life of what was Worthing's leading hotel for three-quarters of the nineteenth century, just as Warne's (see Section 6) was to be for most of the twentieth. There were plans to build a replacement hotel, to be called the Grand Hotel, but these never came to fruition, although for some years there was a parade of shops known as Grand Hotel Buildings on the South Street side of the site. This in due course gave way to the more ambitious Royal Arcade, which opened in 1925, and still stands today.

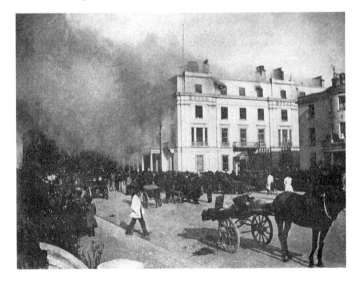

The Royal Hotel on the morning after the fire that destroyed it in May 1901.

The New Parisian Baths / The County Club & the New Theatre Royal

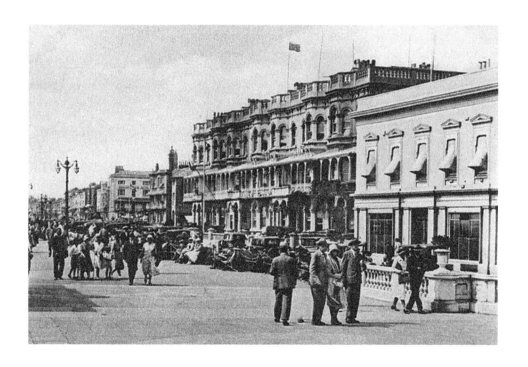

The two buildings that feature in this section stood within a few feet of each other (one in Bath Place, the other on the corner of Bath Place and Marine Parade), and they provided relaxation and entertainment over almost exactly the same period. One was a theatre from 1884 to 1929, and the other, though it had previously served several other purposes, was a gentlemen's club from 1891 to 1934. We will deal first with the latter.

The Royal Baths

The three buildings that have successively occupied the location between the Royal Arcade and Bath Place have over the years probably had more different uses than the buildings on any other site on Worthing seafront. Today Connaught House stands there, with an amusement arcade on the ground floor and a nightclub above.

The first building on the site, erected in 1797, was Wicks's Original Royal Baths, a curious-looking wooden structure that jutted out from the line of the other buildings along the esplanade (as did its successor). John Wicks's baths were the first in Worthing, and they remained the only baths in the town until 1818–23 (the exact dates of construction are unclear) when Thomas Trotter, the proprietor of the Ann Street theatre, built the Royal Baths some 230 yards to the west, on the corner of a street that no longer exists called Paragon Street (see Section 17).

The opening of Worthing's first bathhouse was an important step in the transformation of the town from a straggling village to a thriving Georgian seaside resort and, in *A Guide to All the Watering and Sea-Bathing Places* (1803), John Feltham writes: 'the erection of a very commodious warm baths (Wicke's) [*sic*] sufficiently prove how far Worthing has risen in public estimation'.

John Evans, author of *A Picture of Worthing* (1805), gives a little more detail about Wicks's bathhouse:

> There is also a warm bath, belonging to Mr John Wickes [*sic*]; it has been lately erected and is heated to whatever temperature may be required; thus the benefits of hot and cold bathing, so much insisted on by the faculty [that is, the medical profession] may be enjoyed in perfection.

In 1829, the original bathhouse was demolished and replaced by a new building, which went under the grander title of the New Parisian Baths, and it was this

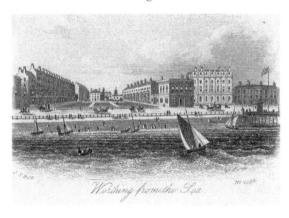

This mid-nineteenth century engraving shows, left to right, Montague Terrace, Bath Place, the building that later became the County Club, the Royal Sea House Hotel and the Marine Hotel. In 1879, the gap between Montague Terrace and Bath Place was filled by Cambridge Terrace, and five years later the New Assembly Rooms – subsequently the New Theatre Royal – was built behind it.

An engraving from *An Album of Worthing Views* (1882), in which artistic licence has been deployed to give the County Club building (left of centre) – at that time the Pier Bazaar – a pitched roof that in reality it never had.

building that in due course became the County Club. The proprietor of the New Parisian Baths, a man called Mark Markwick, was given permission to build a tank 17 feet by 12 feet in front of the building and under the seafront esplanade. Markwick came to an unusual arrangement with the town commissioners, namely that 'a cast iron tube to allow the escape of foul air' from the tank would also be 'used by the Commissioners for a lamp post'.

Although the New Parisian Baths was presumably an improvement on its old-fashioned predecessor, it did not remain in business for long, closing after just eight years. The building had a number of uses after that, including as a shop known as the Pier Bazaar, which was its use when the 1882 engraving was published. On this image, the building is shown with a pitched roof, but this was clearly artistic licence, since all other images of the building, including the early engraving on page 98 and the photograph on the title page of this section, have the building with a flat roof.

The Pier Bazaar closed in 1888 and the building, by now No. 35 Marine Parade, briefly became the Parade Restaurant. Then, from 1891 to 1934, it was the County Club. This seems to have been a provincial version of the gentlemen's clubs in the West End of London. The 1895 edition of *A Descriptive Account of Worthing* tells us that 'among the several excellent clubs in Worthing' this was 'the principal one'. It was 'entirely non-political in character' and contained 'comfortable reading, card, smoking, coffee and billiard rooms'.

After the County Club closed in 1934, the building was demolished and replaced the following year by Connaught House, built in complementary style to the Royal Arcade, which had been erected ten years earlier on the site of the Royal Hotel. Connaught House was the first building on the site to be in line with the other buildings on Marine Parade, rather than jutting out onto the esplanade.

Sir Charles Burrell

The County Club was, according to *A Descriptive Account of Worthing*, 'conducted under the management of a committee and two trustees'. In 1895, the two trustees, who held office for life or until they resigned, were two eminent men of West Sussex – Sir Charles Burrell (1848–99) and William Holland Ballett Fletcher (1852/3–1941). The fact that men of such substance were the trustees of the club – and, presumably, also made use of it – suggests that it served the town's upper and upper-middle classes. It is unlikely that Worthing's shopkeepers and artisans were members.

These two trustees' lives are of interest, since they remind us that late Victorian Worthing was a very different place from the classless town it is today.

Sir Charles Raymond Burrell, the 6th Baronet (1848–99) – whom we will call 'our' Sir Charles to distinguish him from his grandfather, Sir Charles Merrik Burrell, the 3rd Baronet (1774–1862) – came from the distinguished family that had owned the Knepp Castle estate near West Grinstead for over two hundred years. Sir Charles Merrik Burrell represented the parliamentary seat of New Shoreham for an extraordinary fifty-six years. After his death, Sir Percy Burrell (1812–76), our Sir Charles' uncle, and then Sir Walter Wyndham Burrell (1814–86), our Sir Charles' father, succeeded both to the baronetcy and to the seemingly almost equally hereditary parliamentary seat.

The New Shoreham seat returned two MPs from 1295 until it was abolished in 1885, a remarkable continuous history of almost six centuries. From 1880 until 1885 the other New Shoreham MP was Robert Loder, who became Sir Robert in 1887 (see Section 4).

In 1872 our Sir Charles married Robert Loder's daughter, Etheldreda, and between then and 1881 he served in the Royal Sussex Militia, retiring with the rank of captain. Had the New Shoreham seat not been abolished in 1885, Sir Charles would doubtless in due course have become one of its MPs, as his father, uncle and grandfather had been. As it was, he devoted his time to the normal duties associated with Victorian country landowners, and made many improvements to the grounds of Knepp Castle. In 1889, his brother-in-law, Sir Edmund Loder, bought the Leonardslee estate, just half-a-dozen miles from Knepp, and it is probable that Sir Edmund, who was a keen plant collector and garden designer, had a hand in the development of the grounds at Knepp. Sir Charles died in 1899, at the age of just fifty-one, but Knepp is still in the Burrell family today and occupied by another Sir Charles Raymond Burrell, the 10th baronet and the great-great-grandson of our Sir Charles.

The Burrell family were also freemasons, and the Burrell Lodge in Brighton, which was founded in 1879 and still exists today, was founded by our Sir Charles' father. In its very early years, meetings of the lodge were sometimes held in Shoreham, but from 1890 onwards always in Brighton. Sir Charles was Master of the Lodge for the year 1883, but for some reason he resigned from the Lodge in 1886, breaking the connection between it and the Burrell family.

William Fletcher

In the year that he was named in *A Descriptive Account of Worthing* as one of the trustees of the County Club, William Fletcher was the mayor of Worthing, in which capacity he served from 1894 to 1896. In the 1890s Fletcher and his family lived at a house called Fairlawn in Chapel Road. Then, in 1899, Fletcher's father died – the same year as Sir Charles Burrell – and Fletcher inherited from him the title of Lord of the Manor of Aldwick, at Bognor, together with Bersted Lodge, which he renamed Aldwick Manor. He improved the surrounding parkland by planting trees, shrubs and exotic plants.

In 1901 he was living there with his wife and his only surviving child, John, then aged twenty-one, and five servants. A younger son, Edward, had died in infancy. John, a lieutenant in the London Regiment, was killed on active service in 1915. There was therefore no one to inherit Aldwick Manor, but this was of benefit to the

people of Bognor, since today the grounds – now known as Hotham Park – form the only large public park in the town. The manor house, now called Hotham Park House, was converted into flats in the late 1970s. The fate of the Aldwick Manor estate was therefore identical to that of the Beach House estate in Worthing, where the house also became flats, and the grounds and parkland were made available for public use.

The New Theatre Royal

By an odd coincidence, the second of Worthing's great old theatres remained open for almost the same number of years – forty-five as opposed to forty-eight – as the first. The old theatre in Ann Street (see Section 28) traded as a theatre from 1807 until 1855, while the theatre on the west side of Bath Place served the people of Worthing from 1884 until 1929.

The building was a gift to the town from Sir Robert Loder of Beach House. It was originally called the New Assembly Rooms – or, sometimes, the New Theatre and Assembly Rooms – and, as these names suggest, it was originally intended to serve purposes other than just the theatrical. Concerts, lectures and other entertainments were also held there. But every year there were plays, and the first summer Ben Greet held a short season there.

Ben Greet (1857–1936) – Sir Ben from 1929 – was a distinguished English actor-manager during the late nineteenth and early twentieth centuries. He began his acting career in Southampton in 1879, and then spent three years at the Theatre Royal, Margate, before he made his London debut in 1883. But it was in Worthing the following year that he started his career as a manager as well as an actor.

Interestingly, Greet was returning to a town that he knew well, for his first job after leaving school had been in Worthing. From around 1875 until 1879 he had taught at Revd John Gresson's preparatory school for boys. This school was originally located at Richmond House in Chapel Road – during that period it was known at Richmond House School – but by the end of the 1870s it was at West Mansion, at the western end of Heene Terrace. A pupil at Gresson's school at about the same time as Greet taught there was the distinguished army officer General Sir Charles Harington Harington (1872–1940). Later, under John Gresson's son Frank, the school moved to Crowborough, where it was known as the Grange.

Although the New Assembly Rooms did not officially become known as the New Theatre Royal until 1897, the name 'Theatre Royal' seems sometimes to have been in use earlier than that – an advertisement in the *Worthing Gazette* of 5 September 1894 for a play called Theodora, for example, gives the name 'Theatre Royal, Worthing' for the venue.

Three days after that advertisement appeared in the *Gazette*, Oscar Wilde, who spent two months in Worthing that summer, attended a concert at the theatre. The main performers were the Olympian Quartet, whom Wilde had christened 'the vagabond singers of the sands'. Wilde and his friend Lord Alfred Douglas ('Bosie') had taken a special interest in this group of musicians – in all likelihood because they were young and good-looking – and co-sponsored the concert with the mayor. Bosie was not in Worthing at that point, so Wilde took his elder son Cyril to the

Above left: A programme for the New Theatre Royal. The text in small print below the engraving reads, 'Bonnets or hats are not allowed at Evening Performances in the First Two Rows of either Stalls or Dress Circle or in the Private Boxes'. It is puzzling that these impediments to others' view of the stage were seemingly allowed at matinées.

Above right: The New Theatre Royal around 1905.

event, and the audience applauded warmly as they entered. The *Worthing Gazette* of 12 September gives this short account:

> The four vocalists who have given performances on the sea-front during the season, and who style themselves the Olympian Quartet, had a farewell benefit concert at the Assembly Rooms on Friday evening. They had secured the patronage of the Mayor (Alderman R. Piper), Lord William [*sic*] Douglas, and Mr Oscar Wilde, and a large audience was present. Various performers assisted them, an ample and interesting programme being presented.

A dozen years after the New Assembly Rooms had opened, the interior was restructured, and thereafter it had a thousand seats. Now called the New Theatre Royal, it reopened on 26 July 1897 and, as in 1884, Ben Greet brought a company to Worthing. The play was Shakespeare's *As You Like It*, and the cast included Henry B. Irving and Laurence Irving, the sons of the great Victorian actor-manager Sir Henry Irving; and, in a small part, Harley Granville Barker, then only nineteen years old, who was to become one of the theatrical giants of the first half of the twentieth century.

Around 1905 the theatre was acquired by the great Worthing entertainment entrepreneur Carl Seebold – who was to build the Dome in 1910 – and in 1906 the interior of the building underwent a further restructuring. In 1922, however, Seebold sold the New Theatre Royal. He now saw more future in cinemas than in theatres, and by 1926 he owned two others besides the Dome: the Rivoli (whose site is now Rivoli Court, on the east side of Chapel Road, just north of the junction with North Street) and the Picturedrome (today the Connaught Theatre). Seebold was prescient, for the New Theatre Royal proved unable to survive the competition from films. It closed only ten years after he sold it, and the building was demolished a few years later.

SECTION 15

THE BIRDCAGE BANDSTAND

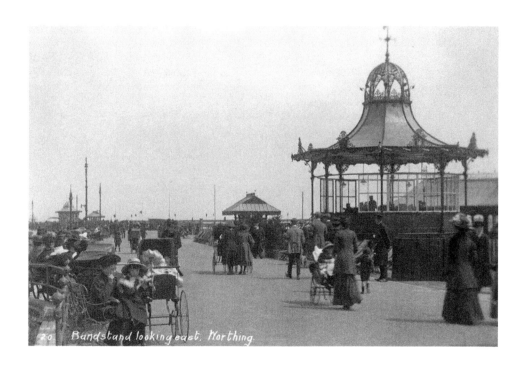

Bandstand looking east, Worthing.

The earliest bandstand on Worthing seafront was a modest moveable affair (below), which – after it was replaced in 1897 with the handsome birdcage bandstand seen in the other pictures that illustrate this section – was for many years in use in Steyne Gardens.

It is perhaps surprising that Worthing did not acquire a more impressive bandstand sooner than it did, for outdoor music was an important feature of Victorian seaside holidays. In view of the fact that 1897 was the year of Queen Victoria's Diamond Jubilee, it is reasonable to suppose that the construction of a new bandstand formed part of Worthing's tribute to the queen. The bandstand was built by Walter Macfarlane, the most important manufacturer of ornamental ironwork in Scotland, at the massive Saracen Foundry at Possilpark in Glasgow.

Oddly, the band that played inside the old moveable bandstand on Worthing seafront was – certainly as late as 1894 – a purely string band, rather than one that included brass instruments. W. Hurran of No. 110 Beresford Road, Harringay Park, London expressed his surprise at this in a letter printed in the *Worthing Gazette* on 22 August 1894. He wrote that, while he 'would not for a moment attempt to throw cold water on the efforts of those now engaged', there were 'not half enough of them' and, besides, 'a string band, without it is of very great strength, is not suitable for outdoor performances'. Hurran thought that it would be better to follow the example of Hastings and have 'a strong military band' paid for by 'a grant from the town and voluntary subscriptions'.

In 1897, to coincide with the new bandstand, a new town band was formed, and this probably did include brass instruments. But, within ten years it had folded and

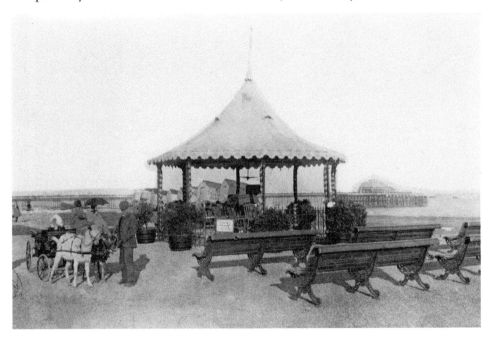

This moveable bandstand was in use on the seafront until the birdcage bandstand was constructed in 1897, after which it was relocated to Steyne Gardens. Under magnification it can be seen that the notice in the centre is advertising that the band will play at 11.30 and 7.30. Note the goat-cart on the left of the photograph.

after that only visiting bands used the bandstand, including four or five times a year the local Salvation Army band.

For the first ten years of the birdcage bandstand's existence there was nowhere for any of the audience to shelter from the rain. Then, in 1907, a shelter was erected to the south of the bandstand.

The birdcage bandstand survived for less than thirty years. In 1925 it was replaced with a new bandstand and a large enclosure (see Section 16), as part of the ambitious project by the architects Adshead & Ramsey that also included the new land-end pier pavilion.

Harold Camburn

No apology is needed for devoting a sub-section to the life and work of the Tunbridge Wells based photographer and publisher Harold Camburn, three of whose postcards are reproduced in this section (one of them on the title page) and numerous others elsewhere in this book, for the people of Worthing owe him a great debt. Between 1910 and around 1921, Camburn published more postcard views of the Worthing area than any other postcard publisher, with the probable exception of the two local photographers Edwards & Son and Loader's Photo Stores, whose cards were produced in very small quantities.

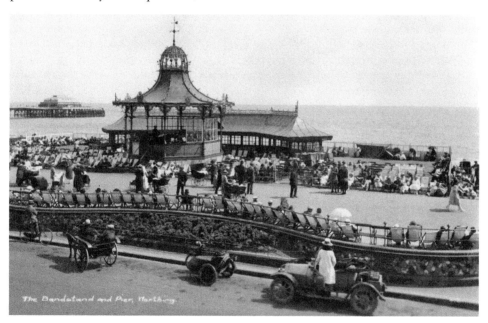

The bandstand, seen on a Harold Camburn card first published around 1921. Just left of centre is the motorbike on which Camburn travelled around Kent, Sussex and Surrey, taking the photographs for the postcards he published under his Wells Series imprint. He included the motorbike on a number of his postcards as a sort of signature. His photographic equipment was carried in the sidecar. The Camburn postcard reproduced on the title page of this section was first published in 1910.

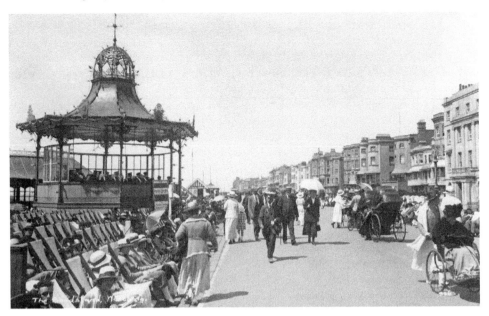

Another Camburn view of the bandstand from around 1921.

Not only was Camburn prolific, he was also a very gifted photographer. In addition, all his local-view cards were produced on good-quality photographic paper, the images on these so-called 'Real Photograph' postcards being crisper and clearer than those on the printed cards that the large firms generally published.

Harold Hawtrey Camburn, the youngest of four children, was born on 8 November 1876 in Sutton in Surrey. (The biographical information about Harold Camburn in this paragraph and the two other biographical paragraphs in this sub-section derives from articles in *Picture Postcard Monthly* by John Robards and Edward James Gilbert.) His father, George Hawtrey Camburn, was a Wesleyan minister and the family moved house a number of times while Harold was growing up. By 1901, Camburn, now aged twenty-four, was working for the Tunbridge Wells photographer Percy Lankester. Lankester's photographic interests lay mainly in portraiture and artistic photography, and the fact that he began publishing picture postcards in 1903 may have been due to the enthusiastic interest of his young employee. In 1906 Camburn set up in business on his own, and three years later he married Mary Gillett, the daughter of a prosperous builder, who helped him with the running of his business. It is not known whether they had any children.

Camburn's postcards are immediately recognisable from the 'handwritten' captions at the bottom. All but his early cards have his Wells Series trademark on the back, with its familiar logo of well-head and rope. He used a different number-sequence for each location he photographed, a helpful system that is surprisingly rare among postcard publishers. He was almost certainly imitating the only other firm of any size that used this 'localised' numbering system – the great French firm of Lévy Sons & Co., whose sequence of postcards of Worthing, photographed between 1906 and about 1914, runs to ninety-nine numbers.

In general, Camburn allocated a separate number sequence to each small village he photographed, and it is odd that in the case of Worthing the outlying villages

were included in the main Worthing sequence. Perhaps he was again following the Lévy firm, since the Lévy sequence includes not only, reasonably enough, Tarring, Broadwater and High Salvington, but also, less logically, Bramber. Camburn cast his net even wider than Lévy, however, for his Worthing sequence also includes cards of Lancing, Findon, Angmering, East Preston, Sompting and Steyning – and, bizarrely, Arundel.

We do not know why Camburn chose to specialise in Worthing rather than, say, the large seaside resorts of Brighton and Eastbourne, which were closer to Tunbridge Wells. One reason was perhaps that a hundred years ago Worthing and its hinterland had such charm and diversity. Worthing may not have been as grand as Brighton, or as stately as Eastbourne, but it was more photogenic than either. The town, the seafront and the outlying villages were full of picturesque possibilities.

In the early days of his association with Worthing, Camburn entered into special relationships with three shops in the town: F. Pickford (sometimes 'Mrs Pickford') of Railway Approach; J. R. Keeley, a stationer at No. 67 Chapel Road; and Walter Bros in South Street. In each case the shop was credited on the back of the card, which also carried Camburn's name or, later, the 'Wells Series' trade name. In a few very early cases, just the shop is credited. These cooperative arrangements lasted for only a year or two, however. As Camburn's cards grew more popular, he clearly decided that – in a large town like Worthing, where there were dozens of shops that sold postcards – this kind of favouritism was not good for business.

Camburn enlisted for war service in February 1917, and became an Air Mechanic 2nd Class with the Royal Naval Air Service. From the summer of 1917 until early 1919 he was stationed in the eastern Mediterranean, where, in his spare time, he took hundreds of photographs, over eight hundred of which he later donated to the Fleet Air Arm Museum. Most of these photographs were taken either on the Greek Islands or in the Dardanelles, where, ironically, the paddle steamer *Tuzla*, formerly *Worthing Belle* (see Section 12) – a boat that Camburn had photographed four years before the war started – had been sunk by the British Navy in 1915.

Camburn produced relatively few new postcards of the Worthing area after the First World War. His last views of Worthing were photographed around 1921, though he was probably still distributing his cards in the town for a few years after that.

We do not know exactly how many cards of the Worthing area Camburn published, but we can make an informed estimate. The sequence numbered 1 to 199 is complete. On reaching 200, however, Camburn appears simultaneously to have started three new sequences. The 200 series was mainly of cards of Steyning, Beeding and Bramber; the cards in the 300 series were almost all of Rustington, East Preston and Angmering-on-Sea; and the cards in the 400 sequence were mainly of Worthing itself. None of these sequences was ever completed, the highest numbers being in the low 240s, 320s and 420s respectively. Camburn also produced a handful of cards of Worthing that had no catalogue number. Finally, after Camburn abandoned Worthing itself, he produced two short separate series: one of Bramber and Beeding; and the other of Angmering. These add another sixty or so to our total. Camburn therefore probably published between 350 and 365 views of the Worthing area – a staggering total when we reflect that he was not a local man and that he produced only around 225 postcards of his home town of Tunbridge Wells.

After the war, Camburn's focus changed. He evidently saw no point in trying to compete in Worthing with big national companies such as Valentine, Dennis and

In the spring of 1910, Harold Camburn included himself in four views he took on Salvington Hill, using a delayed-action shutter release. No other photographs of Camburn are known to exist. The postcard from which this detail is taken is the only one of the four in which he is standing reasonably close to the camera. On the other three cards he is in the middle distance.

Salmon, which now dominated the postcard trade in Britain's large resorts. These companies had little interest in small villages, however, and Camburn saw a market there. In those days most villages had shops or post offices, and Camburn would enter into a special arrangement with the proprietor similar to that he had had with the three Worthing shops in 1910. The postcards would be 'personalised' with a publisher credit for the shop, which appeared on the backs of the cards in addition to Camburn's Wells Series trademark. There would be views of the shop itself, the church, the pub, the main street, and notable houses in the locality.

Camburn's postcards are a roll call of villages that few people have heard of except those who live there – places such as Eridge, Hook Green, Groombridge, Hartfield, Robertsbridge, Turners Hill, Beech Hill, Henfield, Laughton, Stedham, and Frant. The number of different views he published of some villages was astonishingly high. There were, for example, at least ninety-three differently numbered cards of Penshurst, 102 of Rotherfield and 112 of Withyham. Although most of Camburn's local-view cards are of villages in Kent, Sussex and – to a lesser extent – Surrey, he was also commissioned to produce postcards of a few locations further afield, including Woburn Sands in Bedfordshire, Lowestoft and Ipswich in Suffolk, and Eccleshall in Staffordshire.

In 1951, Camburn retired at the age of seventy-five, sold his printing equipment and stock to Tempo Laboratories, and moved to Havant in Hampshire. He died in Portsmouth in the summer of 1956. His wife Mary survived him by eleven years.

SECTION 16

THE BAND ENCLOSURE / THE LIDO

The Adshead & Ramsey Project

In 1925–26 the architects Adshead & Ramsey were commissioned to replace the pier kiosks and the birdcage bandstand with, respectively, a music pavilion and a band enclosure – a scheme that transformed the appearance of Worthing seafront.

Stanley Adshead (1868–1946), who in 1914 became Professor of Town Planning at the University of London, and Stanley Ramsey (1882–1968) had joined forces in 1911 and they remained in practice together until 1931. Their first major project was to design the Duchy of Cornwall Estate in Kennington. The two new Adshead & Ramsey buildings in Worthing were sufficiently interesting and important to attract – on 12 November 1926 – a four-page feature in a journal of the time called the *Architect & Building News*. Two-thirds of the first page consists of an uncredited 830-word article with a single picture above it, while the other three pages were each occupied by two photographs of the new buildings.

The first paragraph of the article has an ironic resonance, for it was written nine decades ago, at a time when relatively little damage had yet been done to the architectural integrity of Worthing. If the (anonymous) author were alive today, it is easy to imagine how vehement his condemnation would be of the demolition over the past seventy-five years of dozens of attractive Georgian or Victorian buildings in the town, many of them of considerable historical importance. This is what he wrote in 1926:

> The beautiful towns on the south coast of England have suffered, and are still suffering, so much damage at the hands of estate developers and others that it is pleasant to draw attention to a quite modern seaside building [the pavilion at the land-end of the pier] which represents the best traditions of seaside architecture.

A view from between 1925 and 1929, showing the band enclosure with its first bandstand, which had a square floor and a triangular roof.

The band enclosure also illustrated here is a delightful design which seems to express the perfect seaside character. Of horseshoe plan, the enclosure at the far end, where the bandstand is situated, projects beyond the tidal line and so is, as it were, half-way to being a pier. Around the open space in the centre is a covered portion of ample dimensions. The whole scheme is distinguished by the elegant classic detail of which Messrs Adshead & Ramsey have shown themselves to be past masters.

One criticism occurs to the present writer and this relates to the discrepancy in texture between the band enclosure, which is whitewashed, and has the lightness of tone appropriate to its environment and the pavilion, where the bare concrete surface, with its peculiarly lifeless dull grey, has unfortunately been exposed. It is to be hoped that, when funds permit, this blemish will be removed, and the walls of the pavilion be given the same attractive finish as now distinguishes the band enclosure.

The municipality of Worthing is to be congratulated upon having the wisdom to give these artists an opportunity to make such an important addition to the amenities of their sea front.

Adshead & Ramsey's new band enclosure, which cost £25,000 and seated 2,184 people, opened on 1 August 1925, but almost immediately the bandstand inside it attracted criticism. This paragraph appeared later that year in the *Musical News and Herald*:

Arising out of the criticisms directed against the new 'shell' bandstand at Worthing, the special developments committee of the Town Council has recommended alterations that involve the erection of a new circular roof, with the open semi-circular portion supported by Corinthian pillars. The platform would be doubled in area. The General Purposes Committee has returned the scheme for 'further consideration'.

Stanley Adshead in 1927, a couple of years after he co-designed the new band enclosure at Worthing. Photograph by Bassano & Vandyk. (© National Portrait Gallery, London)

Frustratingly, this brief report does not mention the nature of the criticisms, although they seem to have related partly to the small size of the area where the musicians played. It is possible also that the acoustics were less good than had been hoped. Aesthetic considerations may have been a factor too, since the original version looked rather like a garden shed. Certainly the new version, which was built in 1929 and survives inside the Lido today, is more harmonious and attractive.

It is odd today to think of two thousand people sitting to listen to a brass band playing on Worthing seafront, but the photograph on this page demonstrates that the enclosure was indeed sometimes full to capacity. It was, however, only a few decades after the new band enclosure was built that open-air music at seaside resorts began to go into near-terminal decline. The Second World War was one factor. Military bands had other things to do than play on seafronts, and many of the musicians in civilian bands were also away at the war. After the war, tastes in music – and the way it was listened to – were beginning to change. Until the start of the twentieth century, music was something you made for yourself at home or at the local inn, paid to hear in concert halls or music halls, or went to listen to – usually free of charge – in parks and public places.

The gramophone and the wireless had already been around for five and three decades by the start of the 1950s, but the new decade brought a fresh threat. In 1950, ten per cent of British homes had televisions; by 1960 the figure was eighty-seven per cent. In addition, vinyl microgroove discs had superseded 78 rpm records by the late fifties. This meant that for the first time high-quality musical sound was available in the home. Playing time was no longer limited to one track per record side, since 12" LPs could accommodate over twenty minutes of music per side.

Meanwhile, cheap package holidays abroad meant that foreign travel began to be an affordable and, to many, a more attractive alternative to a week or two at the

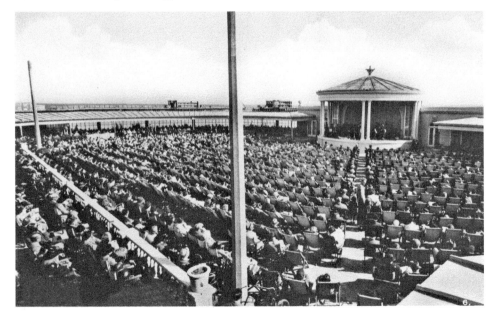

A full house for a concert during the late 1930s, showing the later round bandstand.

English seaside; and some resorts, Worthing among them, made a deliberate decision not to encourage day trippers. As a result of changes such as these, traditional seaside entertainments – outdoor bands, Punch and Judy shows, donkey rides – gradually disappeared from most British beaches.

The Lido

In 1957 Worthing's band enclosure closed, and the central area was converted into an unheated swimming pool and renamed the Lido. The new pool was opened in May 1959 by the Olympic swimmers Judy Grinham and Angela Barnwell. Judy Grinham had won the gold medal 100-metre backstroke in a new world record time at the 1956 Olympic Games in Melbourne, while four years earlier Angela Barnwell, who was born and brought up in Worthing, had competed in the 1952 Helsinki Olympics at the age of just sixteen. She came eighth in the finals of the Women's 100 Metres Freestyle event and was a member of the British team that came fifth in the final of Women's 4 × 100 Metres Freestyle Relay. On her return to Worthing in August, a civic reception was held in her honour, a crowd of five thousand gathering outside the Town Hall. Sadly Angela Barnwell died of cancer in 1965, aged just twenty-nine.

According to Anne Jessel's www.lostlidos.co.uk website, the dimensions of the unheated salt water pool at Worthing Lido were 100ft x 42ft, with the depth of water varying between 3ft and 7ft 6ins. There was initially no diving stage, but eventually a low-board stage with a one metre springboard was installed. During the first two weeks of the first season, which was of nineteen weeks' duration, 8,613

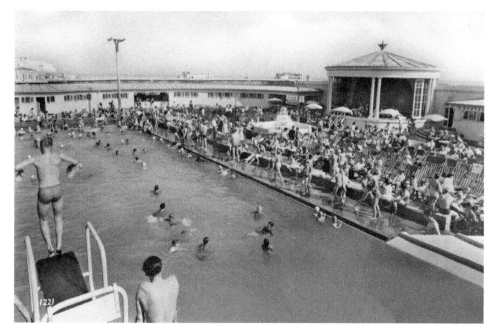

A photograph of around 1960, taken from the same position as the view on the facing page, but with the swimming pool now the main attraction.

people paid to use the Lido, although the pool had to close on four occasions during the season whilst slits were repaired in the original plastic lining.

In 1967, only eight years after the Lido pool was completed, the new heated indoor Aquarena swimming pool opened to the east of Beach House and, unsurprisingly, use of the Lido began to decline. The pool closed in 1988, and was then used for a year to house dolphins from the Brighton Sea Life Centre, whose usual accommodation was being rebuilt at the time. In the winter of 1989/90, the pool was built over and the present family entertainment centre was created on the site. The new attraction was opened in July 1990 by the actor Richard O'Sullivan and Gary Smart, grandson of the famous circus-owner Billy Smart.

SECTION 17

The Royal Baths / Marlborough House

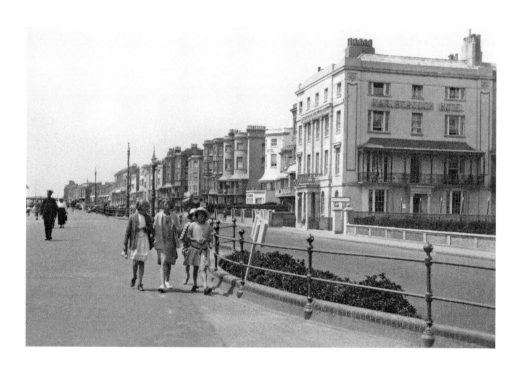

The three most important names in the history of early Worthing – indeed perhaps in the town's entire history – are those of Edward Ogle, Thomas Trotter and the architect John Biagio Rebecca; and it is sad that none of them is commemorated in the name of any street or building in the modern town. But these three exceptional men should not be forgotten, since without their presence in the town the development of early Worthing – and to some extent the shape of the town today – would have been very different.

The life and work of Edward Ogle is fully documented in my book *Jane Austen's Worthing*, but nothing has been written about Thomas Trotter's life since a detailed account in Mary Theresa Odell's *More About the Old Theatre, Worthing* (1945). Much of the information that follows is drawn from this book.

Thomas Trotter

Thomas Trotter was born in 1779. By the age of fifteen he was already an actor, based at Hythe in Kent. It appears that from an early age Trotter developed an interest in the managerial and entrepreneurial side of the theatre, although he never lost his love of appearing on the stage. In the summer of 1802 – and seemingly in subsequent summers – Trotter held theatrical performances in a barn at the top of Worthing High Street. There was a three-month season, from August to October. These productions were well received, and on 29 June the following year thirty-four residents signed a petition advocating the construction of a permanent theatre. The name at the head of the list, inevitably, was that of Edward Ogle, Worthing's leading citizen at the time (see Section 24), and it was Ogle that financed the building of the theatre on land he owned on the north side of Ann Street.

In the meantime Trotter had built theatres at Milton – now Sittingbourne – in 1803 and Hythe in 1804. The Worthing theatre opened in 1807. The first season was very successful, and early the following year Ogle sold the theatre and the land adjoining it to Trotter for £2,260. Trotter also ran theatres – often simultaneously – not only in Hythe and Milton, but also in Shoreham, Littlehampton, Arundel, Gravesend, Maidstone and Southend. From 1814–19 he ran the Brighton theatre in tandem with the Worthing theatre, but this was not a financial success, and when he gave up on Brighton he told the audience that he had had 'plenty of employment in their service, but very little pay for it'. A journal called the *Theatrical Inquisitor* claimed that he had failed because he 'entirely lacked industry, talent and spirit' – a spiteful and ill-informed thing to say of a man of such boundless energy and enthusiasm.

Worthing, however, was the centre of Trotter's empire, where his activities extended beyond the theatrical, and it was in Worthing that he died on 8 September 1851. He had expressed a wish to be interred in the town, but he had left the final decision to his wife, Margaret, and she decided that he should be buried at Gravesend, which was probably the town of his birth. As can be seen from the photograph of his tomb on the facing page, he was given quite a grand memorial. Margaret died just over four years later on 5 January 1856, and is buried in the same grave. The dates on the gravestone are the dates of interment.

The middle of the nineteenth century was a period when Worthing was in the doldrums, and Trotter's extensive property portfolio in the town went for absurdly

The tomb of Thomas and Margaret Trotter
at Gravesend, in Kent.

low prices when it was sold, most of it at an auction held in 1852. Cottages at
Nos 9 and 14 Warwick Place went for £155 and £190 respectively; a house at No.
6 Egremont Place for £235; Nos 4–5 Market Street for £145; No. 6 Market Street
for £150; No. 7 Market Street for £135; and two houses in Ann Street for £235
and £180 respectively. The Royal Baths and Marlborough House – which had cost
£5,237 to build three decades earlier – fetched either £900 or £1900 (Odell's book
gives different figures on different pages).

After Margaret Trotter's death in 1856, the Trotters' 'cottage orné' in Ann Street,
which had cost £2,739 to build, sold for £240; and the historic Ann Street theatre,
which had cost £6,992, sold for just £160, to serve for the next century or so as a
bacon and cheese store for Worthing's leading grocers, Potter, Bailey & Co.

The Royal Baths

Trotter's new Royal Baths, built around 1818–1823, were a grander rival to
Worthing's existing bath-house, Wicks's Original Royal Baths. (The term 'Royal' was
freely used in those days). At this time Wicks's Baths, which had been patronised by
Jane Austen's sister Cassandra during the Austens' stay in Worthing in 1805, were
still located in a humble single-storey building at the sea-end of Bath Place. This was
rebuilt in 1829. Later, this building became the County Club (see Section 14).

At the same time as he was embarking on his Royal Baths project, Trotter was
the driving force behind the construction, in 1819–21, of the Esplanade, a raised
walkway along the seafront between Splash Point and West Buildings. Until then the
buildings on the seafront had abutted the beach and were vulnerable to storm-tides.

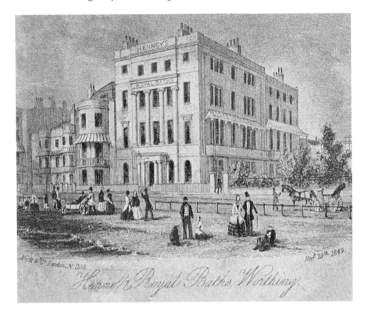

The Royal Baths in 1849, by now under the proprietorship of Thomas Henney.

Trotter's Baths stood 230 yards to the west of Wicks's Baths, at the south-east corner of a lost street called Paragon Street, and almost opposite the location that was in due course to be occupied by Worthing's various bandstands. The architect was John Rebecca, who was also responsible for Beach House, the Chapel of Ease (later St Paul's) and Castle Goring. The main entrance to Trotter's building was on the new Esplanade, with a second entrance just round the corner, facing east. The seafront entrance provided access to the baths and the waiting, reading and drawing rooms associated with it, while the side entrance served the accommodation.

The baths were supplied with seawater by pipes that went out a long distance into the sea, in order to avoid contamination. At each returning tide a self-acting hydraulic engine conveyed the water to a reservoir at the baths. A seawater bath – either cold or quickly heated by steam – was therefore available at any time. Different types of bath were on offer, including 'Indian Medicated', 'Vapour', 'Shampoo', and 'Shower and Douche'. The baths for gentlemen were on the ground floor, and those for ladies on the first floor. Attached to the north of the main building were two houses, originally known as Marlborough Houses (in the plural).

Later Uses

The Royal Baths probably closed at some point in the 1860s. By 1870 the part of the old Royal Baths building that faced east had been renamed No. 1 Marlborough Terrace, and the two Marlborough Houses to the north of it were called Nos 2 and 3 Marlborough Terrace. During the 1870s and the first half of the 1880s, No. 2 Marlborough Terrace was occupied, intriguingly, by a French nobleman living in exile called the Chevalier de la Peletière. The Chevalier appears for the last time in the 1885 directory, so he must have died around then, but his widow continued to occupy the house until around 1892.

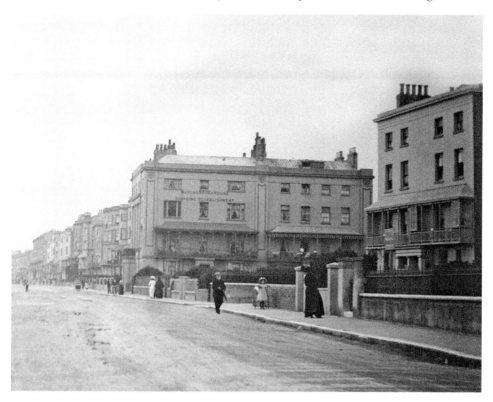

An Edwardian photograph of what was by this time the Marlborough House Boarding Establishment. The right-hand side of the building (centre-right) consisted of two houses known as 2–3 Marlborough Terrace.

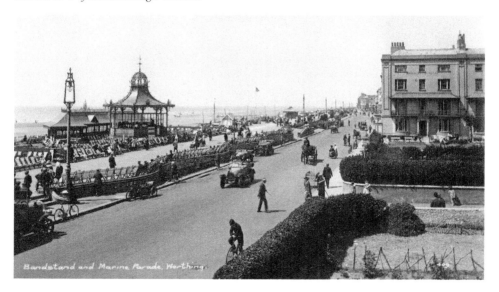

A Harold Camburn postcard from about 1921, showing where Marlborough House stood in relation to the birdcage bandstand.

Meanwhile, the two component parts of the old Royal Baths had become two separate boarding houses. These were known in 1900 as Marlborough House (this was the part of the building that had its front door on the seafront) and Argyle House, previously No. 1 Marlborough Terrace. By 1906 the two boarding houses had been combined to form the Marlborough House Boarding Establishment, run by the Misses Powis. Later the establishment was renamed the Marlborough Hotel, and this name can be seen on the east-facing side of the building on the Harold Camburn postcard on the previous page.

The date usually given for the demolition of the building is 1940, but a caption in Odell's book says that it was demolished 'just prior to the World War'. Since the book was published just a few years later – in 1945 – this dating has some credibility; so perhaps the building was in fact demolished in 1939.

SECTION 18

Augusta House / The Stanhoe Hotel

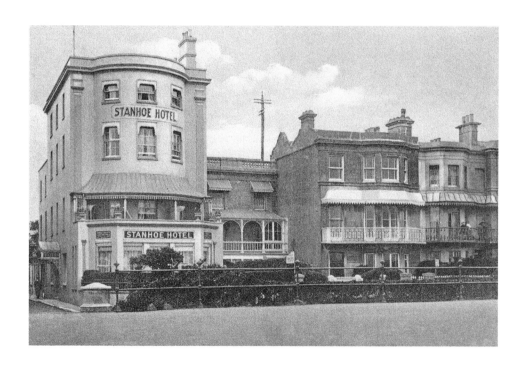

The two buildings that feature in this section stood successively at No. 65 Marine Parade, immediately to the east of Augusta Place. The earlier – and much longer lasting – was erected soon after Nelson's great naval victory over the French at Trafalgar in 1805, and was originally called Trafalgar House. Later, following Princess Augusta's stay there in 1829–30, it was renamed Augusta House in her honour. In 1893 it became the Stanhoe Hall boarding establishment, from around 1901 known as the Stanhoe Hotel.

In his indispensable 1945 book *Glimpses of Old Worthing*, Henfrey Smail, Worthing's greatest historian, writes that part of Augusta House was at some point demolished, and that the surviving half became the Stanhoe Hotel. However this assertion is incorrect. The error almost certainly arose because of the misleading caption on the 1861 engraving seen on this page. The building in the middle of the picture is not Augusta House but Augusta Terrace, formerly Trafalgar Terrace. Anyone looking at this engraving – and supposing, entirely reasonably, that the building in the centre was Augusta House – would have no alternative but to assume that the eastern side had been demolished at some point before it became the Stanhoe Hotel. In reality, however, Augusta House, later the Stanhoe, is the building on the right of the picture; and it never had more than a three-window-wide façade.

The small house to the east of Augusta House – which appears on most of the other pictures – was older than its neighbour. Originally known as Lelliot's Cottage, it became Trafalgar Cottage after 1805 and Augusta Cottage after 1830.

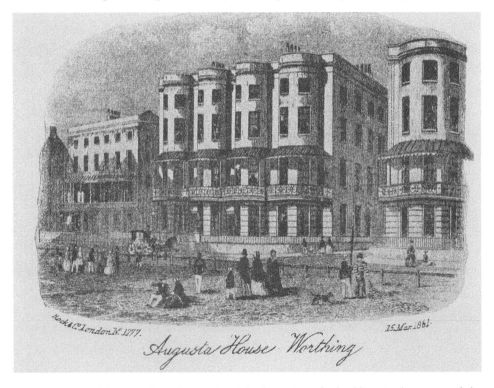

Augusta House Worthing

The caption on this engraving of 1861 is misleading, since the building in the centre of the picture is Augusta Terrace. Augusta House, later the Stanhoe Hotel, is on the right.

Princess Augusta

Princess Augusta (1768–1840), who stayed at Trafalgar House from November 1829 until February or March 1830, was the sixth of the fifteen children of George III. Although she never married, Augusta was, according to her governess, Miss Planta, 'the handsomest of all the princesses'. She was not the first member of the royal family to stay in Worthing. Her youngest sister, Princess Amelia, had spent four months in Worthing in 1798, and her niece, Princess Charlotte, had stayed for part of the summer of 1807.

On the evening of Princess Augusta's arrival, the town was illuminated in her honour, as it had been twenty-two years earlier for Princess Charlotte. The *Spectator* published a light-hearted account of the town's tribute to its new royal visitor in its issue of 14 November 1829 (the punctuation has been modernised to make the report easier to follow):

WORTHING – This is a very delightful little watering-place, which in the beginning of November is generally dull and empty; but at present one circumstance especially has induced many families to take houses here, and every day adds to their number.

The one especial circumstance to which we ascribe this unwonted resort [unusual number of visitors] is a visit from Royalty, the Princess Augusta Sophia having taken up her abode at Worthing, and thereby conferred on it a point of genuine English attraction that even Brighton cannot boast – Brighton, which still looks and longs with an exceeding anxiety for the King [George IV, who had often stayed in Brighton when he was Prince Regent, but now had other commitments].

The Princess Augusta Sophia arrived on Monday [9 November]; and the collective wisdom of Worthing had previously met and decided that the event would be most fitly honoured – and the attachment of the inhabitants to her Royal Highness and the House of Brunswick best set forth – by an illumination.

The High Constable, Mr Thomas Palmer, a glazier (nothing loth), issued his mandate, and Worthing was illuminated.

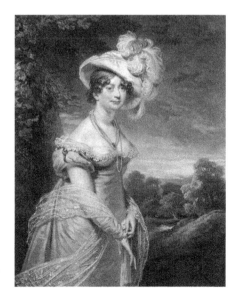

Princess Augusta Sophia, the sixth of the fifteen children of George III, in 1824, five years before her stay in Worthing. By Samuel William Reynolds and Samuel Cousins, after Sir William Beechey. (© National Portrait Gallery, London)

To particularise would be both difficult and perhaps invidious, for many who wished to display their sentiments in transparencies and lamps were disappointed, and obliged to substitute what is vulgarly called 'lamination muttons, forty to the pound' [candles made of mutton fat] – but which, when well and judiciously distributed, give a very decent albeit a transient light.

The hotels, both Parsons' [the Sea House, later the Royal] and the Steyne; the libraries, both Mrs. Stafford's and Miss Carter's; the vapour-baths and shops all shone out on this interesting occasion for the credit of Worthing; and the evening passed without an accident, save the singeing of some few petticoats by the fireworks that were thrown among the too happy country girls.

In *Glimpses of Old Worthing*, Henfrey Smail tells us that on her arrival the princess was greeted by the town band, which was headed by the ubiquitous Thomas Palmer. Smail adds that at the Chapel of Ease (now St Paul's Centre) three pews were upholstered in red cloth for the use of the princess during her stay; and that when she went to church she was attended by two footmen in powdered wigs and scarlet livery. The town beadle, Samuel Toler, was instructed to be on permanent duty near Trafalgar House, and the town commissioners had two new lamp posts with large lamps specially erected nearby for the princess's convenience and security.

In the letter reproduced below, written by Princess Augusta from Worthing on 22 December 1829, the princess wrote of herself in the third person, as was the royal way. According to Henfrey Smail, the letter was written to the wife of Revd John Penfold, vicar of Steyning, whose sister, Mary Powell, reader to Princess Augusta's mother Queen Charlotte, had just died. In her letter Princess Augusta says that she feels 'great regret at the loss', while considering it 'a blessed release to the individual who has suffered so much, so long and so patiently'. Mary Powell had asked that her bible should be given to Princess Augusta after her death, and the princess graciously tells Mrs Penfold that 'nothing could be more gratifying to her feelings than this old friend having thought her worthy of possessing her bible'. Princess Augusta ends by expressing the hope that when Mrs Penfold returns to Sussex she will call on her at

A letter written by Princess Augusta on 22 December 1829, during her stay in Worthing.

Worthing and bring the bible with her – 'as it will enhance its value coming from the hands of one as dear to Mrs Powell as she knows her niece was to her'.

This last section seems to indicate that Mrs Penfold was in fact Mary Powell's niece rather than her sister-in-law; but the relationships are not totally clear.

The Thimms

By the 1870s the name Augusta House seems to some extent to have fallen out of use, for in Worthing directories of the 1870s and 1880s the building is listed simply as No. 65 Marine Parade (or, before the street renumbering of 1881, No. 36 Marine Parade). Like so many other buildings on Worthing seafront, it was by now a lodging house. From around 1879 until 1890 this was run by Mrs Harrison, and afterwards for two or three years by the Misses Burton. Then the building was acquired by Horace and Mary Thimm, who refurbished it comprehensively and opened it in the summer of 1893 as a 'high class boarding establishment', initially called Stanhoe Hall, but later renamed the Stanhoe Hotel.

The name Stanhoe came from Stanhoe Lodge, the house in Southern Road, Fortis Green, north London where Horace Thimm's father had lived for many years. Stanhoe Lodge was, in its turn, probably named after a fine Queen Anne house called Stanhoe Hall, situated in the Norfolk village of Stanhoe. The use of this version of

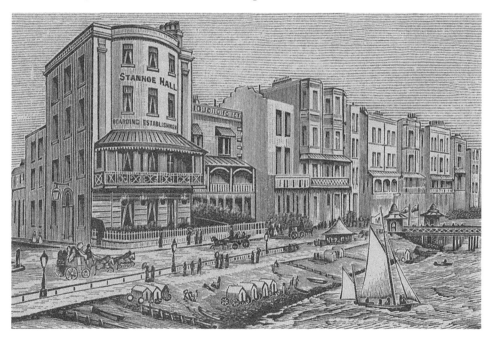

In this engraving of 1895, done for an 'advertorial' for Stanhoe Hall, the buildings to the east of Augusta Cottage bear little resemblance to the reality. Note also the toy-sized representations of the original pre-1897 bandstand and of the pier and pier kiosks, which have been positioned considerably to the west of their true locations in order to give the impression that they were nearer the Stanhoe than they actually were.

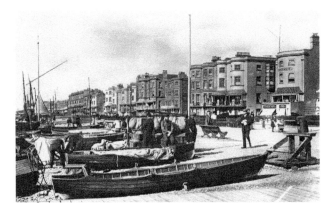

An Edwardian view of the seafront looking west from the Stanhoe Hotel, which can be seen at the far right of the picture. Note how, while the original façade of the two easterly bows of Augusta Terrace retain their original curving appearance, the two western bows have been altered, and now have a more angular, Victorian look.

the name for the Worthing boarding house suggests that the Thimms were aware of this, although they themselves had no connection with the village. Stanhoe Lodge had perhaps originally been the London house of the owners of Stanhoe Hall in Norfolk.

Horace's father, Franz Thimm, was a famous London bookseller whose shop at No. 24 Brook Street was, according to Thomas Wright's *Oscar's Books* (2008), frequented by Oscar Wilde. In his early days as a bookseller Franz and his family had lived above the Brook Street shop, but as he throve and prospered they moved to Stanhoe Lodge, which was a substantial house with three reception rooms, two of which were 27 feet in length (although only 13 feet wide). It was there that Franz died in 1889.

The eldest and the youngest of Franz Thimm's three sons went into the army. During the 1890s, Franz Jr was a commander in the Irrawaddy Flotilla Company in Rangoon, Burma. Meanwhile, Carl – the author of a celebrated book called *A Complete Bibliography of Fencing and Duelling* (1896) – served as a captain in the Imperial Yeomanry during the Second Boer War (1899–1902). The middle son, Horace, was made of less adventurous stuff than his brothers. In 1871, aged seventeen, he was a bank clerk. He married quite late, in 1892 – when he was thirty-eight and his wife, Mary, was twenty-six – and soon afterwards the couple moved to Worthing. Horace's widowed mother Horatia seems to have come too, for it was in Worthing that she died in 1898.

The 1895 edition of *A Descriptive Account of Worthing* included an 'advertorial' about Stanhoe Hall, illustrated with the attractive engraving seen on the previous page. This engraving demonstrates that the building was bigger than it looked from the front, extending some way down Augusta Place. The rooms were large too. The article tells us that the dining room on the ground floor had a capacity of thirty-six, and that the drawing room – which, as often in substantial nineteenth-century houses, was on the first floor – was a 'spacious apartment'.

The promotional article also takes pains to stress the high quality of the furnishings and fitments at Stanhoe Hall. 'Excellent taste and refinement' were 'noticeable in every room', and 'valuable oil paintings and other works of art' were on display in the halls, corridors and landings. The drawing room contained a 'new Erard grand piano', and the billiard room 'an entirely new full-sized table, by Hennig Brothers'.

Thoughtful provisions were made for guests with particular requirements: 'Mrs Thimm makes a special feature of Saturday to Monday accommodation, quite unique in the high-class boarding-house arrangements.' Quite why a weekend break

should have been a rarity in high-class boarding houses is puzzling, but the Thimms evidently saw themselves as trail-blazers in this respect. Another considerate touch was that 'a special breakfast' was served 'to enable gentlemen to reach London early' – there being a train from Worthing that made it possible for guests to arrive 'in town' by nine o'clock.

Horace and Mary Thimm remained at the Stanhoe till around 1907, and after their departure the hotel went through a number of owners over the next three decades: A. H. Stocker, Mrs Ross, George L. Polsen, and the Misses F. and P. Frankham. Finally, just before the Second World War, Edlins Ltd bought the hotel and Augusta Cottage to its east; and both were demolished.

The New Stanhoe

In 1950 Edlins erected a replacement Stanhoe Hotel – a curious, utilitarian building which stood further back from the sea than the old hotel, with a car park in front of it and an Augusta Place rather than a Marine Parade address.

Most of the information in this sub-section comes from Clive Purser, who contacted me after reading my article about the old Stanhoe in the *Worthing Herald* in March 2015. Clive grew up at the new Stanhoe, his father having been appointed the hotel's manager in 1952 when Clive was five years old. Clive's father worked for Edlins, and had previously managed several of its pubs in Brighton, where the firm was based.

Clive does not know why the old Stanhoe was demolished, but says that one possibility is that the flooding that affected the new building had even more seriously affected the old one. Indeed this may partly explain why nothing was built on the site when the new Stanhoe was itself demolished, after a brief existence of just three decades.

The new Stanhoe Hotel, which was built in 1950 and remained in place for about twenty years. (Photograph provided by Clive Purser)

The new Stanhoe Hotel was, in spite of its name, only ever a pub. Clive says that there were plans to make the building into a residential hotel by extending it to Marine Parade, but that funds ran out – which is why the front of the building appears, as Clive puts it, 'truncated and devoid of any architectural features'. The layout consisted of a public bar and terrace on the ground floor, a saloon bar on the first floor, and the manager's flat on the second floor, where Clive and his family lived. This flat had access to a private roof terrace, which served as a sort of playground in the sky for Clive and his friends. There were outside lavatories to the rear of the building, and a large cellar that was used for utilities and storage. Since this cellar extended close to the sea, it was prone to flooding at spring high tides, and a permanent electric pump was installed there. Most of the beer barrels and other large items associated with the new Stanhoe were therefore kept in one of a number of lock-ups situated on the west side of Augusta Place. The Stanhoe also had a brick garage with a pitched roof, which had a dancing studio on the first floor.

In those days, Augusta Place was a cul-de-sac and accessed at the northern end from Montague Street only by a passageway running adjacent to a pub called the King's Arms. After the war, No. 63 Marine Parade (the building to the east of Augusta Cottage) became an ice-cream parlour, but this business did not survive long. After it closed, No. 63 became derelict and Clive says that, as children, he and his friends used to break into the rear of the building and play games there.

By 1961 all the old houses between Augusta Place and Montague Place had gone, with the exception of the two Montpelier Houses at the end of Montague Place, which survived until 1974. The new Stanhoe Hotel was demolished around 1970, and ten years later a new red-brick Augusta House was built on the west side of Augusta Place – therefore where Augusta Terrace had stood, and not on the site of the old Augusta House.

At present, the site of the building where Princess Augusta wrote her letter to Mrs Penfold and Mary Thimm offered special early breakfasts is an area of open ground just to the west of the Grafton multi-storey car park and the bowling alley. However Worthing's Town Centre and Seafront Masterplan, published in 2006, envisages that in due course there will be a new structure on the site, as part of an overall redevelopment of the area.

The Stanhoe Hotel and the Fortes Ice Cream Parlor [*sic*] to its east, around 1945. The Fortes firm was based in Brighton, where it had several parlours. Another branch of the family opened a parlour in Llandudno, North Wales, where the firm still manufactures ice cream and has a restaurant. (© www. westsussexpast.org.uk)

SECTION 19

THE THOMAS BANTING MEMORIAL HOME /
THE PARADE WINE LODGE

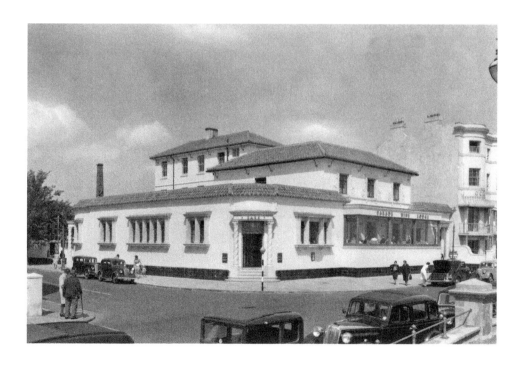

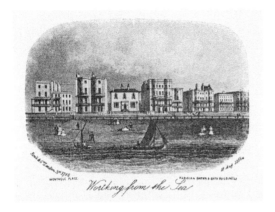

An 1858 engraving of Worthing seafront, with Parade Lodge – later the Thomas Banting Memorial Home – prominent in the centre. Today the building and the terrace to its west are the site of the handsome Regency style Nautilus block, built in 2003.

A hundred years ago there were two two-storey houses on Worthing seafront between Heene Terrace and Splash Point. Today, one survives – the former Coastguard House, to the west of Claydon Court and the old Lifeboat House. The other, Parade Lodge (No. 49 in the old numbering of Marine Parade, and No. 80 in the numbering that applied from 1881 onwards), was owned for many years by a man called Thomas Banting, whose will prescribed that after his death the building should become a convalescent home, which it remained for almost seventy years. After the Second World War the building was converted into a pub, before being demolished in 2001 for a new block of flats.

Thomas Banting

Thomas Banting (1799–1874) was a notable and perhaps rather eccentric figure in nineteenth century Worthing. Curiously, his death was reported in the *Eureka Herald* – of Eureka, Kansas, USA – in its issue of 20 August 1874. The 'obese and celebrated Mr Thomas Banting', it said, had left a large sum of money 'for building a convalescent home at Worthing'. Although it was indeed Thomas that had just died and left vast sums to charity, the *Herald* was confusing Thomas with his elder brother William (1796–1878), who was both 'obese and celebrated'. Thomas was not famous, and we have no idea whether or not he was fat.

There were two reasons why the Banting name was well known. The first was that Banting's was the most famous firm of undertakers in Britain for most of the nineteenth century and for the early part of the twentieth, conducting the funerals of – among other notable personages – George III, George IV, the Duke of Wellington, Prince Albert, Queen Victoria and Edward VII. In due course William took over the family business from his father – Thomas Snr – and continued to live in London with his family, while Thomas Jr at some point moved to Worthing.

The second reason for the fame of the Banting name related to William's obesity and his determination to overcome it. His doctor advised changes to his diet, and William followed this advice, initially with mixed results. However he then found a diet that achieved the desired effect. Banting wanted to share his success with others, and in 1863 he wrote a booklet called *Letter on Corpulence, Addressed to the Public*, which set out his diet plan, which consisted of four meals a day, avoiding

sugar, starch, milk and butter. Each meal consisted of up to six ounces of meat, fish or poultry; plenty of vegetables (but no potatoes); and the 'fruit of any pudding' (thus, without the pastry). Banting allowed himself tea without milk or sugar, and at dinner he could have two or three glasses of good-quality dry claret, sherry or Madeira; but champagne, port and beer were forbidden.

Initially, he printed the booklet at his own expense, but it was later published commercially, and it became so popular that 'Do you bant?' became an everyday question in England and the word entered the language.

Meanwhile, in sunny Worthing, Thomas lived a quiet life and never married. He is buried in Broadwater Cemetery. Although his obelisk is in a prominent position near the entrance to the cemetery, the inscription – perhaps at Thomas's own request – is modest:

<div style="text-align: center">

Thomas Banting
Died at Parade Lodge
Worthing
20th June 1874
Aged 75

</div>

Thomas Banting left the residue of his estate in trust to found a convalescent home for gentlewomen of good social position but reduced means who were recovering from a recent illness. This home, which was located in the house where Thomas had lived on Marine Parade, opened in 1877 or 1878.

A lengthy account of the Thomas Banting Memorial Home in *Kirshaw's Guide and Handbook to Worthing and its Vicinity* (1878) provides much interesting information. The guide informs us that the normal length of stay at the new home was twenty-one days, although this could be extended if necessary. All expenses were met, 'including laundress', so that the lady convalescent had to pay only her travel costs. At that time there were five bedrooms for the convalescents – two of them single rooms and three of them with twin beds – allowing eight ladies in all to 'become inmates of the home'. There were three sitting rooms, and the housekeeping was 'on a liberal scale'.

Kirshaw's Guide also quotes a recent report about the new home in a ladies' newspaper called the *Queen*. The *Queen* reports that Thomas Banting 'for years lived a very retired life at Worthing', and that he left £67,000 to 'various charities, mostly in the metropolis', as well as £30,000 'in order to found a charity whose object should be to help convalescents'. These are staggering sums – combined, the

An Edwardian view of the Thomas Banting Memorial Home.

two bequests represent well over £7,000,000 in today's money. The Thomas Banting Memorial Trust still exists, and as recently as September 2011 awarded £470,000 to Guild Care of Worthing's Healthy Living Programme.

The *Queen* newspaper is full of praise for the fact that the Banting Memorial Home was intended to serve a 'class much in need of it' – and indeed expresses this in terms rather disconcerting to the modern eye:

> The clergyman or professional man who has to keep up a good appearance on a small income is often far worse off than the mechanic [craftsman] or labourer, who has little to do beyond providing for the daily wants of food, shelter, and clothing, and who has all kinds of help contrived for him.

It is difficult to conceive quite what were the 'all kinds of help' the author of the article thought were available to the working classes of those days – other, perhaps, than the workhouse – and the subtext seems to be that such people were in effect a different species, with lesser requirements.

A report in the *Nursing Record & Hospital World* of 14 March 1896 also gives a detailed account of the home, and it is again clear that social distinctions were central to the offering:

> The Convalescent Home at Worthing, known as the Thomas Banting Memorial, meets the necessities of poor gentlewomen only, a class of persons who really need, from the small number of Institutions providing for their wants, such help and sympathy as this excellent Home affords. Applicants, particularly schoolmistresses, governesses, and relatives of farmers, master-tradesmen, schoolmasters and tutors, and private persons, are requested to state such facts as will show that they are accustomed to associate with such ladies as are intended to be admitted. This is especially required of relatives of 'merchants' [the inverted commas are very telling!] or other traders, as only the better classes are intended. Each lady has a separate bedroom. The domestic comforts are in every respect those of a private gentleman's family.

One mildly wonders how the relations of merchants were able to prove that they 'were accustomed to associate' with ladies of the right social class.

The Parade Wine Lodge

Around 1946 the Thomas Banting Memorial Home moved to No. 28 Downview Road, near West Worthing station, before finally closing about forty years later. No. 28 Downview Road is still a care home today, under the name of Tenby House. Meanwhile Banting's old house on the seafront was incorporated into a new building, which extended also over the site of Nos 81–82 Marine Parade to its west. This new building served for half a century or so as a popular Worthing pub, initially – under the ownership of Roberts & Son – as the Parade Wine Lodge, and subsequently as the Litten Tree.

An article published in the *Worthing Herald* on 23 July 2001 – reproduced on www.worthingpubs.com – provides interesting information from Denis Fry, who was managing director of Roberts & Son for five years and was on the board of directors for eight, before the company was sold in 1978.

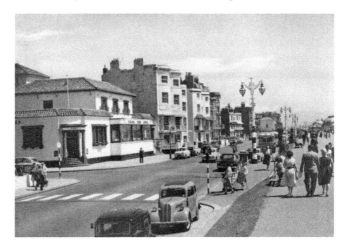

Looking east along
Marine Parade from the
Parade Wine Lodge in
the 1950s.

Fry says that the Wine Lodge idea was the brainchild of the Lynn family, who had bought Roberts & Son in 1922, but retained the Roberts trading name. In 1948, most public houses were owned by breweries and their range was limited. Few served food, and indeed there was a lack of good restaurants in Worthing at the time. The Lynns decided to do something different by opening a restaurant with a bar with a good selection of wines. The building that housed the old Banting home was empty, and they bought and transformed it, incorporating the house into a larger structure that also occupied the site of Nos 81–82 Marine Parade to its west. The new Wine Lodge opened in 1950. It was apparently the first new public house to be opened in England after the war and it also had the longest bar in the country. For half a century it remained a prominent landmark on Worthing seafront and a popular eating and drinking place.

Charlie Woodham

In *Licensed to Laugh*, his autobiography of 2015, Charlie Woodham adds colour to our knowledge of the Roberts firm in general and the Wine Lodge in particular. The book also contains a number of general anecdotes about life in Worthing in the 1960s.

Woodham was not originally from Worthing, but his parents moved to No. 23 Third Avenue, Broadwater not long before his national service ended in 1959, when he was twenty-one, and Charlie joined them there. Soon afterwards he got a job as an assistant at one of Roberts & Son's dozen Worthing branches, in Rowlands Road.

Woodham tells us that Roberts & Son had been founded 150 years earlier – in 1808, according to the Victoria History of the County of Sussex – and that at that time the Roberts group consisted of three small companies, the Brighton & Hove Wine Company, Roberts & Son Ltd and S. R. Lloyd Ltd. In addition to its numerous off-licences all over Sussex, the firm owned the Parade Wine Lodge and the Thieves Kitchen (today the Vintner's) in Worthing and the Royal Hotel in Bognor Regis.

Woodham was young and ambitious, and one day when on an errand in the firm's Head Office above the Thieves Kitchen he knocked on the door of the Managing Director, George Lynn – 'Mr George', as he was known.

Lynn looked up at Woodham and asked who he was and what he wanted. Woodham gave his name and said he had been working for the company for six

months and was not progressing as fast as he had hoped. This bold impulse worked, for soon afterwards he was promoted to the rank of Relief Assistant. This role, as its name suggested, was to stand in for assistants at branches of the firm's shops who were on holiday or off sick. Woodham's salary also increased, from £7 10s a week to £8 a week plus travelling expenses.

However, Woodham was also keen to gain experience behind the bar and, in due course, asked 'Mr George' if he could offer some evening work at one of the firm's two Worthing pubs. Lynn acquiesced, and the next evening Woodham – who incidentally tells us that his own favourite 'watering-hole' was the Marine Hotel (see Section 9) – reported the next evening to the Parade Wine Lodge. Woodham says that the manager at that time was 'a huge, fearsome man called Mr Alexander', of whom all the staff were terrified because 'his discipline was firm and uncompromising'. Mr Alexander was given to striding up and down the bar, smiling benevolently at the customers and scowling at the staff. 'He seemed to have a split personality,' says Woodham, 'and was able to ingratiate himself with the customers out of one side of his mouth while, at the same time, abusing unfortunate members of staff out of the other side.' Another employee of the Wine Lodge at that time was 'a small, elderly wizened gentleman called Danny' who was reputed to earn more than anyone else because he took backhanders from customers in return for reserving them spaces in the Wine Lodge's car park, which could accommodate only twelve cars.

The Litten Tree

The Parade Wine Lodge was later acquired by a large national pub group and renamed the Litten Tree, a made-up name meaning a tree that has been lit up. At one time there were at least forty Litten Trees in England, but after various takeovers the group – which also in due course owned the Yates and Slug & Lettuce chains – collapsed into administration in 2008, and few of the group's former pubs still trade under the Litten Tree name.

The character of Worthing's Litten Tree seems to have been more raucous than when it was the Parade Wine Lodge. A flavour of what it was like in its last years can be found in a brief account on the website of a covers band called Supersaurus of a gig there on 3 March 2000. The Litten Tree was apparently 'packed (as usual)' and 'each song was cheered more loudly than the last'. Supersaurus performed some songs that were new to them, such as Robbie Williams' 'It's only us' and the Cult's 'She Sells Sanctuary', as well as older songs such as U2's 'Angel of Harlem' . One of the best received songs was Stiltskin's 'Inside', and after the interval Supersaurus did a heavy rock version of the Osmonds' 'Crazy Horses'. There was time for just one encore at the end – Nirvana's 'Teen Spirit' – because 'the legal hour' had been reached. 'There is not much I can add,' the report ends, 'but the floor of "The Tree" took some battering.'

That part of Worthing seafront is quieter and more sedate these days, for by the start of the twenty-first century the site was worth more as a redevelopment project than as a pub, and in 2001 the Litten Tree was demolished. Since 2003 the splendid Nautilus block has stood there – a textbook example of how a fine modern building designed in a harmonious, traditional style can enhance a historic seafront.

SECTION 20

Heene Parade

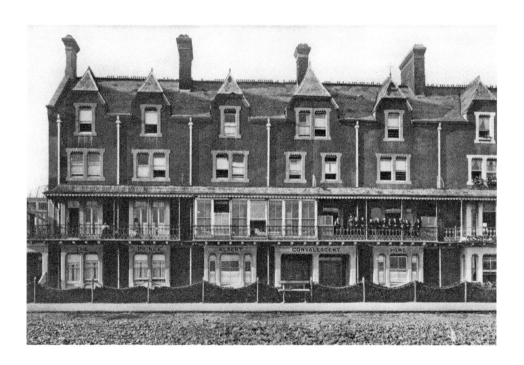

This engraving is dated 1 January 1870, so dates from only two or three years after Heene Parade was built. Note the gap to the east, where Prince's Terrace and Victoria Terrace were later to be built, which shows that West Worthing was indeed a separate settlement at that time.

In the early 1860s a new town was proposed at West Worthing. It was intended to be a separate resort, with its own pier. Although it never really flourished, it continued to have its own identity until it was incorporated into the new borough of Worthing in 1890.

The first structures to be built on the seafront at West Worthing – in 1865 – were the Heene Hotel (later the West Worthing, and then the Burlington) and Heene Terrace, both of which survive today. They were followed a couple of years later by Heene Parade, a terrace of eight houses built just to the east of the Burlington Hotel.

In 1914 the Beach Hotel opened at No. 4 Heene Parade, and by 1934 it had acquired the whole terrace, which it transformed into a ninety-four-bedroom hotel restructured in art deco style (see Section 21). Today the site is occupied by the Premier Inn and Beach Residences.

Peter and Alexander Thorn

The builders responsible for the construction of Heene Parade in 1867 were the Thorn brothers, Peter (1822–71) and Alexander (1833– ?). In Worthing they also built the swimming baths at the south-eastern end of Heene Road, which were demolished in 1973, and – to house their workmen during these projects – Thorn's Terrace, which still stands, on the western side of Thorn Road.

Peter and Alexander Thorn were Londoners, who had set up in business about 1860 in Chelsea. The firm's most important projects were the new Blackfriars Bridge, built in 1864–69 to replace an earlier bridge dating from a hundred years earlier; and Ennismore Gardens in Knightsbridge, built in 1868–74 using much of the stone salvaged from the old Blackfriars Bridge. Neither project, however, was to be a financial success.

The firm remained in business for another fifteen years or so after Peter Thorn's death in 1871, surviving a period of insolvency in 1875 as the result of losses incurred over the construction of Blackfriars Bridge. By 1881 the firm was again thriving, the census of that year describing Alexander as a 'builder employing 383 men and 11 boys'. However the business folded five years later, after Alexander failed to sell many of the houses he had built in Ennismore Gardens – not a problem he would have today.

Emily Davison

The Westward Ho! Private Hotel originally occupied just No. 8, the house at the western end of Heene Parade; but around 1903 it took over No. 7 as well. At the other end of the terrace, the Misses Carr, who for many years ran a girls' school called Seabury at No. 2, were similarly expansionist, adding No. 1 in 1918.

The famous suffragist Emily Davison, who died four days after she stepped out in front of George V's horse *Anmer* at the 1913 Derby, taught at Seabury School from 1896 to 1898.

In 1906, eight years after leaving Worthing, Davison joined the Women's Social and Political Union (WSPU), which had been founded in 1903 by Emmeline Pankhurst. This organisation believed that militant tactics were the only way to achieve votes for women. Even by the standards of the WSPU, however, Davison was extreme in her approach, her activities in due course extending to stone throwing and arson, and she was arrested and imprisoned no fewer than nine times. In June 1912, while serving a six-month sentence for arson in Holloway Prison during which she and dozens of fellow suffragists were on hunger strike and being force-fed, Davison threw herself down a ten-metre iron staircase as a shock tactic to try to force the authorities to abandon the practice. She suffered severe head and spinal injuries, which left her in pain for the remaining twelve months of her life.

There is some doubt about what Davison was trying to achieve at the 1913 Derby, but it is not thought that her intention was to kill herself. Film of the incident – which can be viewed on YouTube, and remains very shocking – shows Davison holding something in her hand as she steps out onto the course, and this may have been a suffragist scarf that she intended to attach to the king's horse. Some experts argue that, with no commentary broadcast over race courses in those days, she could not have known where in the field the horse was running, nor had time to identify it. By this theory, it was pure chance that it was the king's horse which collided with her.

This theory is supported by a vivid eyewitness account from a Mr Turner of Clapham Common quoted in Michael Tanner's 2013 book, *The Suffragette Derby*.

Emily Davison, Christabel Pankhurst, Sylvia Pankhurst and Emmeline Pethick-Lawrence at a suffragette march in Hyde Park on 23 July 1910. Photograph by Christina Broom. (© National Portrait Gallery, London)

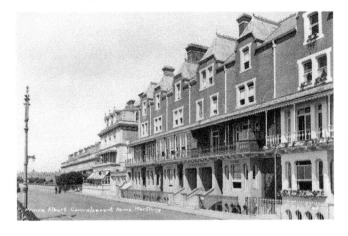

Heene Terrace (far left), the Burlington Hotel and Heene Parade from the east. A Harold Camburn postcard from around 1921.

Turner, who was standing on the opposite side of the track from Emily Davison, wrote as follows:

> I noticed a figure bob under the rails. The horses were thundering down the course at a great pace, bunched up close to the rails. From the position in which the woman was standing it would have been impossible to pick out any special horse. Misjudging the pace of the horses, she missed the first four or five. They dashed by just as she was emerging from the rails. With great calmness she walked in front of the next group of horses. The first missed her but the second came right into her, and catching her with his shoulder, knocked her with terrific force to the ground.

Recent analysis of the film of the incident suggests, however, that Davison's position, which she had chosen carefully – not least to be in the sight of the camera covering the finish of the race – would in fact have allowed her enough time to identify *Anmer*. In the event, Davison was helped by the fact that the horse was running behind the leading pack. If, however, she did indeed plan to attach a scarf to the horse, the plan was fatally flawed, since a racehorse at full gallop travels at nearly forty miles per hour.

What were Emily Davison's exact intentions on that day will never be known for certain, but the general motivation behind her act of protest is of course not in doubt.

After the race George V wrote in his diary, with characteristic understatement, that 'poor Herbert Jones [the jockey] and *Anmer*' had been 'sent flying' on a 'most disappointing day'. The response of the king's mother, Queen Alexandra, widow of Edward VII, was more forceful. She sent Herbert Jones – who had suffered concussion and bruising to the face – a telegram wishing him well after his 'sad accident caused through the abominable conduct of a brutal lunatic woman'. Amazingly *Anmer*, although he had taken a dreadful tumble, was uninjured.

The First World War changed attitudes to the enfranchisement of women, and an act of 1918 gave women partial suffrage. Then, less than three weeks after Emmeline Pankhurst's death in June 1928, a second act passed into law giving women equal voting rights to men's. At Emmeline Pankhurst's funeral, *Anmer*'s jockey, Herbert Jones, touchingly laid a wreath in honour of her and of Emily Davison. His own life, however, was to end in sad circumstances, for he committed suicide in 1951, following his wife's death and the onset of deafness and depression.

Major Eustace Loder

There was an important subplot to the story of the extraordinary 1913 Derby, which, oddly, also has a Worthing connection. This story, too, is told in full in *The Suffragette Derby*.

The finish of the race was very close, but the favourite, *Craganour*, was officially declared the winner, with *Aboyeur*, a 100–1 outsider, second; and the bookies duly paid out. There had, however, been some jostling between the two horses on the run-in to the finish, and an objection to the result was belatedly raised – but not by one of the jockeys or by the owner of *Aboyeur*, as would have been expected, but (and this was very unorthodox) by one of the three stewards.

The steward in question was Major Eustace 'Lucky' Loder, the youngest of the ten children – or joint-youngest, for he had a twin, Sydney – of Sir Robert Loder, owner of Beach House in Worthing (see Section 4); while the owner of *Craganour* was Charles Ismay, whom Eustace Loder disliked.

There were several reasons for this. The first and principal reason was that Ismay had had an extramarital affair with Nelly Loder, the wife of Loder's twin brother. A second was that Ismay was the younger brother of J. Bruce Ismay, the owner of the *Titanic*, which had sunk in April the previous year. Several of Loder's friends had died in the disaster, but Bruce Ismay, who was on the voyage, had taken a seat in a lifeboat and survived, and as a result received much vilification. Anyone bearing the family name was also tainted by association. Loder also suspected the younger Ismay of being involved with individuals who operated on the shadier edges of racing and betting.

There was a final reason why Loder might have preferred that *Craganour* did not win the race. *Craganour* was a son of a mare called *Veneration II*, who had been bred by Loder at his Eyrefield Lodge Stud in County Kildare in Ireland and sold when she was already in foal with *Craganour*. *Craiganour* had then ended up in the ownership of Charles Ismay. The idea that Ismay, of all people, should win the Derby with a horse that Loder had at one time owned (even if only in the womb) must have been supremely galling to him.

In view of the terrible event involving Emily Davison that had occurred as the race ended, it might have been expected that the stewards would have had other preoccupations than the jostling between the two leading horses as they approached the finish – especially since most objective observers seem to have taken the view that the two jockeys were equally at fault. Nonetheless the stewards, including Loder, duly deliberated on the objection that Loder himself had raised, and they awarded the race to *Aboyeur*, much to Ismay's fury. Four days afterwards he tried to lodge an appeal, but the rules of racing required that any challenge be made within forty-eight hours; and subsequent legal attempts also came to nothing.

Eustace Loder died the following year at the age of forty-seven from a kidney disease from which he had long suffered. His dying wish was to see another of his horses, his beloved mare *Pretty Polly*, who in the 1903 and 1904 seasons had won almost every race in which she had featured, including the 1000 Guineas, the Oaks and the St Leger. The mare was led along the lawn and towards the house and her head was put through Loder's bedroom window. Loder died peacefully, having seen for a final time the horse that, of all his horses, had given him the most pleasure.

Prince Albert (later George VI)

In 1920 the Westward Ho! Hotel was acquired by the Grange Convalescent Home, which had occupied No. 6 since 1914. The enlarged establishment was named the Prince Albert Convalescent Home, in honour of George V's second son, later George VI, whose first name was Albert and who, like his grandfather Edward VII, was known as Prince Albert or Bertie until he came to the throne in 1936.

In 1928 Prince Albert – by then the Duke of York – visited the Prince Albert Convalescent Home with his wife Elizabeth (who from George VI's death in 1952 until her own death in 2002 was to be known as Queen Elizabeth the Queen Mother). The original plan had been for the duke and duchess to pay a quiet unofficial visit to the home that bore the duke's name, but officials of the borough felt slighted by this low-key proposal, in particular because they felt that the recently built southern pier pavilion deserved royal recognition. It was therefore agreed that the duke and duchess would stop to look at the new structure; and on the day the duchess was heard tactfully to remark, 'How beautiful everything looks, and what a lovely pavilion!'

The Prince Albert Home was for servicemen injured in the First World War. An advertisement appealing for funds, which probably dates from roughly the same period as the royal visit, describes the institution as 'The Prince Albert Convalescent Home for Disabled Soldiers, Worthing', stating that numerous 'sick and wounded soldiers' had been treated there and that the home was still occupied by disabled soldiers. The advertisement indicated that funds were 'urgently required' to meet 'the extra cost of living' and to clear the home of debt.

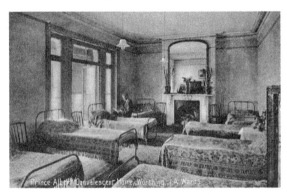

A ward at the Prince Albert Home, with a melancholy inmate in the background.

Seven unhappy-looking patients in the Reading Room at the Prince Albert.

SECTION 21

The Beach Hotel

Soon before the Beach Hotel closed and was demolished in 2012, we visited the hotel and had an interesting and informative chat with Linda Martin, co-proprietor of the hotel with her brother. Both are members of the Farnes family, which owned the hotel for almost ninety years. The hotel's original proprietor had been William Wyllie Macalister, but in 1920, half-a-dozen years after it first opened, Winifred Farnes joined as a receptionist, and within a few months was running the hotel. In due course the Farnes family became the proprietors.

Linda Martin – who helpfully gave me a copy of the report by New Historic Environment Consulting (NHEC) from which much of the information in this section derives – said that the hotel had reached the point where it simply could not be upgraded to twenty-first century requirements. There is a limit to how much structural change can be accomplished within the fabric of a 150-year-old terrace, and indeed over the years the Beach had already been knocked about a great deal.

As we saw in Section 20, the structure that became the Beach was originally a terrace called Heene Parade, built in 1865. Within twenty years of opening at No. 4 Heene Parade in 1914, the Beach Hotel had acquired the whole terrace – No. 5 almost immediately, with No. 3 following in 1918. In 1934 the former girls' school at Nos 1 and 2 was acquired, followed by Nos 6, 7 and 8, which the NHEC report describes as 'formerly the Prince Albert Convalescent Home for Railwaymen'. I have not elsewhere seen mention of the Prince Albert Home as having been for railwaymen, and indeed, as we saw in Section 20, the home was still looking after disabled ex-servicemen in the late 1920s. However perhaps the Prince Albert did indeed briefly serve a different constituency towards the end of its existence.

The architect chosen for the Beach Hotel project was Arthur Goldsmith of the Goldsmith & Pennells practice in Liverpool Gardens, which had recently designed Onslow Court, an attractive art deco built in 1933 that still stands at the eastern edge of Worthing, just west of Brooklands Park. Work on the 'new' ninety-four-bedroom Beach Hotel – which cost £42,000 (excluding furniture and fittings) – began in 1935 and was completed by Christmas 1936.

Floors were raised; the original pitched roof of Heene Parade was replaced with a flat roof; and lavatories, staircases, walls, bay windows and chimney breasts were removed. The NHEC report refers to a 'rationalisation of the former terrace's

An east-facing view of the Beach Hotel, taken soon after the Second World War. On the left is the entrance to the Burlington Hotel's brasserie.

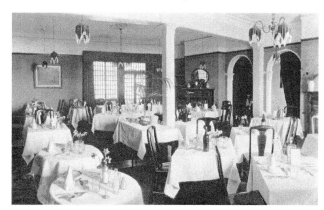

The dining room at the
Beach Hotel in the 1950s.

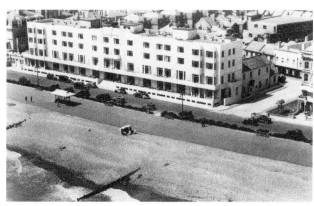

A photograph of the Beach
Hotel from the air, dating
from the late 1940s.

footprint' that retained 'significant portions of the former building's fabric'. 'Outright
retention', however, was limited to the rear at the eastern and western end, while
redevelopment was 'most thorough' at the front of the block. The overall effect was
that the Victorian terrace had been given an art deco encasement.

Over the years there were many further changes, mostly internal, and some of
these diluted the original art deco character of the hotel. Most, however, were
essential to preserve the hotel's position in a competitive environment. As late as
1969 only six of the bedrooms had integral bathrooms, for example, but by 1972
this had risen to seventy-six. In the mid-sixties there was an ambitious plan to
add an extra storey, and indeed planning permission for this was granted in 1966,
but this was never activated. At end of its life, the Beach had eighty bedrooms
(forty-five of them doubles and thirty-five of them singles) and employed fifty full
and part-time staff.

The report that helped condemn the Beach Hotel to destruction said that it was a
building 'of modest quality and a clear departure from surrounding fabric in terms of
both style and quality'. The hotel had little 'relationship with its nineteenth-century
neighbours', and its 'horizontal emphasis' was 'somewhat overbearing'. It is difficult
to disagree with these judgements. The 1935–36 makeover of Heene Parade had, in
truth, resulted in a structure that looked rather heavy and ungainly. Nonetheless,
most of the people of Worthing had a great affection for the Beach Hotel, and much
regretted its demolition.

Sadly the replacement building, which houses a Premier Inn and a block of flats known as the Beach Residences, is an inappropriate structure that dominates in an unbecoming way not only the western end of Worthing seafront but also its luckless nineteenth-century neighbour, the Burlington Hotel. The new building is too bulky, and it has no sense of the context in which it stands. If its predecessor had little 'relationship with its nineteenth-century neighbours' and was 'a clear departure from surrounding fabric', the same applies even more comprehensively to the replacement. It is disappointing that the opportunity to put a graceful and attractive structure in this important position was wasted, not least because the same Worthing-based firm, Roffey, had only recently built – at the other end of the seafront – the handsome and award-winning Eardley block, designed in close imitation of the nineteenth-century terrace it replaced.

Paddy Burt

Although it never quite had the prestige or the cachet of Warne's, for most of the twentieth century the Beach was Worthing's second most famous hotel. A complimentary review in the *Daily Telegraph* of 9 October 2004 by the pseudonymous Paddy Burt tells us something of the hotel's character towards the end of its existence.

Burt opens her review by describing the Beach as 'a grand seaside hotel that's not in the least bit grandiose', and says that she and her husband admired the ground-floor balconies, which were suggestive of 'sunny summer afternoons of long ago'. She found the car park at the rear spacious, but the entrance from it into the hotel unprepossessing, and wishes that she and her husband had swept in through the revolving doors at the front like Noel Coward and Gertrude Lawrence.

There was a lift to the first floor, where the long, red-carpeted corridor was 'a bit institutional'. She and her husband very much liked their room, however, which was furnished with a 'nicely old-fashioned' bed with sheets and blankets; an armchair and a sofa; a wardrobe with sliding mirrored doors; and a dressing-table with a triple mirror. The bar downstairs was a huge room with 'a jazzily-patterned carpet and a splendid polished wood counter', and the bar staff and the waiters in the restaurant were dressed in black 'to match their patent leather hair'. The food was good, although the self-service breakfast the following morning was 'mayhem' because all the guests seemed to have arrived in the dining room at the same time. However, Burt is full of praise for the generosity of the provision: a large round table in the middle of room was 'crammed with bowls of this and bowls of that' – 'they have turned breakfast into a feast'.

Burt says that, though she and her husband did not meet any of the Farnes family, they had the impression that they were 'directing everything carefully from just behind the scenes'. She ends her review: 'There's a tendency nowadays for old-fashioned hotels to be "modernised". If this happened to the Beach Hotel, it would be ruined.'

That risk was averted when the hotel was demolished in 2012.

SECTION 22

THE METROPOLE HOTEL

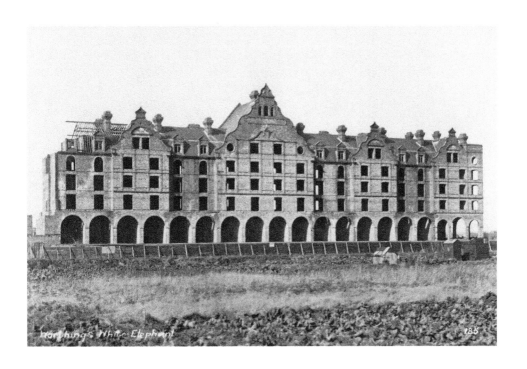

Worthing's White Elephant

The 'lostness' of most of the buildings featured in this book relates to the fact that not a brick of the original structure remains. In the case of the never-to-exist Metropole Hotel (as in one or two other sections), we are stretching our definitions a little – in this case because the building in question, which stood for three decades as a picturesque shell, was 'lost' not by being demolished but by being completed.

Heene Terrace, which was built in 1865, remained the most westerly structure on Worthing seafront for over thirty years. Then, in 1893, plans were approved for a new 370-bedroom hotel in West Worthing, to be called the Metropole. Building work started at the end of the 1890s. The firm behind the project ran into financial difficulties, however, and the structure was abandoned when it was still only a shell, although the scaffolding remained in place for many years.

The Harold Camburn postcard on this page, which features scaffolding, can be dated with certainty to 1910, while the photograph on the title page of this section – from another Camburn card – dates from around 1918. The scaffolding was therefore still in place when Edward VII died, but was gone by the end of the First World War. The shell of the Metropole was universally known as Worthing's White Elephant, and this name is used in the captions on both Camburn cards.

Presumably the original plan involved the Metropole Hotel having a south-facing as well as an east-facing section, as on the later architect's drawing seen on the facing page. In that case the section that was partially built would only ever have been one part of the hotel. This section was eventually completed in 1923, but as a block of flats – known,

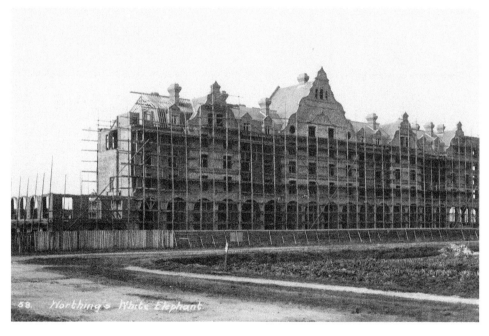

A Harold Camburn postcard of around 1910, showing the shell of the Metropole with scaffolding on it. The Camburn card on the title page dates from around 1918, by which time the scaffolding had been removed.

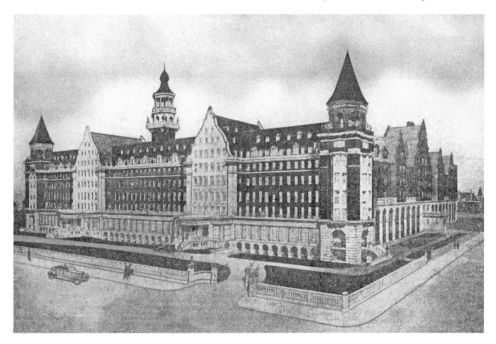

This architect's drawing, one of a number of proposals for the completion of the building, is entitled 'The Towers' rather than 'The Metropole', so it probably dates from the late 1920s, after the 'white elephant' facing Grand Avenue (seen on the right of the picture) had been converted into flats. The style of the car at bottom left also suggests a late 1920s date. It is not clear whether this vast proposed structure facing the sea was intended as a hotel or flats, but it was probably the latter, not least because the idea of a hotel had come to grief three decades earlier.

briefly, as Grand Avenue Mansions (an appropriate name); from 1924, as the Towers (evocative, if not entirely apt); and, from the start of the seventies (rather curiously), as Dolphin Lodge. Marine Point, the ill-matching and unbecoming addition to the sea-end of the building, was built in 1961.

The shell of the Metropole was still the only seafront structure west of Heene Terrace until well after the First World War. By the early thirties, however, family houses had been built along the section of seafront between Grand Avenue and Heene Terrace. Over the final few decades of the twentieth century these houses, except for a few at the Heene Terrace end, were replaced by Ceausescuesque apartment blocks, with the result that this section of West Worthing has become a sort of Bucharest-on-Sea.

Until the mid-1920s the terrain beyond a small number of houses that had already been built to the west of Grand Avenue was still entirely open ground, and even today – with the exception of Marine Point – 'low rise' has remained the principle here.

The promenade along the West Parade part of the seafront was still new in the early 1930s, and captions on postcards from the period indicate that various different terms were used for it at that time, including 'New Promenade, West Parade', 'West Promenade', and 'The Promenade, West Worthing'.

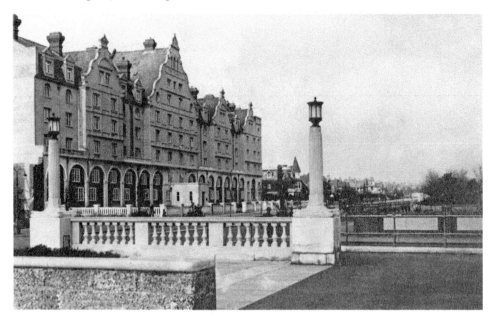

This view from the mid-1930s shows the block during the period when it was known as the Towers. Marine Point, the ugly addition at the sea-end, would not be built until 1961.

The section of seafront between Heene Terrace and the Towers in the late 1930s. Except for a few two-storey houses that remain at the Heene Terrace end, most of this section of West Parade today consists of large blocks of flats.

SECTION 23

ROBERTS MARINE MANSIONS

The first version of Roberts Marine Mansions, seen in the photographs in this section – a replacement block with the same name occupies the site today – is a building that came and went without making much impact on the consciousness of Worthing. Like many buildings in many towns, it was 'there' until, suddenly, it was not.

There was a building of the same name in Bexhill-on-Sea. Both buildings served holiday or convalescent purposes for members of the drapery trade, and they belonged to the same charitable organisation. They were named after Sir John Roberts (1834–1917), a man of humble origin who was apprenticed at an early age into the textile trade. He prospered in this calling, and became rich and successful. In 1894 he sold his business for a substantial sum of money, and thereafter lived the life of a country gentleman and philanthropist at Salway House in Woodford Green, Essex (demolished in 1931).

In Woodford, Roberts funded the Jubilee Hospital, which served the community from 1899 to 1986, before being decommissioned and replaced with retirement homes. He also built the Memorial Hall at St Mary's Church, Woodford in memory of his brother, Thomas. The hall opened in 1902, and is still in use. Two years later Roberts acquired Woodford's old Wesleyan chapel for use by the local community. Today it is a dwelling.

Of more interest to us, however, is Roberts' purchase of the Marine Mansions Hotel in Bexhill-on-Sea in 1903. Roberts converted this wonderful, extravagant turreted four-storey building – built just eight years earlier – into a holiday and convalescent home for members of the drapery trade, and renamed it Roberts Marine Mansions. Partly supported by subscriptions from employers, this establishment typically took care of over two thousand guests a year, for visits averaging a week. It suffered bomb damage in the Second World War and was demolished in 1954. Modern flats and a shop were built on the site in 1961.

The Worthing version of Roberts Marine Mansions was built around 1939. This was over twenty years after Sir John Roberts had died, so it must have been funded by the trustees of a charitable trust he had set up. The building was designed by H. A. Dawson, who was also co-architect of Artillery House, a modernistic, stone-faced office block of 1928–30 in Artillery Row in central London, and of Abbey Flats in Abbey Road, St John's Wood. Roberts Marine

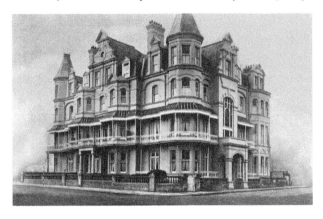

The Bexhill-on-Sea incarnation of Roberts Marine Mansions. Formerly a hotel, this was a much grander building than the purpose-built Worthing version.

Roberts Marine Mansions, Worthing, with Wallace Avenue on the right.

Mansions in Worthing – though simpler and more austere than its counterpart in Bexhill – has been described by the Margate-based writer and artist Dan Thompson as 'a lovely 1930s block … full of beautiful period details, windows and railings and reliefs on the walls'.

When Roberts Marine Mansions was first built, the road along Worthing seafront did not extend that far. The building was approached from the north, and it had a Wallace Avenue address. The Worthing establishment seems to have served as a holiday and convalescent home for members of the drapery trade for not much longer than its Bexhill counterpart, however, perhaps largely because British holiday and convalescent patterns changed as the years passed. Elderly and unwell drapers may increasingly have found Ibiza and Corfu more to their taste than West Worthing. The block seems at some point to have been converted into flats, and it was probably at the same time that its name was changed to Roberts Marine Mansion – in the singular – although this name seems sometimes have been in (incorrect) use in the building's earlier years. In 1995 the building was acquired by Roffey, the firm of Worthing builders and developers also responsible for Warnes, the Eardley and the Beach Residences / Premier Inn complex, and it was demolished the following year, to be replaced by a block of flats of the same name but very different in character.

The photographs of Roberts Marine Mansions used here all come from postcards. The postcard on the title page of this section and the card of the dining room on page 152 were both sent by people who were staying at Roberts Marine Mansions in the 1940s. On the first, posted on 6 February 1948, someone calling himself Watty writes: 'This is the place. A very nice one too. You would enjoy a holiday here. My room I have marked with a cross [it was the window third from the right on the first floor] so you can see

The dining room at Worthing's Roberts Marine Mansions, from a postcard sent in 1940, the year after the establishment opened.

I have a nice front view.' The card showing the dining room – a bright, sunny room located at the eastern end of the building, with windows facing east and south – was posted on 23 April 1940. The sender, who, rather oddly, signs himself Clements & Co., writes: 'I saw the doctor here again yesterday, and he wants me to have another two weeks.'

LOST IN THE TOWN CENTRE

~

SECTION 24

WARWICK HOUSE

Warwick House was the most important house in the history of Worthing, and its construction in the late eighteenth century was the single event that, more than any other, set in motion Worthing's transition from fishing and farming village to fully-fledged seaside resort. The house has its own 'biography', Henfrey Smail's magnificent *Warwick House* (1952), and I drew much material from this for my own chapter about the house in *Jane Austen's Worthing*. Warwick House was the model for Trafalgar House in Jane Austen's unfinished novel, *Sanditon*.

Smail's book also contains a full account of Princess Charlotte's stay at Warwick House in the summer of 1807, an event that brought the new resort of Worthing to national prominence. Princess Charlotte (1796–1817), who was only eleven years old at the time of her stay in Worthing, was second-in-line to the throne, and, if she had not died in childbirth ten years later at the age of twenty-one, she would have become queen on the death of her father, George IV, in 1830.

We shall not repeat the story of Princess Charlotte's visit here. However, Edward Ogle is the most significant figure in the history of early Worthing and, although he features prominently in *Jane Austen's Worthing*, he cannot be excluded totally from the present book. There is a sub-section about him below. We will also focus in this section on two very different men who were associated with Warwick House at the start and the end of its existence – the man who built it around 1785, and the man who demolished it in 1896 – about neither of whom anything has been written in any previous books about Worthing, beyond the odd passing reference.

John Luther

At the end of the seventeenth century the land on which Warwick House was to be built was owned by William Wade, the rector of Broadwater. In 1702 Wade sold the land to John Booker of Arundel, and it was then inherited first by Booker's widow and then by his granddaughter. Finally, probably around 1780, the land was sold to John Luther, who built a handsome 'marine residence' on the land. The house does not appear on a map of Worthing of 1778–83 and it was certainly in place by 1789, so it must have been built in the mid-1780s.

John Luther's reputation in the Worthing historical record has until now relied on two sentences about him in Revd John Evans's 1805 book, *A Picture of Worthing*: 'It is remarkable that the gentleman who built it, Mr Luther, lost, at one throw of the dice, one hundred thousand pounds! Fifty thousand only, however, were paid down: a dear tax on dissipation and folly.'

John Luther (1738–86) was, however, a much more interesting and notable figure than this anecdote suggests. The Luthers were an old and distinguished Essex family, which claimed to be related to the great sixteenth-century German Protestant reformer, Martin Luther. The family's principal estate was Myles's, near Kelvedon (named after a former owner, Miles de Munteny), which had been bought by Thomas Luther in 1566 – twenty years after Martin Luther's death. By the time that John Luther's father, Richard, inherited the estate, it consisted of 250 acres in Kelvedon Hatch, Stondon Massey and High Ongar. Richard Luther also inherited – from his maternal uncle, William Dawtrey – two other estates, at Doddinghurst, also in Essex, and Up Waltham (later Upwaltham) near Petworth in Sussex. When

his father died in 1767, these estates passed to John. The Up Waltham estate does not seem to have had a house of any significance on it, so Luther, who was only around forty when he bought the land in Worthing – and in his mid-forties when he built a house on it – probably intended the Worthing house to serve as his residence during those periods when he was attending to his Sussex estates. He was not to know that he would die within a couple of years.

Luther's main estates and his main home, as already indicated, were in Essex, where he had been an MP from 1763 to 1784. Little else, however, is known about his life beyond what we learn from a book by his closest friend, Richard Watson (1737–1816), a Cambridge academic who later became Bishop of Llandaff. Watson's memoirs, *Anecdotes of the life of Richard Watson, Bishop of Llandaff*, published in 1817, the year after his death, contain several references to Luther, two of which are of particular interest.

The first describes a curious episode that took place in 1764, when Luther left his wife and fled to France. Watson's account omits as much as it includes, and a particular oddity is that it appears that it took Watson four trips to France before he could prevail upon Luther to return. It would appear that Luther had some kind of mental breakdown:

On the 12th of February, 1764, I received a letter informing me that a separation had taken place between my friend Mr. Luther, then one of the Members for Essex, and his wife, and that he was gone hastily abroad. My heart was ever warm in friendship, and it ordered me, on this occasion, to follow my friend. I saw he was deserted and unhappy, and I flew to give him, if possible, some consolation. I set off from Cambridge on the same day I had received the account. I could read but I could not speak a word of French; I had no servant nor any money; I presently borrowed fifty pounds, and bought a French and English Dictionary, and thus equipped, I went

Richard Watson, bishop of Llandaff, in 1809. Watson was a close friend of John Luther, the first owner of Warwick House, and attended him in his deathbed in 1786. Engraving by Henry Meyer, after George Romney. (© National Portrait Gallery, London)

post to Dover, without so much as knowing whether my friend was gone to France, and from thence, almost without sleeping, I got to Paris and enquired him out.

The meeting was such as might have been expected. I did not stay above twelve hours in Paris, but immediately returned to England, and, after a variety of accidents and great fatigue, for I crossed the Channel four times, and travelled twelve hundred miles in very bad weather in a fortnight, I brought my friend back to his country and his family. His appearance in the House of Commons instantly quashed all the injurious reports which, from his hasty manner of leaving the country, scandal had raised to his disadvantage. He was a thorough honest man, and one of the friends I ever loved with the greatest affection. His temper was warm, and his wife (a very deserving woman) had been over-persuaded to marry him — had she loved him as he loved her, she would have borne with his infirmity of temper. Great are the public evils, and little the private comforts attending interested marriages [that is, marriages of financial convenience]; when they become general, they not only portend but bring on a nation's ruin.

Watson's final comment seems rather apocalyptic, but clerics are prone to point a moral to adorn a tale.

Luther's wife was Levina, the daughter of Bennet Alexander Bennet. She was born in 1738, the same year as her husband, and they were married in 1762 when – since the wedding took place in January – they were probably both twenty-three years old. The crisis of 1864 came almost exactly two years after the marriage. We do not know if the Luthers were reconciled after this, but the undertone of Watson's remarks is that the marriage did not recover. Indeed Levina Luther seems in due course to have become the mistress of another very rich man, Humphry Morice (1723–85), who was an MP for Launceston in Cornwall from 1750 until 1780. There is no other conclusion to be drawn from the fact that on his death Morice left almost his entire estate to Levina, to whom he was not related in any way. Significantly, also, Morice never married – he could not have married Levina Luther had he wished to, since she and John Luther were never divorced.

Twenty-two years after John Luther's flight to France, Richard Watson, by now Bishop of Llandaff, supported his old friend in even more unhappy circumstances:

On the 11th of January, 1786, I was sent for by express, to my friend Mr Luther, in Essex. I found him, as was thought by Sir Richard Jebb and his other physician, so much out of danger, that they both left him the next morning. In the course of a few hours after they were gone, a stoppage of urine came on; I immediately sent to town for Mr Pott; who not being at home, his son-in-law, Mr Earle, came down to Myles's, and on using the catheter, he found that a mortification had taken place in the neck of the bladder, and that there were no hopes: my poor friend died on the 13th, in the morning. On opening the will, I was found to be sole executor. His Essex estate was left to his younger nephew, Francis Fane, Esq., in strict entail to some other of his relations, with the remainder to me. His Sussex estate was left to me and my heirs, charged with a legacy of three thousand pounds. I sold this estate in the following July, to Lord Egremont, for twenty-three thousand five hundred pounds.

Another of the major beneficiaries of John Luther's will, incidentally, was his housekeeper, Mrs Williams. Wills are telling documents, and just as we have assumed

from Humphry Morice's will that Levina Luther was his mistress, it is reasonable to speculate that Mrs Williams may have been Luther's.

The Lord Egremont who had bought Luther's Sussex estates at Up Waltham and in Worthing was George Wyndham, 3rd Earl of Egremont, owner of Petworth House. On the land he acquired at Up Waltham he built – between 1787 and 1790 – a racing stables and stud, where he bred five Derby winners and seven runners-up, a record that is unlikely ever to be broken. The land in Worthing and the 'marine residence' that Luther had recently built on it were, however, of no use to Egremont, and in 1789 he sold them to George Greville, 2nd Earl of Warwick (1746–1816).

Thereafter the house was known as Warwick House. The Earl of Warwick's primary residence, however, remained Warwick Castle, 140 miles away, and his association with Worthing turned out to be brief. In the aftermath of the French Revolution of 1789, Britain was at war with France, and in 1795 the earl became a colonel in the Warwickshire Fencibles, and was appointed Lord Lieutenant of Warwickshire. He no longer needed a holiday home in Worthing, and in 1795 he sold the Warwick House estate to Major John Commerell, who six years later sold it to Edward Ogle.

Edward Ogle

Edward Ogle, who bought the Warwick House estate in 1801 and lived there until his death in 1819, was the man who almost single-handedly transformed the straggling and chaotic village of Worthing into a well-ordered nineteenth-century seaside resort. Chapters in my book *Jane Austen's Worthing* – Jane Austen knew him and based on him one of the characters in her unfinished novel *Sanditon* – tell in detail the story of Ogle's life and his achievements in Worthing over the first decade of the nineteenth century. Here, therefore, we shall mainly include information about Ogle that has come to light since my earlier book was published.

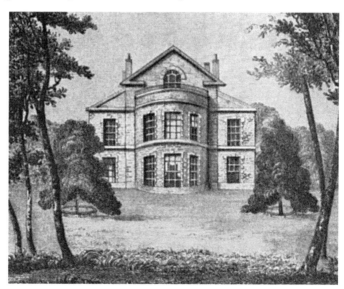

Warwick House in 1824, around thirty years after it was built.

Edward and his elder brother James were the two sons among the six children of James and Mary Ogle, who lived in Rothbury, twenty-six miles north of Newcastle. Edward was born in 1759 and James in 1757. In *Jane Austen's Worthing* I stated – correctly – that members of the Ogle family had been prominent landed gentry in Northumberland from before the time of the Norman Conquest, but this carried the implication that Edward Ogle's background was one of wealth and privilege. Further research, however, suggests that this was almost certainly not the case.

Two and a half centuries ago, Rothbury itself was a very humble little town. In 1760, soon after the Ogle brothers were born, Dr Richard Pococke, an eighteenth-century bishop who seems to have spent more time travelling than attending to successive dioceses in Ireland, described Rothbury as 'a poor town of two streets which are not paved, and the houses are mostly thatched', adding that 'they have several shops and handicrafts exercised here, particularly that of hatters'. It was not a place of significance. Indeed, according to D. D. Dixon's 1903 book, *Upper Coquetdale, Northumberland*, the population of the township of Rothbury in 1801 was just 668. When James and Edward Ogle were young children in the 1770s, it would have been even less than that.

The account in *Jane Austen's Worthing* includes almost nothing about the Ogle brothers' parents. However evidence in *Six North Country Diaries*, edited by J. C. Hodgson in 1910, suggests that the Ogle brothers' mother was probably the Mrs Ogle who died in Alnwick in 1796, described as 'the widow of the late Mr James Ogle, hatter in Rothbury' – thus, one of the Rothbury hatters mentioned by Bishop Pococke. Hodgson suggests that this Mrs Ogle was probably Mary, née Parker, wife of James Ogle of Rothbury, who was baptised in the town on 7 June 1709. These two were indubitably Edward and James Ogle's parents, and James Ogle the hatter whose widow died in 1796 would have been the right age to be the James Ogle who was their father. All this is of interest because it would appear that Edward Ogle was the son of artisanship rather than of privilege – which makes sense, since Edward's career trajectory suggests a clever and ambitious self-made man.

The first step towards the brothers making their fortune was to leave the modest little town where they grew up. There are missing years in the record, but by the end of the 1780s they were embedded in London's docklands. They were the partners in the firm of Messrs Ogle & Co., which owned a warehouse and a wharf near London Bridge, together with nine barges to ferry goods into the heart of London from the deep water docks further east. The Ogle brothers were also the partners in the firm of James & Edward Ogle & Co., Ship & Insurance Brokers, of New City Chambers, Bishopsgate Street, and in due course became the largest individual investors in the City Canal project. This new canal, completed in 1805, connected two stretches of the Thames and gave ships a short-cut to the wharves on the upper reaches of the river. Edward also became the Chairman of the Committee of Proprietors of the Legal Quays, which made him one of the most important figures in London's docklands. According to Spike Sweeting – in his 2014 University of Warwick PhD thesis, 'Capitalism, The State and Things: The Port of London, circa 1730–1800' – 'The wharfingers' leader-cum-secretary in 1773 was Barrington Buggin, who owned at least nine wharfs and was succeeded by his son, also called Barrington, in 1780. By 1790, Edward Ogle appears to have emerged as pre-eminent.' After two Buggins had each had their turn, a man named Ogle must have come as a relief to London wharf-owners.

During my research for this book, I came across on the internet a living direct descendant of Edward Ogle's brother James by the name of Mark Emery and I had a brief but interesting correspondence with him. Mark's great-grandmother on his mother's side was Henrietta Brookbank Ogle, daughter of Edward Lodge Ogle, one of James Ogle's sons. Mark is therefore the great-great-great-great nephew of Edward Ogle of Worthing. Mark directed me to a privately published 1902 book by Sir Henry Ogle about the Ogle family entitled *Ogle and Bothal: A History of the Baronies of Ogle, Bothal and Hepple*, the full text of which is available online. The information is largely genealogical, and many hundreds of members of the Ogle family briefly appear, going back to before the Norman Conquest. There is little about the Ogle brothers, therefore, beyond a few bald facts. but the book does include one new and interesting piece of information, namely that Edward Ogle's death on 26 March 1819 took place not in Worthing, as might have been expected, but in a house in Southampton Street in London. Since the book also tells us that James Ogle's house was in Southampton Street, it was presumably there that Edward died. Another online document identifies James' house as No. 5.

After Edward Ogle's death, Warwick House and its grounds passed to James. Gradually, the estate was broken up and the house itself went through various hands. Its glory years were already over, and most of the next seven decades were a sad tale of decline both for the house and – for many of those years – for the town of Worthing as well.

Ephraim Kellett

There is symmetry in ending this account of Warwick House with the story of the man who demolished it, and an extra symmetry in the fact that the developer who knocked down Warwick house and built on its grounds between 1896 and 1909 was, like Edward Ogle, an ambitious and determined incomer from the north of England. His name was Ephraim Kellett. He was a man who believed in keeping his business activities in the family in a quite remarkable way, as this brief account of tight-knit family entrepreneurship at the end of the nineteenth and the start of the twentieth century will demonstrate.

Ephraim Kellett (1846–1932) came from the village of Wyke, south of Bradford, where he had been born, as were four of his and his wife Nancy's five children: Harriett in 1871; Amon (incorrectly 'Amos' or 'Arnon' in some records) in 1873; and Olive and Thomas (presumably twins) in 1878. Soon after the birth of the twins, the Kellett family began the long and circuitous journey southwards that finally brought them to Worthing. Ephraim evidently went wherever the best work and the most interesting projects took him. The 1881 census tells us that in that year the family was living in Stourbridge in Worcestershire. Half a dozen years later the Kelletts were in Swansea, where their fifth and final child, Mabel, was born in 1887 or 1888. In 1891 the family was in Barnes in Middlesex. And then, a few years later, they arrived in Worthing.

The Kelletts' association with Worthing began when Ephraim's brother, Abram (1842–1918), a civil engineer and building contractor, won the contract to build a new water main in the High Street after the typhoid epidemic of 1893. It was he

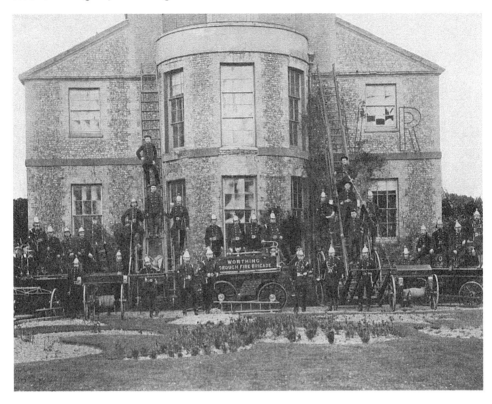

The Worthing Fire Brigade posing in front of Warwick House. The letters 'VR' on the wall on the right suggest that this photograph may have been taken in 1887, the year of Queen Victoria's Golden Jubilee.

who alerted his brother to the fact that Warwick House and its grounds were on the market. Ephraim and his family must have arrived in Worthing no later than 1896, for it was in that year that Warwick House was demolished. By 1901 he had built the house in Warwick Gardens – a new 'Warwick House' – where he and his family lived for many years.

The houses Kellett built in Charlecote Road, Warwick Gardens, Wyke Avenue (named after the Yorkshire village from where the Kelletts came), Ash Grove and Elm Road are conventional dwellings, but the important plot of land facing Steyne Gardens and the sea was reserved for a remarkable and unusual building that still stands at the north end of Steyne Gardens, its front a few yards south of where the front of Warwick House had been. The first part of the new building to be operational, late in 1901, was the Broadway Restaurant and Temperance Hotel, at No. 6. The manager of the hotel, which was little more than a guest-house, was Mary Munro, who in the 1901 census is listed as 'a boarder' in Ephraim's household at the new Warwick House. She was already thirty-two years old, quite old to be unmarried in those days. Whether she was already Amon Kellett's betrothed when she began boarding with the Kelletts, or they fell in love only after she came to lodge there, Amon and Mary were married in 1902. The following year Mary gave birth to their first child, John, who died within six months or so.

The bandstand at the eastern end of the grounds of Warwick House. During the first half of the 1890s illuminated promenades concerts were held here.

The Temperance Hotel survived for only a few years, and soon its rooms served instead as the accommodation for Amon and Mary and their family. Prior to their marriage, Amon had worked as a foreman for his father's building firm, but after his marriage he abandoned this in favour of the gentler occupation of baker and confectioner, which is given as his occupation in the 1911 census. By that time Amon and Mary had two living children, Donald (aged five) and Gordon (aged one), both of whom seem to have remained in the area all their lives, dying in Worthing in 1967 and 1979 respectively. Amon died in 1922, ten years before his father, at the early age of forty-nine. Mary survived him by over thirty years, dying in 1953 at the age of eighty-five.

For half a century – from 1901 or 1902 until around 1950 – the most important retail operation on the ground floor of the building was the grocer's shop at Nos 8–9, The Broadway. This, helpfully for attracting trade, was prominent for anyone approaching Worthing from the east, and it appeared on dozens of postcards of the Broadway. The original partners in the grocery business were Ephraim Kellett himself and his son-in-law, Edmund Ivens, who had married Ephraim's daughter Harriett in 1897. For some reason Ivens did not remain long in the business, the partnership being officially dissolved on 25 March 1904. The existing trading name – Ivens & Kellett – was retained, however, and Ephraim's younger son Thomas replaced his brother-in-law as the proprietor and manager of the business. James Kellett, Abram Kellett's youngest son, and Frederick Childs, Edmund Ivens's brother-in-law, also became partners, so the family firm of Ivens, Kelletts (now plural) & Childs was formed.

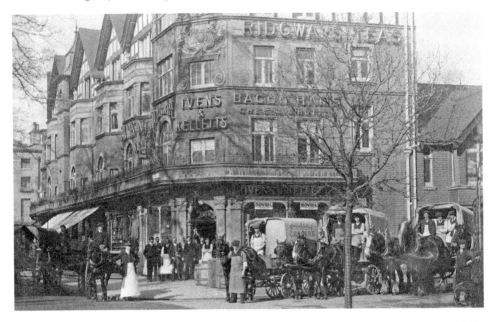

This postcard featuring the workforce of Ivens & Kelletts, 'wholesale grocers', in front of the firm's shop at Nos 8–9, The Broadway dates from around 1910.

From the early Ivens & Kellett days, the firm had been a wholesaler as well as a retailer – and indeed the words 'Wholesale Grocers' can be seen on the side of one of the waggons on the photograph above. A former corn merchant's premises next to Broadwater Bridge was the firm's main warehouse, and there was another warehouse at Fareham in Hampshire. The firm also ran a second grocer's shop at No. 81 Rowlands Road, and after John Chalmers, the chemist at No. 3, The Broadway, died in 1915, Ivens, Kelletts & Childs themselves took over the chemist's shop at No. 3 for a few years.

This key group of five men by the door to the grocery shop (enlarged from the previous image) almost certainly includes members of the Kellett family. The older man on the left of the group – the only man wearing a hat – is probably Ephraim Kellett himself, and the two young men with moustaches are probably his sons, Amon and Thomas. These three are standing slightly ahead of the others.

SECTION 25

THE COLONNADE

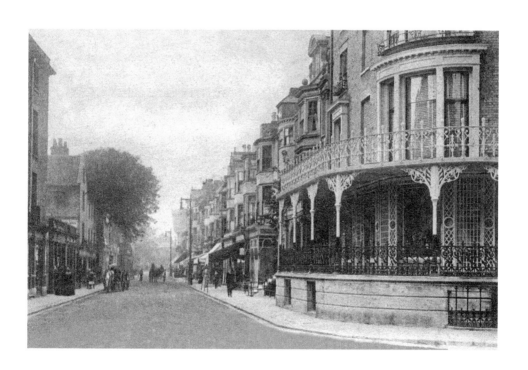

After Edward Ogle bought Warwick House and the land that went with it in 1801, he set about transforming the chaotic but rapidly growing seaside village of Worthing into a well-ordered modern resort. His first project was to build the Colonnade in 1802, on the corner of High Street and Warwick Street. We are stretching the title of this book a little to accommodate this building, since it still stands. However it is unrecognisable from its early glory and is thus almost as comprehensively 'lost' as if it had been razed to the ground.

The northern end of the building comprised three lodging-houses, originally Nos 1–3, The Colonnade, but later renumbered 3, 5 and 7, High Street. On the corner with Warwick Street there was a library (later No. 1 High Street), which became known as Colonnade House after the library closed about 1838.

Libraries in those days were not just places where books could be read or borrowed. They were also social institutions, where people went to gossip, play games, or listen to music.

Worthing already had one library in 1802, Stafford's Marine Library, located in Marine Place. This seems to have been rather cramped establishment, and in 1808 or 1809 Stafford – probably in response to the competition provided by Ogle's library – moved his premises to a brand-new building on the seafront, just east of where the entrance to the bus depot now is (see Section 7).

Mary Spooner

From 1803 until her death on 12 March 1825, the library in the Colonnade was run by Mrs Mary Spooner. By around 1806 it also housed the town's post office, which had started life at Stafford's Library, and the pseudonymous poet Paul Potion, author of *A Poetical Picture of Worthing and its Vicinity* (1814), celebrated this fact in his inimitable style:

> And mention too must here be made,
> That also at the *Colonnade;*
> The Worthing *Part Office* is seen,
> Which fronts the corner of the Steyne;
> A mail too, ev'ry day they boast,
> From east to west along the coast.

Paul Potion, whose name and a piece of verse quoted at the start of his book both imply that he was an apothecary, was probably John Shearsmith, who was a doctor in the town in the early part of the nineteenth century. In small towns such as Worthing doctors often also dispensed medicines and, in 1811, when Shearsmith was briefly in Horsham prison for debt, he was described by the *London Gazette* as a 'surgeon and apothecary'.

Whether or not John Shearsmith was also Paul Potion, Shearsmith himself writes of the Colonnade Library and Post Office in his 1824 book, *A Topographical Description of Worthing*:

> Of more recent erection than Warwick House, the Colonnade may be considered amongst the first public improvements of importance; in which is situated the Library

of the same name and the Post Office, both of which have been for a series of years most respectably conducted by Mrs. Spooner.

Attached to the Library is a Reading Room, to which the subscribers have access; and where is found every morning by eight o'clock, the daily papers, periodical publications, &c, at which hour also the letters are ready for delivery.

The Library comprises a large stock of books in the various departments of literature — the perusal of which is comprehended in the subscription, together with that of newspapers, &. The situation of this Library is beautiful, from its vicinity to Warwick House, and commanding from the Colonnade a full view of the Steyne and Sea. A magnificent display of jewellery, Tunbridge ware, &c. is exhibited in the Library for sale, or disposed of by that species of Lottery denominated Loo, in which Pam is of course a pre-eminent personage.

In the card game Loo the Jack of Clubs represented Pam, a medieval comic-erotic character in a play called *Pamphilus*, one of whose main characters is a manipulative old bawd who tricks a young woman into her house so that she can be seduced by an admirer. It is curious that Shearsmith should make this seemingly pointless reference to Pam. Although he has been careful to tell us that Mary Spooner ran the library 'most respectably', perhaps he is here implying that Mrs Spooner offered what might be euphemistically described as an introduction service. One of Worthing's other libraries had been run from 1809 until 1819 by John Mackoull, who was intermittently also a brothel-keeper; and in the 1817 edition of his book *A Sketch of Worthing* Mackoull expresses regret that Worthing's prostitutes have been run out of town by the local clergyman.

Certainly Mrs Spooner ran a wide range of different businesses from her library. At this time there was a national lottery run by the MP Thomas Bish, a colourful individual who later became the proprietor of Vauxhall pleasure gardens. In an advertisement in the *Sussex Weekly Advertiser* of 25 August 1811 – which names Mrs Spooner as the Worthing agent for his lottery, the other agents for Sussex and Hampshire being located in Brighton, Portsmouth and Whitchurch – Bish enthuses about his autumn draw:

> T. Bish is happy in acquainting the Public, that he has contracted with the Government for a small Lottery of only 13,500 Tickets, on such terms as enables him to sell Tickets and Shares considerably cheaper than for many years. Bish has been remarkably fortunate for several years in selling a vast number of Capital Prizes, which have been distributed by his Agents in this and the neighbouring Counties. As the Whole of this Lottery will be drawn on the 22nd October, no time should be lost, especially as there are only 13,500 Tickets.

It is again in the *Sussex Weekly Advertiser* that we learn of another of the business-like Mrs Spooner's roles, for the 21 March 1814 issue of the newspaper names her as the Worthing agent for the Globe Insurance Company. This firm, which was initially called the Globe Fire Office and had premises in Cornhill and Pall Mall, had been founded in 1803. By September the following year, the Globe Fire Office already had 140 so-called 'country agents' such as Mrs Spooner. In 1805 the second volume of David Hughson's *London: Being an Accurate History and Description of*

the British Metropolis and Its Neighbourhood helpfully summarised the nature of the Globe Fire Office's business:

> Proceeding eastwardly through Cornhill, the first object of attention is the Globe Fire Office, the establishment of which comprehends granting insurances against loss or damage by fire, insurances on lives and survivorships, the endowment of children, and immediate, deferred, and progressive annuities. The capital of this company is one million sterling. They insure houses fired by lightening.

The company merged with the Liverpool and London Fire and Life Insurance Company in 1864 to become the Liverpool and London and Globe Insurance Company, which then became a subsidiary of Royal Insurance in 1919.

After Mrs Spooner died, on 12 March 1825, a Mr Brewer took over the library for a few years, but, as we have seen, it closed about 1838. A new and particularly successful competitor library, Miss Carter's, had opened in 1812 at No. 12 Warwick Street, which today – renumbered No. 25 – houses the Warwick Arms. In the early 1830s Carter's Library moved across the street, possibly to Stanford's Cottage, now Pizza Express, but the evidence is contradictory. Either way, the library Miss Carter had founded was, under successive owners, Worthing's main library until the start of the twentieth century.

The Fire of 1888

In view of the fact that Mrs Spooner was an agent for the Globe Fire Office, there is a certain irony in the fact that the Colonnade building was all but destroyed by a major fire six decades after she died. The damage was as bad as it was largely owing to the incompetence of the local fire brigade, as is made clear in a report in the 14 January issue of the *Worthing Intelligencer*, quoted verbatim in Henfrey Smail's 1952 book *Warwick House*.

The fire, which occurred on 10 January 1888, began at No. 3, which had recently become a day and boarding school for young ladies run by Miss Dorey. Police Sergeant Byrne was passing the building just before two o'clock in the morning when he saw a bright light from the fanlight above the front door. He then spotted three girls on the balcony, who called out that the staircase was on fire and they were trapped. Byrne aroused the occupants of No. 5 and was able to evacuate the girls along the balcony that ran continuously along all the Colonnade houses.

A fire engine arrived soon afterwards, but there were no firemen, nor had anyone thought to bring a hose. So a painter called Charles Bridger rushed off to the fire station and with the help of others brought back the heavy hose. Some firemen finally arrived, but then spent a long time pushing the fire engine from one position to another, causing lengthy further delay. A group of people then went to the fire station to collect the second fire engine, which was quickly stationed in Ann Street, from where water was directed at the back of the building. Finally the first fire engine was also ready for use, but the hose turned out to be full of holes, and it took some time before an effective stream of water could be directed at the flames.

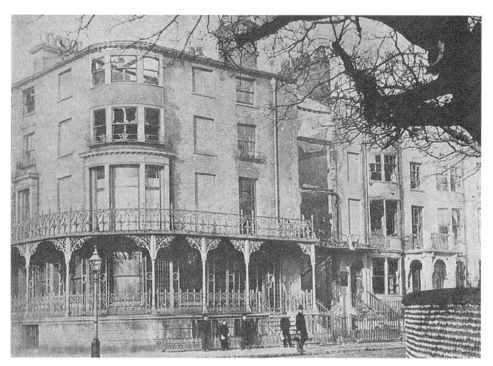

The Colonnade after the fire of 10 January 1888.

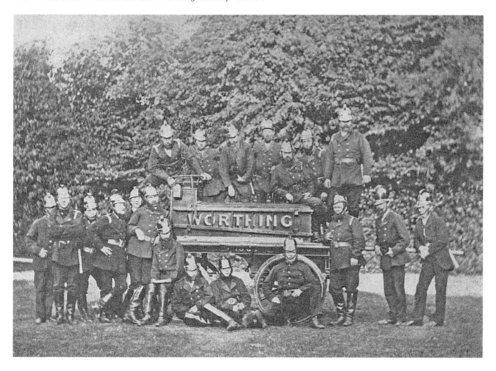

Worthing Fire Brigade, around 1894.

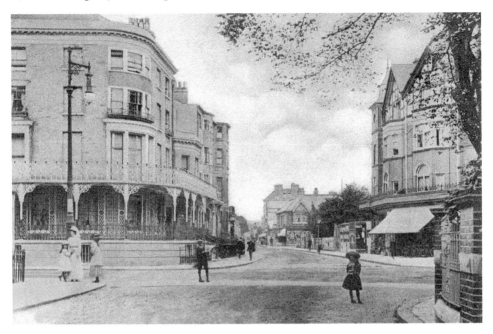

This view up High Street, with the Colonnade on the left, dates from around 1904.

By six o'clock, however, the fire was finally under control. No. 3, where the fire had started, was completely destroyed, and Nos 1 and 5 suffered major damage. No. 7, at the northern end of the Colonnade, escaped unscathed. Amazingly, however, the basic structure was strong enough for Nos 1–5 to be rebuilt, a tribute to the architects and builders of some eighty-five years earlier, although No. 3 was not restored to its original height.

As the photographs of 1904 and 1902 on this and the previous page show, the cast-iron colonnade that gave the building its name was retained, but sadly this was removed in 1936 when the building underwent a further restructuring.

The photograph on the facing page is a similar view to the photograph above, but dates from about twenty years earlier. The wall on the right of the picture was the westerly boundary of the grounds of Warwick House.

SECTION 26

The High Street

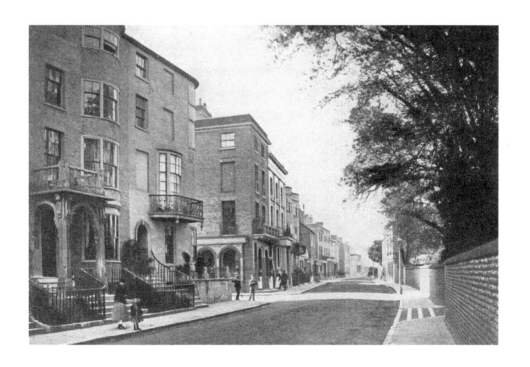

A stranger who drives into modern Worthing by way of High Street is likely to say to himself 'This isn't up to much' – unaware that the street was once the most interesting and architecturally diverse street in Worthing, and indeed the most important street in the town. High Street also had some of the town's earliest buildings, with some of the houses dating back to the sixteenth century.

As late as the end of the eighteenth century, Worthing was still no more than a straggling hamlet, its houses, farms and orchards scattered around what was known as Worthing Street. The northern part of the street ran where North Street and High Street now are. The street then divided at the north-west corner of Steyne Gardens, with West Lane following the line of Warwick Street and South Street to the seafront, while East Lane continued for a couple of hundred yards, before it too turned sharply down to the sea opposite modern-day St George's Road. In addition, there was Cross Lane – now Montague Street – which ran west from near the southern end of West Lane.

Although the *coup de grâce* was delivered to the High Street when much of the lower half of the west side – along with Market Street and the north side of Ann Street – was flattened at the end of the sixties to make way for the Guildbourne Centre and its car park, many of the street's old houses had already been demolished during the previous half-century and more. Now almost nothing is left.

We generally think of a High Street as the principal shopping street of a town, but 'high' simply means 'main', and not all high streets were principally commercial. The buildings in Worthing's High Street served a wide range of uses. There were shops and businesses, certainly, but much of the street was residential, and some of the early town's finest houses were to be found there.

Although almost all the old buildings that used to stand in Worthing's High Street are gone, they have been painstakingly researched and recorded by Worthing historians Mike Standing and the late Ron Kerridge, much of whose material was published in their indispensable book, *Worthing: From Saxon Settlement to Seaside Town* (2000). There is a yet more detailed analysis of the old High Street at www. oldworthingstreet.com, which incorporates further research from when Kerridge and Standing were writing their book, together with fresh research done in collaboration with Barrie Keech. This website, as detailed and comprehensive an account of a historic street as can exist of any street in England, is full of fascinating information, photographs and maps.

The 'picture gallery' that follows should therefore in part be regarded as an appetiser for the Old Worthing Street website, from which, indeed, almost all the information in the captions derives.

The numbering used here for the High Street buildings is the 'modem' numbering that has been in place since 1881. This applies even where an earlier period or earlier buildings are being referred to.

Not a single old building on the west side of the street survives today, with the exception of the Colonnade terrace, between Ann Street and Warwick Street. The 'west side gallery' therefore represents an almost complete pictorial record of the buildings that occupied that side of the street until less than a hundred years ago. On the east side of High Street there are a few melancholy remnants.

WEST SIDE OF HIGH STREET, NORTH TO SOUTH

These modest buildings at the northern end of the west side of High Street were built on the site of two cottages, Nos 61 and 59 High Street, which dated from 1821. On the left of this photograph are the four houses of Campion Terrace (1889), which was never allocated a High Street number. The three-storey house is Campion House, No. 59 High Street (1890). To its north are two-storey No. 59a (1896) and single-storey No. 59b (1904). This photograph was taken in 1986 just prior to the demolition of these buildings. Pharos House and its car park now occupy the site, on the south-west corner of the Waitrose roundabout.

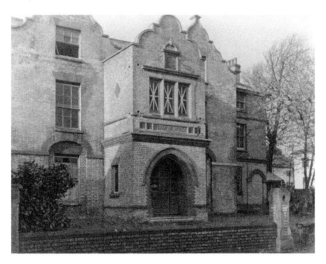

Thurloe House, No. 45 High Street, built between 1793 and 1814, stood just south of Union Place and was the first significant house on the west side of High Street. The only building of any interest that occupied the 'utility land' between it and Campion Terrace was a small cottage, No. 49 High Street, which stood from 1838 until 1986, a few yards north of Union Place. From 1922 onwards Thurloe House served as Worthing's police station, and then – from 1939 until its demolition around 1959 – as an annex to the new police station built behind it. This photograph dates from 1955. (© www.westsussexpast.org.uk)

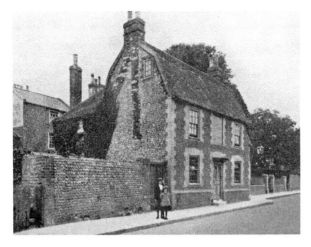

Thurloe Cottage, No. 43 High Street, which was built before 1782 and demolished around 1959. The garden in front of Thurloe House can be seen on the right of the photograph.

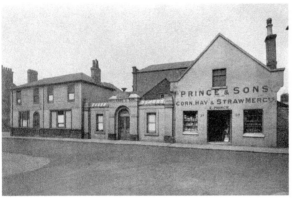

When this photograph was taken in the 1930s, No. 37 (right of picture) was the premises of Prince & Sons, Corn, Hay and Straw Merchants and Nos 35–33 (centre and left) of Hollands & Son, printers and bookbinders.

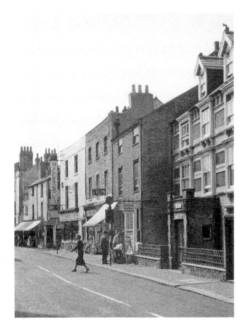

This photograph is of the section of the west side of High Street from Chatsworth Road to just south of the entrance to Market Street, which can be seen near the left side of the photograph by a sign reading 'Miller's for Cycles'. At the time this photograph was taken in 1963, the premises seen here were (right to left): a substantial house called Imrie (No. 29), which stood at the junction of High Street and Chatsworth Road; R. H. Silvester & Son, furniture removers (No. 27); E. C. Francis, confectioner (No. 27a); Evelyn, ladies' hairdresser (No. 25); J. H. Miller, bicycle retailer (Nos 23–21, the white building just north of Market Street); and, immediately the other side of Market Street, D. Whelan, confectioner (No. 19), Laine Electric (No. 19a), and Joseph E. Langdell, fruiterer (No. 17). (© www.westsussexpast.org.uk)

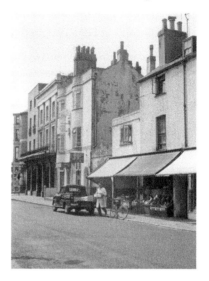

This photograph, which starts where the previous one ends, shows Nos 17–9 High Street, the section between Market Street, which is just out of sight to the right, and Ann Street. The corner of the Colonnade terrace, the other side of Ann Street, is just visible at far left. At the time this photograph was taken in 1963 the premises seen here were (right to left): Joseph E. Langdell, fruiterer (No. 17); a single-storey warehouse used by Potter & Bailey & Co. (No. 15, almost invisible); St. Anne's café (No. 13, a handsome Regency building dating from around 1820); and Potter, Bailey & Co.'s shop (Nos 11–9). (© www.westsussexpast.org.uk)

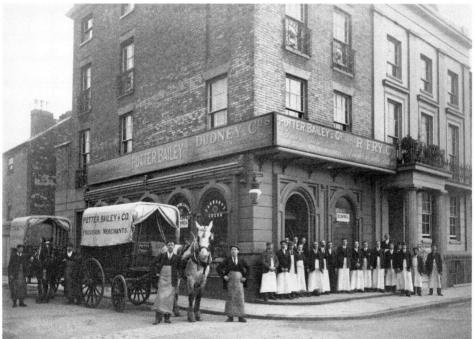

Potter Bailey & Co.'s flagship grocery shop at Nos 11–9 High Street in the 1890s. The fascia on the Ann Street side of the shop includes, as well as the firm's own name, 'Dudney & Co's Celebrated South Down Ales and Stout'; and the fascia on the High Street side includes 'R. Fry & Co's Brighton Table Waters'. Presumably these businesses paid to be featured. Note also the absence of any female employees, as also in the photograph of the workforce of rival grocers Ivens & Kellett on page 162. No. 11 High Street was built in 1808 for John Shearsmith, a doctor in the town and the author of *A Topographical Description of Worthing* (1824); but he seems to have over-reached himself, for he owned it for only a year. Indeed, in 1811, as we saw in Section 25, he was briefly in prison for debt. (© www.westsussexpast.org.uk)

EAST SIDE OF HIGH STREET, NORTH TO SOUTH

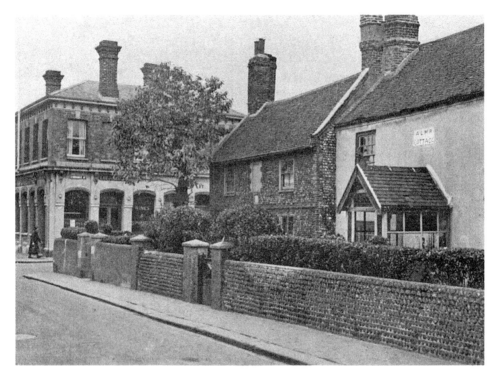

The public house on the left of this photograph, No. 80 High Street, gives us our bearings, since it still stands. Today it is called the Corner House, but it was formerly known as the Stage, the Jack Horner and, for most of its existence, the Anchor. The current building, which dates from around 1895, replaced an eighteenth-century inn. Lyndhurst Road joins High Street at centre-left. On the right are Nos 78 and 76 High Street. From around 1854 onwards, No. 76 was known as Alma Cottage. There was a house on this site from 1551, but the building seen here is a restructuring of 1686. Alma Cottage was badly damaged by fire in 1946 and demolished in 1948. The line of the front of these two houses is today the line of the front edge of the wide pavement in front of Waitrose. Where the front wall of No. 78 used to stand is now under the tarmac of the roundabout.

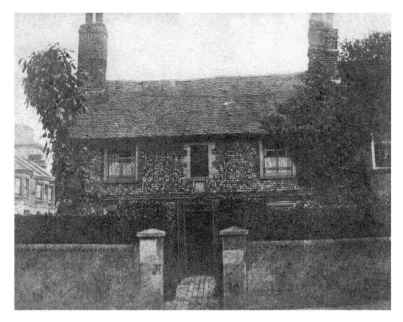

No. 78 High Street, erected in 1762, was demolished in 1960 when the entrance to Lyndhurst Road was widened. The houses seen on the left of this 1902 photograph are on the north side of Lyndhurst Road. (© www.westsussexpast.org.uk)

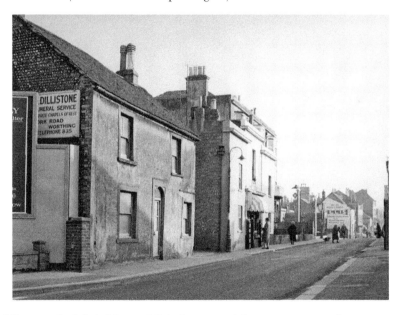

The building on the left is No. 74 High Street, used from 1954 onwards as a store by the builders J. Dittistone Ltd, who had occupied the yard behind it and an outbuilding numbered 72 High Street since 1923. The sign on the wall advertises the firm's funeral business in York Road, today located in South Farm Road. In the centre of the photograph are Nos 70–66 High Street, which was occupied at the time of this 1964 photograph by R. J. Blossett's bookshop. All these buildings were demolished in the early 1970s. (© www.westsussexpast.org.uk)

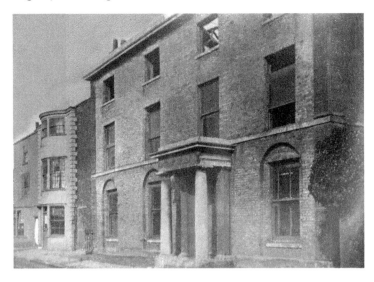

This fine house, No. 38 High Street, was built by 1800, and from 1801 until 1828 was the home and surgery of Michael Morrah, the town's leading doctor at that time. Later, between 1846 and 1887, it was Warwick Hall School. This photograph was taken in 1902. Charlecote Road did not yet exist at that time, but was about to be laid out between Nos 38 and 40 High Street, the bow-windowed house to the left, which is today the Orchard Café. The café is the most southerly of a precious group of four old High Street buildings that survive, the others being Nos 46, 44 and 42. (© www.westsussexpast.org.uk)

Dr Morrah's old house was demolished around 1902 and Worthing's Central Fire Station opened on the site in 1904. This closed in 1961 and the building was then a tyre-fitting business for a few years, before being demolished in 1969. Today Crown House, a typically hideous slab of early 1970s architecture, occupies the site of Nos 38–32 High Street. On the left of the photograph can be seen the corner of the Toby Jug, today the Orchard Café. (© www.westsussexpast.org.uk)

The corner of the fire station on the left of this picture gives us our bearings. No. 36 High Street, the two-storey house in the centre of the photograph, was a dairy from 1904 until the early 1960s. The four-storey building to the right is No. 34 High Street, which was converted into flats in the 1920s. In this 1963 photograph, a sign in the window of No. 36 indicates that it and No. 34, 'these valuable business premises', have recently been sold by Jordan & Cook. Both buildings were demolished in the 1960s. These are the final 'lost buildings' that abutted the eastern side of High Street, since the two-storey and the three-storey buildings on the right of this photograph, Nos 30 and 28, still stand today; and all the buildings south of these were built in the twentieth century on the former grounds of Warwick House. (© www.westsussexpast.org.uk)

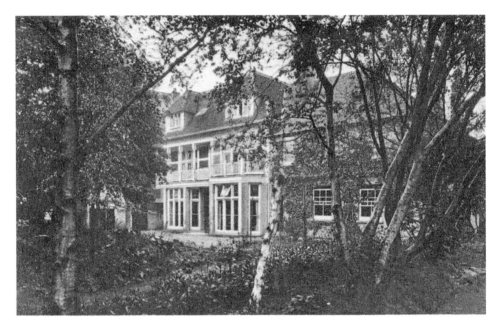

No. 32 High Street, the final 'lost building' with a High Street address, did not have a frontage onto the street, being hidden away behind Nos 36–34. The original house on the site dated back to the first half of the eighteenth century, but was restructured or rebuilt around 1850 and became known as Worthing Cottage and then, from around 1888, as Charlecote (hence Charlecote Road). In 1918 it was acquired by the Girls' Friendly Society, an organisation dedicated to helping and supporting unmarried mothers and other women who had fallen short of the ideal of 'virtuous Christian maidenhood'. By the early 1930s, when this photograph was taken, the house had been extended onto part of the old orchard to the east of the house and was known as the Orchard House GFS Home of Rest. It remained in the ownership of the GFS until it was demolished in 1969.

SECTION 27

COOK'S ROW & MARKET STREET

For most of the nineteenth and twentieth centuries, a relatively modest but historically interesting street called Market Street ran between Chapel Road and High Street, one block north of and parallel to Ann Street. A further block north there was, until the end of the nineteenth century, an even more humble street, really no more than a lane, called Cook's Row. These two streets are the subject of this section. We begin with the latter.

Cook's Row

Most surviving photographs of Worthing from a century or more ago depict areas of the town of which its citizens could feel proud. This can give the misleading impression that the whole town was salubrious and all its buildings handsome. In reality there were some very deprived areas in Worthing in those days. The closest of these to the heart of the town was Cook's Row, which was where Chatsworth Road now is – or, more or less, for while the western end of Cook's Row exactly followed the line of present-day Chatsworth Road, its eastern end was more complicated.

The view, below, of Cook's Row looking west from the High Street shows that the building at the end prevented the eastern half of Cook's Row continuing in a straight line into the western half, which led into Chapel Road. The far end of Cook's Row was reached by following the lane round to the right and then doing a U-turn past the Cannon Brewery, which is out of sight just to the right of the picture. The photograph, on the facing page, of the Cannon Brewery (the front of which stood at an angle to Cook's Row) was taken from about halfway along modern Chatsworth Road, with the photographer facing north-east.

During the first few decades of the nineteenth century, the quirkiest little building in Cook's Row was the so-called Black Hole, which served as the town's lock-up, where vagrants and wrong-doers were imprisoned. When, in 1815, a generous resident presented the town with its first fire engine, this was kept alongside the vagrants in the Black Hole, which thereafter had the grand title 'The Black Hole and Engine House'. However the Black Hole served these joint purposes for only twenty years. After Worthing's first Town Hall opened at the top of South Street in 1835,

Cook's Row in 1894, looking west from High Street.

The Cannon Brewery, on the north side of Cook's Row.

Worthing's prisoners and its fire engine were accommodated in the lower part of the new building.

By the end of the century this dilapidated little street was becoming an embarrassment to the town, and in 1894 the decision was taken to demolish nine of the houses in Cook's Row. These were the houses on the left of the first picture, which appear on the Ordnance Survey map of 1879, but are absent from the 1896 map.

After these houses had been demolished, the central section was reconfigured so that the street ran more directly to Chapel Road, although there still had to be a minor jink in the middle of the street to go past the building at the end of the picture on page 180. This jink was now left and then right – not right and then left, as had been the case with the earlier and more major jink. These jinks were of course removed when Chatsworth Road was laid out a few years later.

Meanwhile, the brewery – also demolished in 1894 – was rebuilt as the Cannon Inn. This time the building faced due south. The Cannon Inn later became a café, which closed in 1935, and in 1949 the building was bought by the *Worthing Gazette*, before being demolished twenty-five years later to make way for the present offices of the *Worthing Herald*.

Alfred Cortis

The 5 September 1894 issue of the *Worthing Gazette* includes a report of the meeting of the town council at which the decision was taken to demolish the nine houses on the south side of Cook's Row.

It was Alderman Alfred Cortis, Chairman of the Sanitary Committee (who in 1890–91 had been the first mayor of Worthing), who moved that the houses in Cook's Row be condemned and demolished. There was immediate approval from those present, but this was followed by a spat between Cortis and Councillor Captain A. B. S. Fraser, which was reported in detail in the *Gazette*.

Alfred Cortis, Worthing's first mayor and a generous benefactor to the town. (© www.westsussexpast.org.uk)

Alderman Cortis started to read a passage of legalese, whereupon Councillor Fraser impatiently interrupted him, saying, 'I will second the proposition.'

'I know you can be very rude,' said Cortis.

'So can you!'

'I think that is rude,' Cortis said to the mayor. 'I don't know what you think?'

'I think it is, rather,' replied the mayor.

Cortis pointed out that he was 'simply giving information for the benefit of those who are not so well informed', to which Fraser retorted that he had seconded the proposition so that it might be put to the vote.

'I know Councillor Captain Fraser is ready to vote at any moment,' said Cortis.

'Not for you!' said Fraser, and thereupon refused to second the motion after all, so Alderman Frederick Caesar Linfield (who was to be the mayor in 1906–08) 'undertook that duty', and the motion was duly carried.

The unexpectedly interesting life and background of Captain Fraser (mayor in 1896–98) is documented in my book *Oscar Wilde's Scandalous Summer* (Fraser met Wilde at the so-called Venetian Fête held in the town that year), so here we will focus on Alfred Cortis, who was one of Worthing's most distinguished citizens and most generous benefactors at the end of the nineteenth and start of the twentieth century.

He was born in 1833, the son of George Cortis, who had a butcher's shop in South Street, next to the Nelson Inn. Alfred, however, chose a different trade, and by 1861 – twenty-seven years old, and still living with his parents at Nelson House in South Street – he was a corn and coal merchant. At that time his elder brother George was a butcher, like his father, and had his own shop at No. 8 Warwick Street.

Within ten years, George Jr had abandoned butchery and joined his brother in the corn business. At this point they were both living under the paternal roof, which by

now was in Park Crescent. George Snr, whose wife had died in 1864, was retired. The brothers are described only as corn merchants – there is now no mention of coal.

George Jr married in 1873, and in 1881 he and his wife Eliza were living in Thomas and Ann Champion's lodging house in Crescent Road. The entry for George's occupation in that year initially read 'corn and coal merchant', but someone has subsequently put a line through 'and coal'. Strangely, the coal merchant occupation later returned (perhaps George and Alfred at some point divided up the business) and in the 1891 and 1901 censuses George is listed only with that occupation, and living at Sion House in Shelley Road. Then, in 1911, aged eighty-one and still at Sion House, he is, puzzlingly, once again a corn merchant.

George's first wife had died in 1888, and he had remarried in 1889, but he does not appear to have had any children by either wife. He died in 1917. His brother Alfred remained single all his life. He seemed, in effect, to be married to the municipality. The 1881 census is the first that shows him with his own household. He is living in Liverpool Gardens with his eighty-one-year-old widowed aunt, Emily Fuller. In that and all subsequent censuses, Alfred is shown as a corn (or corn and seed) merchant, so coal seems to have entirely disappeared from his life by then. In 1891 and 1901, he is living at Liverpool House, No. 34 Liverpool Road, but for some reason the 1911 census finds him staying at the Thackeray Hotel in Great Russell Street, London, a large temperance hotel situated opposite the British Museum. However, it was in Worthing that he died the following year, collapsing into his chair and dying instantly at yet another council meeting. He was seventy-nine.

One of Cortis's many contributions to the town was during the typhoid epidemic of 1893. The *West Sussex Gazette* of 24 August reports the discovery of a new supply of water at Broadwater, thanks to the efforts of the 'worthy Alderman' Alfred Cortis who conducted the search at his own expense, and 'energetically acted while his colleagues were talking at endless meetings'. The paper added that gangs of workmen were already laying a new water main from the Upper High Street through the fields to Broadwater.

The Summer 2011 issue of the *Broadsheet*, the newsletter of the Friends of Broadwater and Worthing Cemetery, includes some interesting information about Cortis's non-municipal enthusiasms. He served for many years in the 2nd Volunteer Battalion of the Royal Sussex regiment; and by the early 1870s he had the rank of captain. An expert shot, he won numerous shooting competitions and was selected to represent Great Britain for a record twenty-one consecutive years. In 1872 and 1886 he won the silver medal in the competition for the Queen's Prize of the National Rifle Association. Today this event is held at Bisley, but this applied from 1890 onwards, and Cortis's successes were at Wimbledon. (The Silver Medal, incidentally, is not a 'runner-up' award, but is given to the winner of the second stage of the competition, the gold medal going to the winner of the third and final stage.)

Cortis's contribution to Worthing did not end with his death. In 1912 the *Lancet* reported that a debt of over £1,400 in connection with the new out-patients' department at Worthing Hospital had been 'liquidated' by a legacy of £2,000 from Cortis's estate. Even more importantly, Cortis left £5,000 – anonymously, though the identity of the legatee in due course became known – for a new museum and art gallery, which was duly erected at a cost of £4,130, and still stands today.

Market Street

Market Street was laid out at around the same time that the covered market that gave it its name was built. The market, which opened in July 1810, had one entrance on the south side of Market Street and one on the north side of Ann Street. John Mackoull, writing in 1813, describes the market house as 'a handsome, clean, well-built place, exceeding well regulated'. Eggs, butter, fruit and vegetables are 'always in abundance' but, although 'every encouragement is given to keep up the regular supplies of fish, flesh, and fowl', 'it frequently happens from some unknown cause that fish is enormously dear'. The market gradually declined, however, owing partly to mismanagement and partly to the fact that the increasing number of small independent shops in the town took away its business; and by the 1850s few of the stalls were occupied. In 1863 it became a storage yard for Snewin's the builders, and this remained the case until it was demolished over a century later.

Although Market Street was always partly residential – in the early nineteenth century there were a number of small cottages and tenements there – much of the street was initially occupied by stabling, and remained rural in character. The premises of the town's principal dairyman, James Bassett, were located near the High Street end. Most of the milk he sold came from a farm at Broadwater, but he also kept two cows at the back of his building.

With the coming of the railway to Worthing in 1845 there was need for less stabling, and the character of Market Street changed. By 1851 the street had three bootmakers, two blacksmiths, two grocers, an ironmonger, a coach-smith, a tailor, a furniture broker, and a cabinet maker and upholsterer. In those days businesses were often carried on in premises that by today's standards were tiny. The grocers' shops, for example, would have occupied no more than the space of a couple of small rooms.

Market Street had two inns, both on the north side. One, located near the Chapel Road end, was originally called the Volunteer Inn, and later became the Dragoon. The other was the Royal George, one of Worthing's most important early inns. This was on the corner with George Street, a short street that ran between Market Street and Chatsworth Road. From 1812 until Worthing's first Town Hall opened in 1835, the town commissioners met at the Royal George, and the weekly corn market was also held there.

Something of the character of Market Street in its last years can be gauged from the 1964 edition of *Kelly's Directory of Worthing*. As had always been the case, the street was about half residential and half occupied by business premises. The businesses on the north side, starting at the Chapel Road end, were the Dragoon Hotel, the Rodney Press (printers), R. F. & E. M. Teasdale (woodworkers), the Royal George pub and Alneeds (china dealers). The businesses on the south side were a coffee house called the Continental Twist Bar, R. Moseley (antique dealer), A. A. Smith (saw sharpener), Superlamp Ltd (electrical wholesalers), Ernest Moulton (antique dealer) and W. D. Craven (bookbinder).

It was a charming and vibrant little street, with its craftsmen and artisans, its antique and china shops, and its two old pubs. Nonetheless, as Worthing grew and the needs of the motorist became pre-eminent, the decision was taken to demolish Market Street, the south side of Chatsworth Road, the north side of

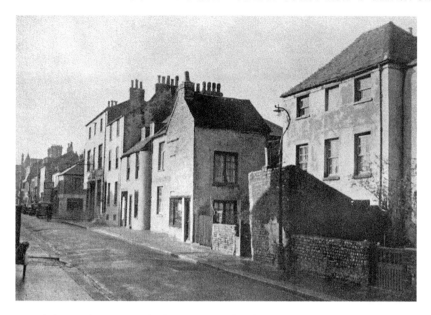

This view of the High Street end of the north side of Market Street dates from earlier than 1937, for the cottage in the centre and the house on the right were demolished in that year. The final three-storey building near the left of the photograph is the Royal George. The mid-1960s photograph on the title page of this section is another view of the north side, with the Royal George prominent, and George Street to its west. (By courtesy of the David Nicholls Collection, www.worthingoldphotos.co.uk)

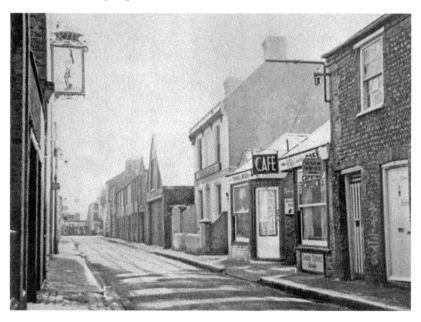

A view of the Chapel Road end of the south side of Market Street, looking east towards High Street. The sign for the Dragoon Hotel is visible on the left. (By courtesy of the David Nicholls Collection, www.worthingoldphotos.co.uk)

The shop of the bookbinder and bookseller W. D. Craven, on the south side of Market Street, near the High Street end. (© www.westsussexpast.org.uk)

Ann Street and much of the High Street to make way for the Guildbourne car park, office block and shopping precinct that now occupy the site. This terrible act of civic vandalism, which obliterated the heart of the nineteenth-century town, took place in 1968–69. Today, just a few sad yards of Market Street survive at the Chapel Road end.

SECTION 28

ANN STREET & THE OLD THEATRE

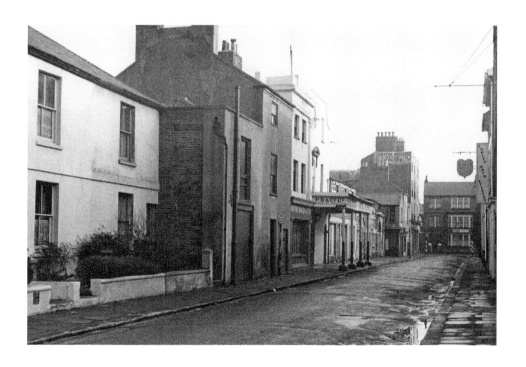

In the early the nineteenth century, Ann Street was second only to High Street as the most important street in Worthing. Its most notable buildings were on the north side, now buried under the Guildbourne Centre. The photographs reproduced in this section show how much was lost that was worthy of preservation, and indeed demonstrate that the north side was more varied and interesting than the humbler south side that survives.

Five historic buildings were located on the north side of Ann Street. The most easterly was the covered market, which ran through to Market Street and operated as a market from 1810 until 1869. To the west of the market entrance, set back from the street behind a tiny garden, was a 'cottage orné'. This charming one-storey house, which later became known as Omega Cottage, was built by the actor-manager and entrepreneur Thomas Trotter, and was later the residence of Edward Snewin, who occupied the old market as a builder's yard from 1869 and whose reminiscences of early Worthing were published in *Glimpses of Old Worthing* (1945). Next was the old theatre, where plays were performed between 1807 and 1855. Immediately to the west of the theatre was Worthing's first dispensary, which opened in 1829 and remained there until it moved to larger premises in Chapel Road in 1846, its role being to provide basic medical care for people too poor to afford doctors' fees. Finally, the town's police station was located on the north side of Ann Street from 1858 to 1922.

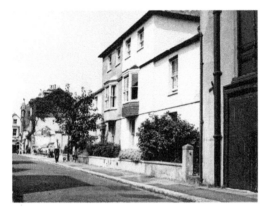

This photograph, the first in a sequence showing the north side of Ann Street before its demolition at the end of the 1960s, is of the western end of the street, looking west towards Chapel Road. The three-storey house in the foreground, with bay windows on the second floor, will serve as a 'locator' in the next three photographs. (© www.westsussexpast.org.uk)

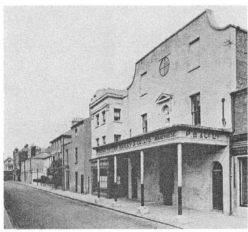

The view west along Ann Street from Potter, Bailey & Co.'s warehouse, which from 1807 until 1855 was Worthing's first theatre. The building just to the west of the old theatre was the town dispensary between 1829 and 1846. The 'locator house' can be seen at the start of the final quarter of the photograph.

The north side of the Chapel Road end of Ann Street, looking east. Just beyond the three-storey house covered with creepers is the site of the old police station, but this building had been demolished by the time this photograph was taken. The 'locator house' can be seen right of centre, and the entrance to the old theatre, now Potter Bailey & Co.'s warehouse, near the right of the photograph. (© www.westsussexpast.org.uk)

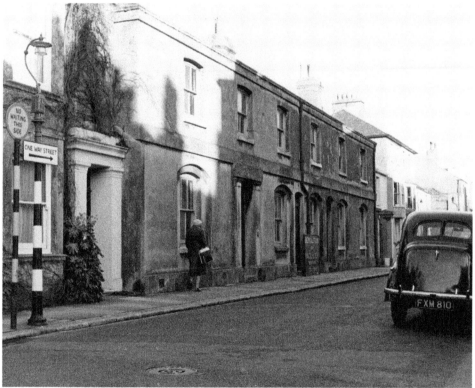

This view is just to the west of the 'locator house', whose top storey is whitened by bright sunlight. Most of the photograph is occupied by the building missing from the previous photograph, which served as Worthing's police station from 1858 until 1922. The photograph on the title page of this section belongs next in the sequence, the eastern end of the two-storey white house on the left of the photograph being exactly halfway along Ann Street. The old theatre is just right of centre, and a building on the east side of High Street can be seen on the far right of the photograph. (Both photographs © www. westsussexpast.org.uk)

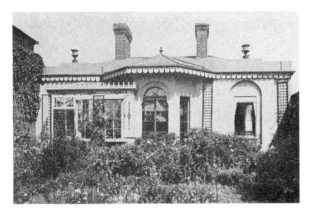

This 'cottage orné' – later known as Omega Cottage – was built for his own occupation by the actor-manager Thomas Trotter in 1807. It was set back from Ann Street behind the charming little garden seen here, but for the last few decades of its existence was hidden from the street by a shop that was built on the front of the garden by the antique dealer Arthur Godden in the 1920s.

The High Street end of Ann Street. On the left is the entrance to the old covered market, which had been the premises of Snewin & Co. since 1869. Near the right of the picture, on the corner with High Street, is the grocer's shop of Potter, Bailey & Co. at Nos 9–11 High Street. The firm had four other groceries and an ironmonger in Worthing, and groceries in Tarring, Durrington and Lancing. (By courtesy of the David Nicholls Collection, www.worthingoldphotos.co.uk)

The Old Theatre

Worthing's first theatre was described by Ian Nairn and Nikolaus Pevsner in their 1965 book on the buildings of Sussex as 'the most endearing of Worthing's old buildings' and 'a very precious survival'. Sadly, it was not regarded as precious by Worthing's town planners and was bulldozed into oblivion less than five years later.

The history of the old theatre was exhaustively documented by Mary Theresa Odell in three books, *The Old Theatre, Worthing, 1807–1855* (1938), *More About the Old Theatre, Worthing* (1945) and *Some Playbills of the Old Theatre, Worthing* (1953). Most of the information that follows derives from these books.

The first theatrical performances in Worthing had been held by Thomas Trotter's company (Trotter's life is documented in Section 17) in a barn at the top of High Street in the summer of 1802, and these continued until the permanent theatre was built in 1807. There was a three-month season, from August to October, and plays were performed on Monday, Wednesday and Friday. Trotter himself played most of the main comedy parts, but he had an accomplished company.

These productions were well received and, in June the following year, thirty-four residents signed a petition advocating the construction of a permanent theatre. This

list is a roll call of the famous names of early Worthing, with Edward Ogle's name, needless to say, heading the list. Other names included Mary Spooner, his librarian at the Colonnade (see Section 25); Susan Bloss, who kept a boarding house in Bedford Row; Michael Morrah, the town's principal doctor; John Wicks, proprietor of Wicks's Royal Baths (see Section 14); and Edward Stanford, owner of the cottage where Jane Austen stayed in 1805 (see Section 29).

Ogle financed the building of the theatre on land that he owned on the north side of Ann Street. The theatre's first season was a great success, and in February 1808 Ogle sold the building and the land adjoining it to Trotter. The theatre was initially referred to as 'New Theatre, Worthing', but it soon became just 'The Theatre'. Then, from 1813 or 1814 onwards, it was known as 'The Theatre Royal', the name it retained until it closed four decades later.

Although the outside of the theatre, as the photograph at the bottom of page 188 demonstrates, was fairly simple, the inside was ornate and richly decorated. The interior was in a horseshoe shape. There was a dress circle, with three tiers of seats, boxes, and a gallery. There were no stalls, but instead a pit. Round the boxes there were seven large glass chandeliers, lit with wax candles. Elsewhere the theatre was illuminated by oil lamps. There was a scenery store, with a wardrobe room above it, and behind the stage were comfortable dressing rooms with large fireplaces.

In the early days, the doors opened at six o'clock, and the performance began at seven, ending at eleven or later. Throughout the theatre's life, as in other similar theatres, playgoers enjoyed not just a single play but a long evening of entertainment. The programme on the opening night, 7 July 1807, was relatively modest, however, consisting of a double bill of Shakespeare's *The Merchant of Venice* and Thomas Morton's comic play with songs, *Children in the Wood*. One of the performers that night was William Oxberry, who went on to become a celebrated actor on the London stage and also wrote a number of books about

William Oxberry (1784–1824), who played
Launcelot Gobbo in *The Merchant of Venice* on
the opening night of the old Worthing theatre,
7 July 1807.

the theatre. His speciality was comic roles. In *The Merchant of Venice* he played Shylock's servant Launcelot Gobbo, and in *Children in the Wood* he took the part of a drunken servant called Gabriel.

In those days, the long evening of diverse entertainment was often sponsored by local or national dignitaries. On the evening of 18 July 1816, for example, the performances were 'by desire and under the patronage of the Right Honourable Lady Anne Chad', the wife of Sir Charles Chad and daughter of the 2nd Earl Winterton. At the top of the advertisement the following rather verbose announcement from the proprietor appeared, welcoming his potential patrons to the opening night of the tenth season:

> Mr Trotter most respectfully announces to the nobility and gentry visitants to Worthing and its vicinity, the inhabitants, and the public in general that the performances will commence on Thursday next, July 18th, 1816. And during the season the most expensive and attractive novelties will be produced, aided by a company of the first provincial celebrity, in addition to many of approved metropolitan talent, who have for many years been honoured with the approbation of the public visiting the Worthing Theatre.

On the opening night, the first play was George Colman's 'celebrated comedy of *The Poor Gentleman*', in which the leading roles were played by Trotter, Mr Cory of the Theatre Royal, Edinburgh and Mr Harley of the Theatre Royal, Drury Lane. After this there was a *pas seul* – a solo dance – by Mr Albin; a comic song called 'Manager Strutt and his Comical Family', sung by Mr Harley; and another dance, this time a *pas de deux*, in which Mr Albin was joined by Miss Flemming. The evening ended with another play by George Colman, a farce called *The Review, or the Wags of Windsor*, in which the busy Mr Harley took the leading role. Trotter did not appear this time, but Mrs Trotter played the part of Grace Gaylove.

John Harley (1786–1858) was one of many famous actors of the first half of the nineteenth century who appeared at the old theatre in Worthing. Known as 'Fat Jack' on account of the fact that he was exceptionally thin, he was highly regarded for his comic acting and his singing of humorous songs. In 1816, he was thirty years old and had recently graduated from the provincial theatre to the London stage, on which he had made his debut in July that year.

Thomas Trotter retired in 1824, although he retained ownership of the building, and for the final three decades of its existence a number of different managers tried to make a success of the Worthing theatre, with mixed results. The 1833 season, for instance, was a disaster, with a newspaper report – Odell does not give its source – casting doubt even on the theatre's ability to continue in business: 'We have not been able to gather any information as to the future of the Worthing Theatre. But this much we can affirm, that a repetition of such proceedings and mismanagement as has been disclosed of late would never be tolerated again.'

The report adds the surprising information that the patrons of the theatre primarily consisted of visitors from London, with the result that it was essential that a system was in place that 'provided talent and respectability combined with regularity and good taste'. In 1834 the theatre did not open at all, and from 1837 onwards it was let on a year-by-year basis.

By the 1850s the decline was terminal. In September 1853, the following newspaper report appeared (again Odell does not give its source):

The manager has gone on struggling through the past month against houses that can have barely supplied the needful [that is, covered running costs]; and as stage heroes and princesses cannot always live on the atmosphere of their own greatness, but must sometimes condescend to feed like plebeian folk, the ill success of their exertions is to be regretted – the more especially as there are really painstaking artistes among them ...The usual convulsive struggles to prolong existence – such as 'Fashionable Nights!', 'Grand Attractions!', 'Half Prices!' – have run their course; and the announcement has gone forth of positively the last week but two. If the Worthing people desire to atone for their apathy in the beginning of the season, now is the time to relieve their conscience of the load.

The 1855 season was to be the theatre's last. At one performance in August 1855 there were apparently fewer than thirty people in the audience. In the pit there were

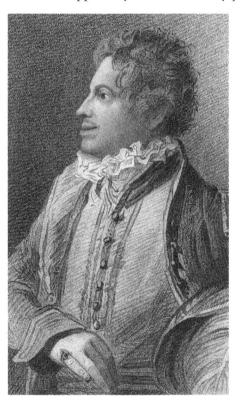

Above left: John Harley (1786–1858) in the role of Lissardo in Susanna Centlivre's play, *The Wonder* (1818). Two years earlier, on 18 July 1816, Harley appeared at the Worthing theatre in a double bill of two plays by George Colman. Portrait by Henry Richard Cook, after Thomas Charles Wageman. (© National Portrait Gallery, London)

Above right: A Theatre Royal playbill from 29 September 1823.

three fishermen, together with a girl fast asleep on one of the benches; in the upper boxes there were three gentlemen; in the lower boxes there was no one at all. The main component of the audience was about twenty 'lively lads' making a great deal of noise in the gallery.

At the start of December, Henry Nye Chart, who had taken control of the Theatre Royal in Brighton the previous year, brought his company over to Worthing, but there was little interest. When the curtain fell at the end of the performance on 6 December it was, as Odell puts it, 'never to rise again'.

A valedictory article in the *Worthing Record* on 22 March 1856 provides a partial explanation for the theatre's decline, reminding us that when it opened Worthing was 'rising into celebrity as a fashionable summer resort, and theatrical entertainments were in fashion' and 'the periodical visitants' to the town 'comprehended many of the families of the high nobility'. The resident company of actors was always 'of respectable ability' and was often supplemented by leading actors from the London stage. In other words, by the 1850s Worthing was no longer a summer holiday destination for the nobility, and had become something of a cultural backwater.

The *Worthing Record* went on to make another, perhaps surprising point, namely that, although people were spending just as much of their time and money on 'amusement' as they did in 'the drama's palmy days', the taste was now for 'more intellectual' entertainment, which the author refers to disparagingly in terms of 'indigestible digests of science or morals which are served up in the shape of lectures'. In other words, people abandoned the theatre not because it was too highbrow, but because it was too lowbrow for the serious-minded tone of the mid-nineteenth century.

It was not that a seismic cultural shift had occurred, such as when cinema arrived at the start of the twentieth century (which put paid to Worthing's second theatre – see Section 14), or when television became ubiquitous from the mid-1950s onwards. There was no new and exciting type of entertainment suddenly on offer in towns such as Worthing. For the middle classes there was music in the town's libraries – of which by now there were five – but that had been the case for half a century. Meanwhile working-class men continued to patronise the town's inns and beerhouses.

There was, however, another reason why small provincial theatres such as Worthing's fell on hard times, as explained in a report in the *Musical World* of 3 May 1856 about the auction of the theatre's contents:

> Like other small country theatres, it had gradually declined, since the railway entered the town, until it was reduced to the lowest ebb of destitution, and the utmost attractions which an adventurous manager visiting Worthing could offer rarely brought more than thirty or forty to the theatre.

In other words, cheap, fast travel to London by train meant that those in Worthing who preferred plays to lectures could avail themselves of the higher quality of the theatrical fare – and the greater choice – that was available in London.

After the Worthing Theatre closed, the building became a warehouse for Worthing's main grocer, Potter, Bailey & Co., whose flagship branch was on the corner of Ann Street and High Street. When the building was demolished in 1969, it had housed groceries for more than twice as long as it had entertained playgoers.

SECTION 29

LANE'S HOUSE / BEDFORD HOUSE & STANFORD'S COTTAGE

At the start of the nineteenth century, Warwick Street was not yet a fully-built street. On the northern side there was a cluster of buildings, at the western end, but nothing else until Edward Ogle built the Colonnade on the corner with High Street in 1802. The intervening section was then infilled with a terrace of houses around 1807–08.

On the southern side of Warwick Street, a group of five buildings stood between Bedford Row and Steyne Field (today's Steyne Gardens). The most westerly of the group, on the corner of Bedford Row, was Lane's House, later Bedford House, which was built around 1785 and demolished in 1940. Next, set back slightly from Warwick Street, came Stanford's Cottage, which survives as Pizza Express; and Lamport's Cottage, which was demolished around 1942. To the north of Lamport's Cottage was a terrace of two or three cottages, and to the east of these was College House (later Park House, and today the Ask Pizza restaurant). In the 1830s, College House, as its name suggests, housed a school. This later moved to the building on Brighton Road that subsequently became known as Beachfield (see Section 2).

Stanford's Cottage and Lamport's Cottage had open views towards the sea across a piece of ground known as Paine's Field. The outlooks from Lane's House and College House were largely open too, although Little Terrace stood on the seafront in the direct line of sight from Lane's House, and the Stafford's Library building stood in the direct line of sight from College House. Between Lamport's Cottage and Stanford's Cottage a footpath ran from Warwick Street to the shore. Its northern end is still clearly delineated today.

Lane's House (later Bedford House)

According to Henfrey Smail and Edward Snewin's *Glimpses of Old Worthing* (1945), there used to be a significant group of buildings at the north end of Bedford Row that dated back to the reign of Elizabeth I. These consisted of a mansion, a second dwelling house – perhaps for a farm manager – and a barn, together with eight acres of land. These were demolished around 1790. Bedford Row itself was built in 1803, but at the north end there were stables and coach houses, and to get through to Warwick Street involved going through a stable yard. In the mid-nineteenth century, the Bedford Mews at the top of Bedford Row held fifty horses.

Today Bedford Row has an enclosed feel, but twenty years after its construction John Shearsmith was describing the terrace in *A Topographical Description of Worthing* (1824) as having 'a very airy and pleasant situation', with an open view eastwards to the backs of the houses in the Steyne. There was a lawn beyond the 'carriage road' (that is, on the other side of the street), and two further lawns 'of considerable extent' between the first lawn and the Steyne terrace. In those days the lodging houses in Bedford Row were 'the resort of families with considerable establishments'.

Shearsmith writes of Lane's House as follows:

> Having in our account of the Esplanade mentioned the lawn of Lane's House, it may be mentioned as of the class of houses already alluded to: being detached and possessing the same requisites. This house is situated at a considerable distance from the Esplanade, and at the same time commands an uninterrupted view of it and the

Bedford House (formerly
Lane's House) awaiting
demolition in 1940. The
photograph of Bedford House
and Stanford's Cottage on
the title page of this section
(© www.westsussexpast.org.uk)
dates from 1907.

sea, having two different carriage entrances, one opening upon the carriage road in
front of the town, and the other at the north end of Bedford Row; it possesses the
advantage of stables, coach-house, etc., the avenue to which is in Warwick Street; is
elegantly furnished, and is every year tenanted by one or more families of rank and
distinction.

In 1798, George III's daughter, Princess Amelia, stayed in Worthing and may have
spent part of her time at Lane's House, although the evidence is not conclusive.
The house was still known as Lane's House as late as the early 1840s, for the 1843
edition of Wallis's Street Plan of Worthing still has it with that name. It was probably
renamed Bedford House in the late 1840s or early 1850s.

Colonel Mapleson

Colonel James Mapleson (1830–1901) was one of the leading opera impresarios in
Britain and America during the second half of the nineteenth century. The exact years
he owned Bedford House are not known, but he had certainly acquired it by 1881.
On the date of that year's census, the only Mapleson in residence was two-year-old
Albert (together with a housekeeper, a nurse and a cook), so Mapleson and his
wife, Marian, must have been away on business. Young Albert, who was born in
Worthing, is described as 'Son of the Lessee of Her Majesty's Theatre'.

In 1891 Mapleson was again not in Worthing on Census Day, but this time Marian
was there, with Albert, now twelve years old, a housemaid and a cook. The house is
not named, but is identified by the address No. 18 Warwick Street. On the date of the
census Mapleson was a 'visitor' at the house of a confectioner called Edwin Mogford in
Bloomsbury Square, London. Another 'visitor' at Mogford's house was the American
opera singer Louise Dotti (1854–1921). Dotti was a particular protégée of Mapleson's –
he gave her a five year contract in the early 1880s – but, in view of the fact that they
were staying in the same house in 1891, it is reasonable to assume that his association
with her may have been as much personal as operatic. It is telling in this context that
Dotti gets only a few brief and impersonal mentions in Mapleson's autobiography,
The Mapleson Memoirs, 1848–1888. Dotti did not, however, find as much

Colonel James Mapleson in the 1870s. Photograph by Lock & Whitfield. (© National Portrait Gallery, London)

favour with the critics as she did with Mapleson. George Odell, a distinguished opera critic of the time, described her in as the 'ever-to-be-endured', the 'little-liked', and the 'hopeless' Dotti in reviews published in, respectively, 1883, 1884 and 1885.

The obituary of Mapleson published in the *New York Times* on 15 November 1901 says that he was 'a very important figure in the direction of Italian opera in this country and in England'. The paper adds that 'it was largely due to Colonel Mapleson's efforts that opera obtained a permanent support in this city after many ineffectual attempts to secure for it a firm establishment'.

The *New York Times* obituary was short and straightforward, but the following day the *Chicago Tribune* gave a more detailed assessment of Mapleson's life and character:

> The death of Colonel J. H. Mapleson in London removes from the world of music the last and, in some respects, the most picturesque of the old-school opera impresarios. All his contemporaries, Lumley, Ullman, Grover, Jacob Grau, Maretzek, the Strakosch brothers, and De Vivo, died some ago. Maurice Grau, the most prominent of the Italian opera managers of today, can hardly be called one of the old school, for he was a ticket seller when Colonel Mapleson was in his glory.
>
> It were useless to deny Colonel Mapleson's great service to the opera-goers of this country. For years he was the leading operatic purveyor, and during that period he presented nearly two score of the most famous artists and introduced many new operas to the American public at considerable expense to his patrons and at considerable loss to himself, for he was nearly always on the verge of bankruptcy and sometimes over the verge. His financial straits, however, in no wise abashed or distressed him. In some mysterious way he always came out on top and continued year after year to present operas in lavish style and pay most extraordinary salaries.

The obituary goes on to contrast Mapleson's dignified behaviour in adversity with the histrionics of his competitors. Diego De Vivo, for example, 'would quit

his hotel and go to a cheap Italian restaurant, and, when he met an acquaintance, indulge in pantomime expressive of grief'. Mapleson, however, always 'preserved his equanimity and his personal dignity, of which latter he had more than most men can handle with ease'.

The anonymous author then becomes somewhat waspish about Mapleson, noting that he 'could never forget that he had been a Colonel in her Majesty's service, not a plain Tommy Atkins', although in fact 'he never fought more dangerous foes than terrapin and champagne, with which he managed to contend, whatever the condition of the exchequer'. The obituary ends:

> He made much of his military title, but made more of the fact that he had been manager of her Majesty's Italian opera. He injudiciously forced her Majesty upon the American people at a time when they cared but little for her, and he took upon himself such an added load of airiness and dignity because of his royal connections that it did not tend to make him popular. In spite of his many faults and his picturesque pomposity, Colonel Mapleson accomplished much valuable service for grand opera In the United States.

Carl Seebold

In 1906 Bedford House was acquired by another impresario, Carl Seebold (1873–1951), who was to contribute more than anyone else to Worthing's entertainment over the first few decades of the twentieth century, and at one time owned three of the town's cinemas. The son of a rope manufacturer from Zurich, Seebold had nine sons and four daughters. He and his musically talented family toured Switzerland under the name of Father Seebold and his Seven Sons and played for many of the royal households of Europe, before ending up in London, where they performed at fashionable venues under various names: the Swiss Band, the Mountain Singers, and the Chamonix Orchestra. Seebold came to Worthing in 1904 from Southend-on-Sea, where he had been the actor-manager at that town's Kursaal, and he took over the New Theatre Royal in Bath Place, which he enlarged from 1906 onwards. He lived at Bedford House for a period – later he moved to No. 52 Richmond Road – but his main interest in his new purchase was the land that went with it, and the long garden that stretched down to the seafront became the location of his new entertainment complex, the Kursaal (renamed the Dome during the First World War), which opened there in 1911.

The final owner of Bedford House was the Southdown Bus Company, which bought the house in 1938 and a year or two later demolished it to provide further space for its garage.

Stanford's Cottage

In a few places in this book we have given ourselves a certain amount of licence with regard to our application of its title, and we now do so again, for the Stanford's Cottage building still stands today. However, it has lost its original internal

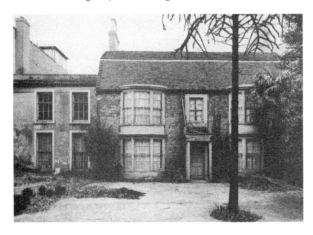

Stanford's Cottage in 1963, when it was a furniture storehouse and had neither a name nor an address.

configuration, the inside having been gutted; it has lost its open and attractive environment, today being hemmed in by other buildings; and it has lost its name. So, although it is not what insurers call a total loss, enough has gone, as in the case of the Colonnade, for us to add it to our roll call.

Stanford's Cottage was named after its original owner, Edward Stanford (*c.* 1768–1858), a tailor, hatter and dealer in pianos. A distinguished citizen of early Worthing, he was one of those who signed the petition of 1803 advocating the construction of a permanent theatre in the town. The house, which was built at the end of the eighteenth century, is best known for having been where Jane Austen stayed with her mother and sister for between seven and fifteen weeks in the autumn of 1805. But, as we shall see, it was briefly owned half a century later by someone who was as distinguished in his own field as Jane Austen was in hers.

On the Warwick Street side of Stanford's Cottage in 1805 was a paved courtyard with a pair of gates and an old chestnut tree in the middle. The north side of Warwick Street had not yet been built. Just to the north, Ann Street had recently been created, but also was not yet built upon. The outlook from the north frontage of Stanford's Cottage was therefore over fields and a few scattered buildings towards Middle Street – subsequently West Street, and today North Street – with the downs beyond. On the right-hand side of this view were various old houses and cottages along the High Street as it ran north from the Colonnade. The area to the east and south-east of the row of four houses in which Stanford's Cottage stood was also open ground at the start of the nineteenth century, since Steyne Row (today Steyne Terrace) was built only in 1807–08.

The possessive approach to the naming of property was common in the eighteenth and early nineteenth centuries, and in those days, as today, an apostrophe was sometimes used before the 's' in such instances, and sometimes not. In 1805 Jane Austen's niece, Fanny, wrote to her former governess giving the address as 'Mr Stanfords, Worthing, Shoreham', and the detailed street plan of Worthing that appears in all three editions of Wallis's *Stranger in Worthing, or New Guide to that Delightful Watering Place* (1826, 1832 and 1843) has the building marked as 'Stanfords Cottage'. The form 'Stanford Cottage' seems to have come into use around the middle of the nineteenth century, since it first appears in post office directories at that time. This piece of Victorian tidying-up regrettably

Jane Austen, painted by her sister
Cassandra around 1810. (©
National Portrait Gallery, London)

loosened the link with Georgian Worthing and the house's original owner.
However, Stanford's Cottage was the name used by Edward Snewin, writing in
1899 about the Worthing he knew as a child in the 1820s, and most Worthing
historians use this version.

Just over a hundred years ago, the house ceased to have a name of its own. It was
not lived in after 1906, and by 1919 it did not even have an address. For most of
the twentieth century it was simply an unnamed storehouse behind the premises of
the house furnisher Colin Moore at Nos 20–22 Warwick Street (since demolished),
and it was probably he who gutted the interior. When the house was given its Grade
II listing in October 1949, the listing text stated: 'It was originally called Stanfords
Cottage but it is now only called a store-house.' As the listing document makes
clear, Stanford's Cottage was originally smaller than it is today, the section at the
north-west end being an addition at some point in the middle of the nineteenth
century, at around the same time as the name Stanford Cottage came into use.

Edward Cortis Stanford

When Edward Stanford died in 1858, he left the house in his will to a young
man called Edward Cortis, a cousin of Alfred Cortis, later to be the first mayor
of Worthing. Cortis and his two brothers were major beneficiaries of Stanford's
will, and one of its provisions was that they had to change their surnames by deed
poll to Stanford. It is not clear why Edward Stanford took such an interest in the
Cortis brothers. He was not their grandfather, for their mother's maiden name was
Cortenay.

Most of the biographical information in this sub-section comes from www.
photohistory-sussex.co.uk, where a fuller account of Edward Cortis's life can
be found.

Edward Cortis Stanford (1837–99), photographic pioneer and author of *On the Economic Applications of Seaweed*, photographed around 1890. (© www.westsussexpast.org.uk)

Edward Cortis was a talented chemist and a keen early photographer. In 1855, when he was just eighteen, he was already advertising his photographic services in the *Worthing Monthly Record*. However, he had no use for the house he had inherited from his benefactor, and – now Edward Cortis Stanford – he sold it at some point between 1858 and 1862, the year he left Worthing to take up the position of Assistant Demonstrator at the School of Pharmacy in London. The sales particulars state that the house had large drawing and dining rooms, a morning room, and eight dormitories (bedrooms). Also, unusually for that time, it had a 'well fitted bathroom', with 'town water and gas laid liberally on'. There is mention of the 'deep lawn' in front of the house – in those days the front door was on the side facing the sea – and the house is described as being 'altogether a rustic and agreeable residence'. When Jane Austen stayed there, however, Stanford's Cottage would not have had a bathroom, nor as many as eight 'dormitories'. Extra bedrooms were added when the house was extended in the middle of the nineteenth century, and it was probably at this time that the bathroom was installed.

Edward Cortis Stanford seems never to have returned to Worthing. He became an expert in iodine extraction, and made a significant advance in seaweed chemistry when he isolated alginate from the kelp seaweeds found on the coasts of Britain. In 1862 he published an influential book called *On the Economic Applications of Seaweed*, and by the following year he was working in the kelp industry. It is appropriate and perhaps not coincidental that a man from Worthing – whose beach has been plagued for over two centuries by seaweed – should have made his fortune out of it.

In 1864, Stanford went to Scotland to take up the post of Manager of the British Seaweed Company, and he built the Stanford chemical works on the banks of the Forth and Clyde Canal to extract iodine and potash from seaweed. In 1893, six years before his death, he became the President of the Society of Chemical Industry.

SECTION 30

THE TOWN HALL

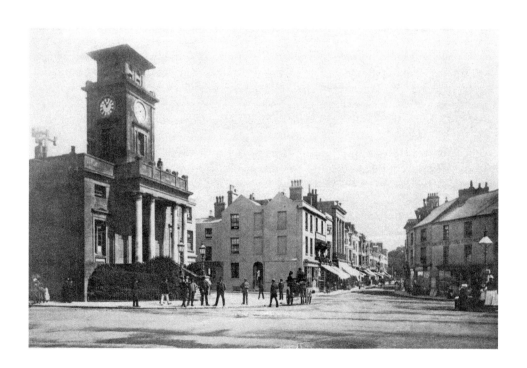

Among the lost buildings of Worthing that one might wish to magic back into existence, none is a stronger candidate than the old Town Hall, which for 130 years stood at the northern end of South Street. It was the most instantly recognisable and most-photographed building in Worthing, and it is a great loss to the heart of the town that it is no longer there. It stood at what might be described as, in chronological terms, the second central point of historic Worthing. The original central point had been the crossroads at the corner of High Street, Warwick Street and the Steyne. During the early years of the nineteenth century, however, the town centre gradually shifted westwards from High Street towards South Street, as Warwick Street and Ann Street were built on. The construction of the Town Hall set that change in tablets of stone.

Until the second decade of the nineteenth century, the only route into Worthing from the north was by way of North Street, High Street and Warwick Street. From the western end of Warwick Street northwards to Teville Common there was just a track, which was widened into a road around 1816. Originally called New London Road – and later Chapel Road, after the Chapel of Ease (later St Paul's Church, and now St Paul's Centre) – this superseded the High Street as the main road into Worthing.

At this time there was no public clock in the town. This was an important omission in an era when most people did not own watches, and in 1818 Michael Morrah, one of the town's doctors, proposed that a clock tower should be erected, using funds to be raised by public subscription. In the event, so much money was raised that it was decided to mount the clock on a town hall rather than merely on a tower.

The site chosen, which at that time was a garden enclosed by an elder hedge, was owned by the Shelley family, owners of Castle Goring. In 1825 negotiations began with Sir Timothy Shelley – father of the poet – for the purchase of the land. The construction of the Town Hall did not, however, begin until 1834. The building was completed the following year, and the town commissioners – who from 1812 onwards had met at the Royal Oak in Market Street – held their first meeting there on 24 June 1835.

The Town Hall was also the location for the monthly County Court sessions and the fortnightly petty sessions. Savings bank business was transacted there too. In those days only the well-off used banks, and the savings bank was available for labourers, domestic servants and children to deposit small sums for safe-keeping. Below the main chamber was the garage for the town's fire engine. Some Edwardian postcards of the building show a long ladder leaning against the front of the building. This was the fire escape, kept there so that it was on hand when required. Cells for prisoners and vagrants were also located below the main chamber. In hot weather the smell from these was so bad that the town commissioners sometimes found it almost impossible to conduct their business in the chamber above.

Until the mid-1860s, the western side of South Street and Chapel Road consisted of open ground. The pasture on the western side of South Street was known as South Street Fields, and in the middle of the nineteenth century fairs and circuses were held there. From 1866 onwards, however, the western sides of the two streets were gradually built upon. South Street was by now Worthing's main shopping street, and the new buildings on the west side of the street were shops. The buildings on the west side of Chapel Road, however, were originally houses, with small forecourt gardens in front of them, and iron railings abutting the pavement.

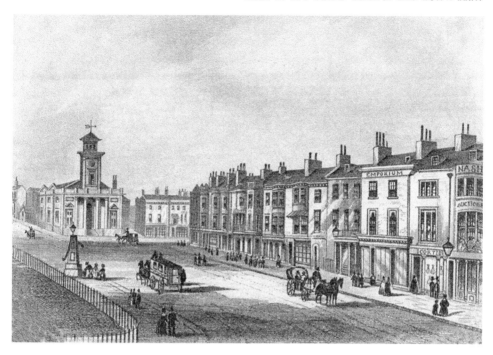

The Town Hall and South Street, around 1860, when the west side of the street was still open fields.

This image of South Street with the Town Hall in the background and an early motor car in the foreground comes from the *Camera Series Album of Views of Worthing*, published in the late 1890s by Brown & Rawcliffe Ltd of Liverpool. The images in this book are based on photographs, which have then been manually enhanced, giving them almost the look of engravings.

The old Town Hall remained in use until it was superseded in 1933 by the new building in Chapel Road. In 1950, the clock tower was found to be in such an unsafe condition that the clock was stopped from striking because of the possible effect on the structure from vibration. There was a scheme to rehabilitate the building at a cost of £9,000, but this had to be abandoned because the structural defects were found to be more serious than had been anticipated; and the clock tower was removed.

This was the beginning of the end. By the 1960s the interior was in an advanced state of dilapidation, and the rest of the building was demolished in 1966.

The B. W. Newton Connection

While I was writing this book I was contacted by Chris Griffiths, who is doing detailed research into the life and work of B. W. Newton. In 1859, Newton gave a series of lectures in Worthing on 'prophecy' that not only proved controversial but also had long-lasting repercussions. Chris hopes in due course to publish a major study of Newton, but in the meantime has provided me with the account that follows of the influence that Newton and those who shared his beliefs had on the people of Worthing.

> The old Town Hall was the focus of a religious controversy that led to a unique religious movement taking root in Worthing in 1859. Its influence lasted over a hundred years. However, all but one of its buildings in Worthing, like the Town Hall, have been lost.
>
> It is a story of four men. The first, Benjamin Wills Newton (1807–99), was a brilliant academic who at one time led a thousand-strong Christian meeting at Plymouth. By 1859 he was preaching in what a report in the *Daily Telegraph* in 1870 referred to as 'a commodious iron church' that he had built in London. The same

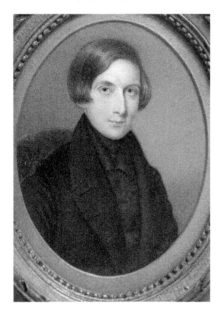

B. W. Newton (1807–99) as a young man. He gave an influential series of lectures on prophecy at Worthing in 1859. (Image provided by Chris Griffiths, from a portrait formerly in his possession and now in the Christian Brethren Archive of the John Rylands Library at the University of Manchester)

report added, 'I doubt if any church in Bayswater ever gathered such a congregation as he attracts on a Monday morning.'

The second man was Thomas Graham Graham (1824–1905), who had Cornish roots, as indeed did Newton. In 1859, he was attending Newton's Christian meeting, having apparently moved to Bayswater for that specific purpose.

The third, John Adams (1822–95), was a shoemaker turned preacher, who from 1847 onwards led a meeting practising adult baptism in the village of Angmering. It was perhaps he who invited B. W. Newton to speak in Worthing, and thus set in motion the long connection between Newton's movement and the town.

The fourth, John Cox (1831–1915), was a senior civil servant, who acted as registrar for what are now the Church Commissioners. He devised an archival filing system for 96,000 Church of England properties that has survived to this day. He too had been with Newton at Bayswater, and he rescued the Newton influence in Worthing when it seemed likely to disappear in 1906.

B. W. Newton, disillusioned with the Church of England, had been one of the founders of the first Brethren Assembly in Plymouth, which he went on to lead. He was eventually hounded out by the followers of John Nelson Darby, the leader of the Exclusive Brethren. Newton severed all contact with the Brethren in 1848, and, although he was very influential in his writing and teaching, he did not seek to form any sect or church. The 1870 article in the *Daily Telegraph* noted that Newton 'does not seek publicity or aim at proselytism'. The unique nature of his ministry was his prophetic teaching. He was a simple futurist. He believed that the Bible prophecies are almost all awaiting a future fulfilment. In particular, the Book of Revelation was not an encoded protest about Nero's Roman Empire, nor a history of Christendom, nor a kind of Christian version of the prophecies of Nostradamus. Newton saw in the Apocalypse a 'revelation' of yet future events that would take place at the end time, before Christ returns.

It was to hear and promote prophetic teaching that Adams invited Newton to Worthing. His lectures, which are still in print, were published in 1859 under the title *The Antichrist Future*. The first edition is dedicated 'To those in Worthing who favoured me with their presence at lectures recently given by me there'. So worried was the Rector of Broadwater, Revd Edward King Elliott, that he arranged for seven rival lectures to be given at the Town Hall by his father, Revd Edward Bishop Elliott, and others, to counter this inflammatory teaching. A further tract by Newton, in response to the Anglican lectures, was printed under the title *The Twelve Hundred and Sixty Days of Antichrist's Reign Future: A Second Tract, Written with Relation to Certain Lectures Recently Delivered at the Town Hall, Worthing*. One of the Anglican lecturers replied with a further pamphlet. He was appalled that Newton, although opposed to Romanism, did not recognise the Pope as the Antichrist.

In 1860, T. G. Graham came to live in Worthing. He bought the chapel in Angmering at which John Adams preached, and then, at his own expense, built New Street Chapel, where he installed Adams as the minister. The façade of the chapel, whose architect was probably Charles Hyde, still survives at No. 96 Montague Street, with the ground floor now used as the Oxfam bookshop.

John Adams was much loved by his congregation and faithfully served the new chapel until his death in 1895. There is a moving report of his funeral in the *Worthing Gazette* of that year: 'The whole of the available space both here and in

Edward Bishop Elliott in the 1860s, a few years after his son, the Rector of Broadwater, invited him to lecture at Worthing Town Hall in an attempt to counter the teaching of B. W. Newton. Photograph by James Holroyd. (© National Portrait Gallery, London)

the main building was fully occupied, the scene being one of profound solemnity ... Considerable emotion was shown by the speaker in the course of his brief address, and there was suppressed sobbing in all parts of the building.'

Graham, having built the new chapel, went on to build himself a mansion, Treveor, now the site of Treveor Close, where he lived until his death and where he entertained B. W. Newton, Newton's mother, and later John Cox. He built a chapel at Nepcote in Findon, and funded a further building at the back of New Street Chapel for use as both a day and a Sunday school. The road leading to it was named Graham Road after him. He also supported the services at chapels in Arundel and Walberton. Graham's enterprises were designated 'Evangelical Protestant' – New Street Chapel was registered as an 'Evangelical Protestant chapel', the village chapels used that name too, and the school was registered as an 'Evangelical Protestant school'. A chapel started by friends of B. W. Newton on the Isle of Wight also used the term.

In the closing years of the nineteenth century, New Street Chapel faced external competition. Encouraged by Charles Haddon Spurgeon – the leading Baptist preacher of the nineteenth century – a Baptist chapel was built in Worthing in 1881. This was so successful that the congregation moved to a larger building in 1885. However, the Baptist pastor, Douglas Crouch, became unhappy with theological trends in the main Baptist denomination, and withdrew from it, as his mentor, Spurgeon, had already done. Most of Crouch's congregation left with him in 1896, and by 1908 he had built the 500-seater Worthing Tabernacle. Alongside this, a congregation continued in the old Worthing Baptist Church in Christchurch Road, remaining within the denomination that would shortly gain an interest in – and later full control of – Graham's village chapels.

The 'Evangelical Protestant' community soon faced more direct challenges. Within a few years they lost their leaders and their chapels. John Adams's health declined,

and he died in 1895. Senility overtook Graham, who died intestate in 1906. The three chapels he owned were sold by his son, Newton Graham. The chapels at Nepcote and Angmering were bought by supporters of Worthing Baptist Church, and they became Baptist Churches. It is not known who bought New Street Chapel, but the congregation had to move out, and the building was deregistered as a place of worship in 1909.

However, help was at hand. John Cox, the son of a Baptist minister and also a close friend of Newton's, had retired to Worthing in 1894. He assisted in the ministry at the chapels. Upon the death of Newton in 1899, he started a monthly journal, *Perilous Times*, to promote Newton's teaching and he saved the Evangelical Protestant work in Worthing by building Chatsworth Hall for the New Street congregation, at his own expense. This building, designed by James E. Lund, and located where the north entrance to the Guildbourne Centre now is, was demolished in 1960.

At Chatsworth Hall, Cox was assisted by Ernest John Burnett (1876–1959), Registrar for Worthing, who continued as pastor until the building closed in 1957. He then held meetings in his home until his death. Burnett became the trustee of a book fund that promoted B. W. Newton's works. His older brother, William Edward Burnett (1862–1950), was another 'Evangelical Protestant'. He had founded the Evangelical Protestant Mission to the Chinese, and died in China following brutal ill treatment during the Communist revolution.

There is a personal postscript to the story. Gerald Leighton Silverwood-Browne (1904–94), nephew of E. J. and W. E. Burnett, took over the trusteeship of the book fund, and lived in Worthing in his later years. Chris Griffiths, the author of this sub-section, visited him at his home in 1992. Silverwood-Browne shared recollections of those who had known Newton. His commitment to Newton was unwavering. He gave Chris seven manuscript books for safekeeping, in which he had copied notes of Newton's lectures and publications.

Although no group aligned to Newton's teaching meets in Worthing today, there are still many people throughout the world who hold strongly to Newton's views. The periodical founded by John Cox continues as the quarterly *Watching and Waiting* magazine, and monthly meetings are still held in London.

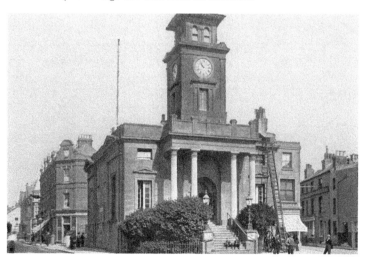

The Town Hall around 1905.

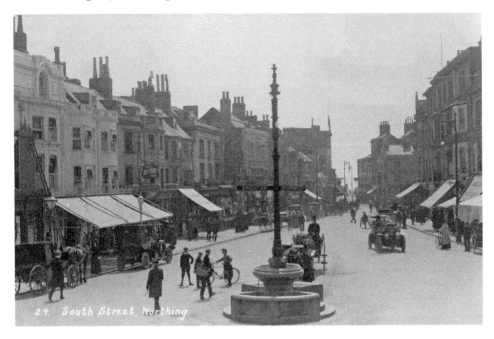

A Harold Camburn postcard of 1910, showing the view from the Town Hall steps towards the sea, with the drinking fountain in the foreground.

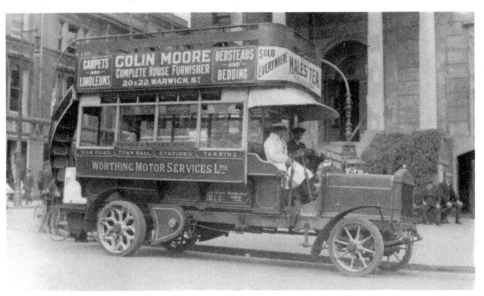

An early motor bus in front of the Town Hall, probably just before the First World War.

LOST ON THE PERIPHERY

~

SECTION 31

CHARMANDEAN

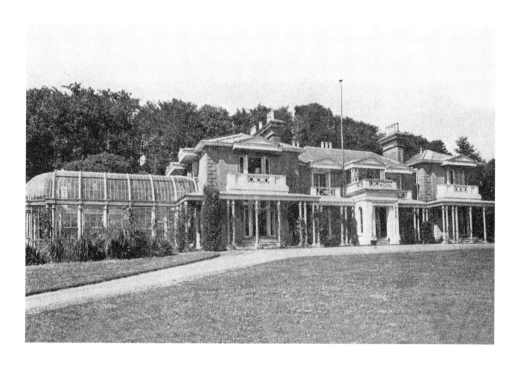

Charmandean, seen from the Brighton road in the early nineteenth century. This is the original simple Georgian house before Mrs Thwaytes's numerous enhancements and additions. The 1950 photograph on the title page of this section also shows the south façade, but this time in its final form.

There were only ever two large private houses of real significance in Worthing itself, Warwick House (see Section 24), and Beach House (see Section 4). In historical terms both were relative latecomers, having been built around 1785 and 1820 respectively, and their grounds, although substantial, were not true estates. In or near Broadwater, however, there were three houses on ancient estates that dated back many hundreds of years: Offington, Broadwater Manor and Charmandean. These houses are the subject of Henfrey Smail's *Notable Houses of Worthing, No. 2* (1950), from which most of the information in the next sub-section comes.

Offington is dealt with in Section 32. Broadwater Manor is outside the remit of the book, for the house still stands. Since 1930 it has been a preparatory school, which until 2014 was known as Broadwater Manor School. Now, following its acquisition by Lancing College, it trades more prosaically as 'Lancing College Preparatory School at Worthing', to distinguish it from Lancing's other preparatory school at Hove. Charmandean is the subject of this section.

Charmandean

The house at Charmandean stood where the houses of Longlands Grove now are, thus around half a mile to the north-east of Offington Corner (today the junction of the A24 and the A27).

The first reference to the estate is in 1521, where there is mention of land called Charemanys. This name probably derived from the Charman family, who, by the middle of the sixteenth century, owned land in the parish of Broadwater. Over two hundred years then pass before there is further tangible information about Charman Dean, as the name was generally written until late in the nineteenth century.

The house was originally a modest structure, built soon after 1806 by a yeoman farmer called John Penfold. Penfold was related to Edward Penfold, the miller of Broadwater Mill, who on his death in 1837 was described in the *Brighton Gazette* as 'one of those primitive, unaspiring, and true old English hearted yeomen, of whom we regret to say so few are left'. Today most of us would be ambivalent about being described as primitive and unaspiring, but the *Gazette*'s tribute was clearly meant to be complimentary. There were four Penfolds, including John and Edward, among the first group of Worthing town commissioners, so they were evidently a prominent and well-regarded family.

After John Penfold's death in 1821, the Charmandean estate seems to have passed out of the family, and in the 1820s the house was occupied by a Mrs Walker. Then, in 1841, Charmandean was bought by the most remarkable of its owners, a woman called Ann Thwaytes (1789–1866). Mrs Thwaytes, as she was always known, was the widow of William Thwaytes (1749–1834), an immensely rich grocer and tea merchant who by around 1800 had become the sole owner of Davison, Newman & Co., one of the leading grocers and tea merchants in London. Many, possibly most, of the 342 chests of tea that were thrown into Boston Harbour in 1773 – the so-called 'Boston Tea Party' – as a protest against restrictive trading practices imposed by Britain were those of Davison, Newman & Co. The firm had a twenty-two per cent share in a large sugar plantation in Jamaica, whose slave population in 1819 consisted of 256 men, women and children, so Mrs Thwaytes's purchase of Charmandean was in part funded by the profits from a slave estate.

The original house was a simple Georgian structure, but Mrs Thwaytes transformed it. In 1842 she added a porch to the south front, canopies to the lower windows, ornamental gables to the upper windows, and a bay window on the east side. She later added two new wings to the house, at the east and west ends, and the canopies were extended to form a veranda running the length of the building, with balconies above them. Finally, an iron conservatory was added to the west end. Mrs Thwaytes's imaginative ideas had turned a modest and sober Georgian building into a delightful and unusual mid-Victorian country house.

Mrs Thwaytes was much given to good works. In January 1842, for example, she distributed coal to poor families of the parish. In due course a charitable organisation was set up for the purpose, but, when in 1854 the organisation for some reason was temporarily non-functional, Mrs Thwaytes herself organised the distribution of Christmas coal to over six hundred families in the parish. She also supported the Worthing Dispensary, which offered a modicum of free health care to the poor, and in 1844 contributed a substantial sum towards the purchase of land for a new building. A site in Chapel Road between Market Street and Ann Street was

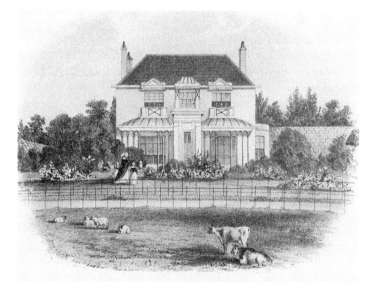

Charmandean as it was in 1842. A 1950 drawing done by Isabella Turner for Henfrey Smail's *Notable Houses of Worthing, No. 2.*

bought from Sir Percy Shelley, son of the poet, and Mrs Thwaytes laid the foundation stone of the new building on 18 September 1845.

Her generosity also made possible the publication of Frederick Dixon's notable book *The Geology and Fossils of the Tertiary and Cretaceous Formations of Sussex*. Dr Dixon, who had been the first consulting surgeon at the original Worthing dispensary in Ann Street, died in 1849 at the age of forty-nine, and the following year Mrs Thwaytes paid for the posthumous publication of his book, which was illustrated with beautiful colour plates. She was also a generous patron of Broadwater Church, contributing £100 towards the cost of a new organ, and paying the organist his annual stipend of £40. In addition she gave £50 towards a stained-glass window in memory of Revd Peter Wood, who died in 1853 after fifty-six years as rector of Broadwater, and his chaplain Revd William Davison, who had died the previous year.

Mrs Thwaytes and the Simm Brothers

Further light is shed on the strange life of Mrs Thwaytes in an article by Rosemary Pearson in the Spring 2011 issue of the *Broadsheet* (the newsletter of the Friends of Broadwater and Worthing Cemetery). Rosemary – with whom I have corresponded and who is happy that I use information from her article – studied the detailed contemporary reports of the case involving Mrs Thwaytes's will, which appeared in the *Times* in April and May 1867. There is also an illuminating article about Mrs Thwaytes on Wikipedia, which uses some of Rosemary's material. Most of the information in this sub-section derives from these sources.

Although Ann Thwaytes's mother called herself Mrs Hook, she never married, and her daughters were both illegitimate. When their mother died in 1803, Sarah and Ann, then aged respectively fifteen and fourteen, had to find work, and in due course Sarah became housekeeper to William Thwaytes. In 1816, Sarah married Alfred Tebbitt, Thwaytes's chief clerk, and the following year Ann, aged twenty-eight, married Thwaytes himself, who by then was sixty-seven. During her marriage, Ann accused her husband of attempting to poison her with mercury and, in 1832, during her husband's last illness, she developed a mental disorder following a bout of typhus. She lay ill for ten weeks facing the wall, thinking she was blind, and her psychological state was never the same again. She believed, for instance, that she was immortal and part of the Trinity.

After William Thwaytes's death, Ann, now forty-five years old, inherited a vast fortune of around £500,000 (approximately £43 million today), and proceeded to use her wealth in often erratic ways. Before her husband's death, she had become very close to her doctor in London, a man called Simm Smith, who had known the poet John Keats (1795–1821) moderately well when they were medical students and whose eldest child, Catherine, was to be the mother of another great English poet, Gerald Manley Hopkins (1844–99). Mrs Thwaytes gave Simm Smith £50,000 (over £4 million today) out of her inheritance, as well as paying him £2,000 a year (something like £170,000) to temporarily give up his London medical practice to manage her business affairs. Also, before her husband was even buried, she made a will leaving almost everything to Smith.

During the six years following her husband's death, Mrs Thwaytes lived first at Clapham Common with her sister Sarah and Sarah's children, and then at Finsbury Circus with a friend called Louisa Little. She spent part of each summer in Herne Bay where, in 1836, she paid for the construction of the town's magnificent clock tower, which still stands today. Then, at the start of the 1840s, Mrs Thwaytes rationalised her domiciliary arrangements into the shape they retained until her death. In 1840 she bought a large town house, No. 17 Hyde Park Gardens in Paddington, and the following year she acquired Charmandean, thereafter dividing her time between these two houses.

Soon after her husband's death, Mrs Thwaytes had grown close to Simm Smith's brother Samuel, who played a role in her life that was at least as important as that of Simm himself. Samuel was a stockbroker, but seemingly not a very successful one. His wife had died at about the same time as William Thwaytes, leaving him with two daughters and a debt of £3,000 (over £250,000), which, needless to say, Mrs Thwaytes paid.

Once Mrs Thwaytes had acquired Charmandean, she installed Samuel Smith and his children there and paid for his daughters' education. Samuel was seventeen or eighteen years younger than Mrs Thwaytes. The nature of her relationship with Samuel – or indeed with Simm – can only be a matter for speculation, but he was clearly a permanent part of her household. The 1851 census finds her at her town house with Samuel Smith and seven servants, while the 1861 census finds her at Charmandean with Smith and eight servants. In both cases the census uses for Smith the term 'visitor', which delineated someone who was not a permanent member of the household. We take a different view.

Mrs Thwaytes died at her London house in 1866, aged seventy-six, and was buried in a vaulted grave at Broadwater Cemetery. Her estate was worth £400,000. Mrs Thwaytes had initially given generous financial help to her sister, Sarah Tebbitt, and Sarah's children, but in due course there had been a (total) falling-out with Sarah and a (partial) falling-out with her nephews and nieces. In the final version of her will Mrs Thwaytes left £45,000 to the latter, but nothing to her sister. It is not entirely clear what was left to the Smith brothers. By one account she left most of her estate, including Charmandean, to Simm, with a substantial sum also for Samuel, to whom Charmandean would pass after his brother's death. By another account, the Smith brothers were to inherit £180,000.

Either way, Mrs Thwaytes's sister, Sarah, and two of Sarah's daughters contested the will on the grounds both of Mrs Thwaytes's mental incapacity and of the Smith brothers having exerted undue influence on her. The case was heard in 1867. The Smiths claimed that Ann was sane, while the Tebbitts described her religious delusions in detail. These included Mrs Thwaytes's belief that she was the bride of Christ and that Judgment Day would occur in the drawing room of her London house. In addition, when she was at Charmandean and there was a full moon, Mrs Thwaytes would, to the astonishment of those that observed the ritual, dress in white and drive her yellow carriage along what is now the A27, past the Sussex Pad Inn and over Old Shoreham Bridge, and then back home again. She often talked to others about her curious beliefs, including her friend Louisa Little and one of Sarah's daughters, who recorded what she said in her diary and used the information in court. In spite of her religious fervour, Mrs Thwaytes did not attend church, but instead had sermons read to her at home.

The judge found in favour of the Tebbitts, deciding that Mrs Thwaytes was of unsound mind when she signed her will and that it was therefore invalid. The judge also indicated that, if his judgement had been that she was sane, he would anyway have found the will invalid on the grounds of undue influence by the Smith brothers.

Schools at Charmandean

In 1871, Charmandean was acquired by a London stockbroker called George Wedd, who was to provide the land on which St Andrew's Church in Victoria Road was built in 1888 and contributed £4,000 to the cost of its construction.

After Wedd's death in 1898, Charmandean had two further private owners. When the second of these, Thomas Dyer-Edwards, died in 1926, the estate was broken up. Most of the land was built over, while the house and the remaining grounds became a boys' preparatory school called St Michael's, which had previously been located in Park Crescent and then, briefly, in Bath Road. St Michael's survived at Charmandean for only five years, and then the house was empty for a further five, before being acquired in 1936 by Lottie West, whose girls' school had been founded in Southsea in 1897. Miss West took all the boarders from the Southsea school with her when she moved to Charmandean. The school in Southsea, which at some point became known as Mayville High School, remained in business and is today co-educational, with over five hundred pupils.

Charmandean School, however, did not survive. Three years after Miss West took over, the building was requisitioned for war use, and after the girls returned two or three years later the school remained at Charmandean for only another decade or so. Miss West retired in 1954 and the school moved to grander premises at Tile House at Lillingstone Dayrell in Buckinghamshire, before closing in 1991. Although a girls' school known as Charmandean was in existence for fifty-five years, the pupils occupied the house near Broadwater for just fifteen of them.

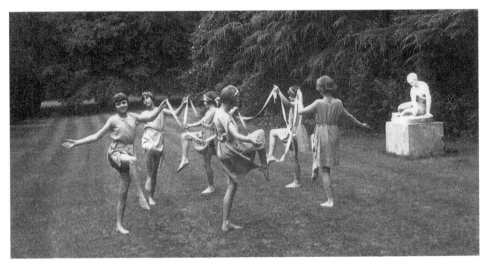

Dancing on the lawn at Charmandean School in the 1930s. (© www.westsussexpast.org.uk)

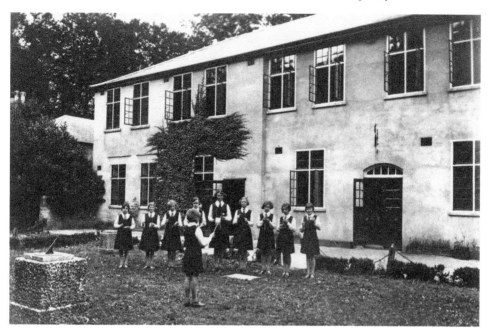

The percussion band at Charmandean in the 1930s. Small girls and percussion instruments sound like a combination fit for St Trinian's. (© www.westsussexpast.org.uk)

The caption to this image describes the scene as a 'pipe-making class', the pipes in question presumably being flutes or recorders. (© www.westsussexpast.org.uk)

Ann Binnington

Lizzie Glover, who was at Charmandean in the early 1940s, has provided me with this vivid and amusing account of her time at the school. It was wartime, and she and her younger sister Judy were sent to Charmandean because her grandmother and aunt lived in Broadwater. The two girls were there for about eighteen months, from the autumn of 1943 – when Lizzie was fourteen and Judy about twelve – until the spring of 1945.

In those days I was Ann Binnington – Ann is my second Christian name – and my nickname was 'Sanibin', after the little bins we put sanitary towels in, to stop them bunging up the lavatories. The principal of Charmandean was Lottie West, a dreadful fat round little woman with high button shoes who had a new mink coat each term. English was taught by Miss Blair, a tiny woman in her mid-thirties with crinkly brown hair, who wore green knitted cardigans with sagging pockets. She accompanied the hymns at morning assembly on the harmonium. One day we stuffed it with rubbish – old newspapers and orange peel – which made it dumb as she tried to play it. When she lifted the lid, the front fell down, and all the rubbish came out, which we found hilarious. Where we got oranges from in those days I don't know. One of the richer girls may have acquired them – perhaps Sebag-Montefiore, who was a fiend, but terrific fun.

Miss Cream, whose appearance suited her name – she had a pale face and colourless eyes – taught languages, both dead and modern, and waved her hands about a great deal, presumably in imitation of what she regarded as the French manner. Her main passion in life was Molière, but she was unable to persuade us to share it. A clear memory is of the whole school – there were about sixty of us – sitting at double desks in an enormous hall room, doing 'homework', while Miss Cream read her wretched Molière and giggled. Meanwhile we pinged paper aeroplanes at each other, or crawled under our desks and out of the door until there were just two rows of girls at the front, and the rest of the room was empty.

We were always half-starving. The upper fourth – my class – was delegated to do the washing-up after meals, and we would rush to the kitchen to get there first so we could scrape the pots and pans to stuff our empty stomachs. The washing-up was done in two deep Butler sinks with only one fill of water, so by the time we'd finished all the dishes the water was afloat with filth and stone cold.

I was often one of the 'Raiders' who would steal past Matron's and Nurse's rooms to the pantry during the night. In those days schoolgirls wore heavy, voluminous, hairy navy blue knickers, and it was inside these that we hid our spoils – raisins, bread and butter, tins of golden syrup, bags of brown crunchy sugar – as we sneaked back to the dormitory for midnight snacks. Once I accidentally got locked into the pantry, and slept on the loaves of bread that, oddly, were kept on the floor.

We held meetings of the 'Escape Committee' in the Chapel, with Sebag-Montefiore squatting like a homunculus on the windowsill, as we sat in the pews below thinking of ways of getting out. On one occasion Fatty Greenhalgh and I were instructed to walk to the beach, over three miles away, and bring back some stones to prove we'd been there. On another 'dare', I remember running round the leaded roof one starry moonlit night.

I slept in a dormitory called Anemones. My sister was in Tulips. A gaggle of young terrorists housed in barracks named after small flowers – you couldn't invent it! The

bathrooms were fourteen wooden-walled cubicles. Another of our horrid little games was to enter one of the cubicles, lock the door, put the plug in, turn the taps fully on, and then climb over the partition into the next cabin and repeat the exercise – with the result that all the baths overflowed, and the water ran down the curving stone staircase that led up to the chapel, which was at the top of the house.

One February evening I was in the process of shinning over the last cubicle wall after turning on all the taps when I happened to look through an interior window into my sister's dormitory. It was full of boys and girls in various stages of undress, and my sister was jumping up and down on her bed, stark naked, yelling at the top of her voice, 'Who wants to kiss Judy Binnington?' They'd invited a troop of boy scouts who were camping near the school to a Valentine's day party. There were roses, cake, chocolates and bottles of ginger beer. I lingered for a while, watching with horrified fascination. In those days I was innocent and prudish, so this display of decadence shocked me – but I was simultaneously a little jealous, and annoyed that we older girls hadn't thought of something similar.

We were horrible, but then so was Lottie. She would punish us with fines. She took a penny for an untied shoelace or a dropped hankie; twopence for not having the right book or making a noise on the stairs; and fourpence for forgetting your beret or gloves for church. It was half a crown if you were caught on the top corridor, where her rooms were. Going there was a kind of initiation ritual. If you did this, it showed you had guts and after that you were 'in'. You went up to the top floor through the upper cloakrooms, which were dark and wet and had green cloaks hanging like grim reapers on the pegs; then past the dark brown half-doored lavatories, and up to the door that opened onto the corridor. Scared witless, you tiptoed past Lottie's office, whose door was always half-open. I had nightmares for years afterwards about that corridor and that terrifying walk.

We were also made to do 'Housewifery' – how to clean houses! It was Lottie's way of getting her rooms cleaned without paying proper staff. We learnt to dust and mop and brush, and we nosed around in her desk. Her office was painted a pale Wedgewood blue. The house had been occupied by soldiers just before I joined the school, and rude words beginning with F and C were scrawled in huge writing behind the door, which made us hoot with laughter. Lottie was too mean to get this obscene bit of wall painted over, but she had a new fur coat every term, which we assumed was paid for out of our fines.

It was all absolutely ghastly. The only thing I learnt there was the art of survival. The teachers were hopeless, and the schoolrooms were permanently cold and damp. My parents took me and my sister away after not much more than a year, and sent us to St Margaret's at Hastings, which was 'fraightfulleh' civilised and decent, and the exact opposite of Charmandean in every way. We didn't have 162 written rules. It was, 'Thet's jest not done heah!'

Barbara Hulanicki

Probably the most famous pupil of Charmandean School during its Sussex years was Barbara Hulanicki, the founder, with her husband, Stephen Fitz-Simon, of Biba. Although the name still exists today as a fashion brand used by the House of Fraser, few people under the age of fifty will be aware of the huge cultural importance

of Biba during its brief existence as a department store between 1964 and 1975. It occupied the entirety of the former premises of Derry & Toms in Kensington High Street and was, during those twelve years, probably the most famous shop in London, eclipsing even Harrods. It was unlike any large department store that London has ever known, with its decadent atmosphere and its lavish art nouveau and art deco décor; and artists, film stars and rock musicians were regular visitors. Sadly, however, Biba was a triumph of style over financial substance, and the store closed in September 1975.

In her 1983 autobiography, *From A to Biba*, Hulanicki relates how, when she was fourteen – thus, in 1950 or 1951 – her mother suddenly announced that she was to become a boarder at Charmandean. Her reaction was one of 'unqualified delight'. She had visions of Enid Blyton adventures and midnight feasts. The school prospectus, which had not been revised since the 1930s, was 'very Isadora Duncan'. It 'showed nymphets dancing in the woods', 'gardens littered with cement statues and young ladies sitting on horses'; and there was a circular swimming pool that looked like a small lake.

The reality was very different. Hulanicki's experience, like that of Ann Billington a few years earlier, was of a disorganised little school in terminal decline. She says that Charmandean turned out to be a kind of St Trinian's. Lottie West, the principal, rarely appeared except to take prayers in the morning, the two main teachers being the headmistress, Miss Bunn, and her 'sidekick', Miss Cream. Because there were no seats available in the classroom appropriate to Hulanicki's age, she and three other girls occupied a small separate room where, since there was no teacher for them, they were sometimes completely forgotten.

The thirty-acre grounds 'had seen much better days'. The lawn where the nymphets had danced in the prospectus photograph was overgrown, and the statues had had their noses and genitalia shot off by the soldiers who had used the house as a barracks during the war. The circular swimming pool was knee deep in pea-green water, and the bottom was full of leaves. There were, however, midnight feasts almost every night, just as Hulanicki had hoped.

As time passed – Hulanicki was there four years – her 'happy schooldays turned tedious'. By 1955, her last year at Charmandean (this contradicts the 1954 date given elsewhere for the school's move to Buckinghamshire), the school had become still more dilapidated, and there was no money for repairs. Holes began to appear in the floors, and some of the ceilings fell in. Few new pupils arrived, and almost none stayed on into the sixth form. Finally, only twenty girls were left, and they all slept in one wing of the house. Sometimes there were no meals, because the two maids who were supposed to run the house left in the evening with carrier bags full of food intended for the girls. One night, the girls were so hungry that they went downstairs to raid the pantry, but there was nothing there, and they were reduced to eating charred toast they found in the dustbin.

Being in a semi-permanent state of hunger is one of both Billington's and Hulanicki's strongest memories of the school. All in all, Charmandean during its last few years in Worthing was not much of an advertisement for English private education.

SECTION 32

OFFINGTON

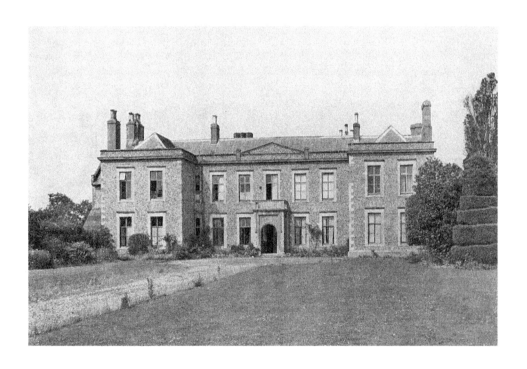

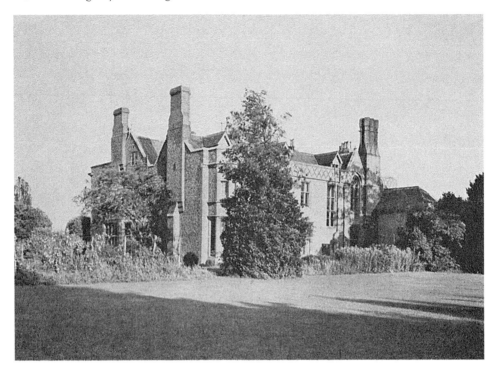

The west front of Offington. The photograph on the title page of this section shows the east façade, which was partially visible from the London road less than a quarter of a mile away. Both photographs date from the 1940s.

The manor at Offington dated back to Saxon times. The name means Offa's farmstead. Offa was a common name in Anglo-Saxon England, and, although King Offa of Mercia – who built Offa's Dyke – may have taken control over the kingdom of Sussex in the eighth century, there is nothing to link the Offington Estate with him.

In 1016 King Canute gave the land at Offington to Earl Godwin, one of the most powerful earls in England and father of King Harold, who was to die at the Battle of Hasting in 1066. It is reasonable to assume that when Godwin died in 1053, Offington was inherited by Harold, who was his eldest surviving son. After the Norman Conquest, the estate, which in those early days consisted of only around two hundred acres, passed into the hands of William Fitz Norman of Cumbe (Coombes, north of Lancing).

The West and De La Warr Dynasty

Those interested in the complete history of Offington should read Henfrey Smail's *Notable Houses of Worthing, No. 2* (1950), from which much of the information in the rest of this section is taken. In this sub-section, however, we will focus on the most interesting and important phase in Offington's history, the two hundred years between the late fourteenth and the late sixteenth centuries.

In 1387 the Offington estate was inherited by Alice Peverel, whose marriage to Sir Thomas West brought it into the ownership of the powerful West family.

His grandson, also Sir Thomas, who inherited the estate on the death of his father (yet another Sir Thomas) in 1405, fought at the Battle of Agincourt in 1415 under Henry V, having provided eighteen men-at-arms and sixty archers for the king's army.

The third Sir Thomas died childless in 1416, and the Offington Estate passed to his brother Reginald, who in 1427 inherited the De La Warr title and estates and became the 6th Lord De La Warr. Reginald supported the House of Lancaster during the Wars of the Roses, but this was a period when the House of York was in the ascendancy, and, as Smail puts it, he 'found it expedient to travel abroad'. Reginald's son, Thomas, inherited the estate in 1477. Not long afterwards the Yorkist cause died with Richard II at the Battle of Bosworth in 1485. Thomas West, 8th Baron De La Warr, found favour under Henry VII (reigned 1485–1509), the first monarch of the Tudor dynasty, and in 1497 he helped suppress the Cornish uprising under Perkin Warbeck. The 8th Baron remained in royal favour during the reign of Henry VIII (1509–47), as did his son, yet another Thomas and the 9th Baron, who inherited the estate and the title after his father died at Offington in 1525.

The 9th Baron was one of the eleven English noblemen who represented the county of Sussex at the Field of Cloth of Gold, the famous meeting between Henry VIII and the French Emperor Charles V at Gravelines in 1520, at which each monarch tried to outdo the other in splendour. De la Warr also rebuilt Halnaker House, the fortified manor house a mile north of Boxgrove, whose ruins are still visible today, and he entertained the king there in 1526.

In due course, however, relations between the two men deteriorated. De La Warr had frequently denounced the Dissolution of the Monasteries and was known to associate with other noblemen disloyal to the king. In December 1538 he was imprisoned in the Tower of London. Fortunately, however, he had powerful friends who interceded on his behalf, and he was released within five days or so and was in due course forgiven by the king. Forgiveness came at a price, however. Henry VIII had taken a liking to Halnaker when he stayed there in 1526, and he made De La Warr the kind of royal offer it was impossible to decline. In 1540 De La Warr was obliged to exchange Halnaker for Wherwell Abbey in Hampshire, a Benedictine nunnery that the king had stolen from the church during the Dissolution of the Monasteries.

The 9th Baron had no children, and had brought up his nephew, William, who lived with him at Offington, to be his heir. In 1549, however, William West was charged with attempting to murder his uncle. It was stated that 'not being content to stay till his uncle's natural death, [he] prepared poison to despatch him quickly'. West initially admitted the charge, but later claimed the confession had been forced out of him. In 1550 the case was tried by the House of Lords, and West was found guilty and disinherited by Act of Parliament. His uncle forgave him, however, and when the 9th Baron died in 1554 – of natural causes – William duly received the bulk of his estate, including Offington. He was, however, unable to inherit the barony of De La Warr on account of the 1550 Act.

Meanwhile, in 1556, William West had been involved in the Dudley conspiracy to try to remove the Catholic Queen Mary (reigned 1553–58) from the throne and replace her with her sister Elizabeth. West was tried for treason and sentenced to death, but the sentence was never carried out, and the following year he was pardoned. The accession of Queen Elizabeth (reigned 1558–1603) brought West

back into royal favour and, although the original title could not be restored to him, in 1570 he was created the 1st Baron De La Warr of the so-called 'second creation'.

The West / De La Warr dynasty's occupation of Offington ended suddenly at the end of the sixteenth century. William West died in 1595, and his son Thomas chose to live at Wherwell Abbey, which, as we have seen, Henry VIII had given his father in exchange for Halnaker. So, in 1597, Thomas sold Offington, bringing to an end the most colourful and notable period of its history. The West family's ownership of the estate had lasted for over two centuries.

After leaving Offington, the De La Warrs continued to be an English noble family of considerable distinction, and indeed the family name is perpetuated in America. The 3rd Baron of the new creation was in charge of a contingent of 150 men who landed in Jamestown, Virginia in 1610 to suppress a revolt by Native Americans, and he was then Governor of Virginia until his death in 1618. The state of Delaware, the Delaware River and the Delaware Indians all derive their names from him. In 1767, the 7th Baron of the new creation became the 1st Earl De La Warr. The De La Warr earldom survives to this day.

Offington from 1597 to 1963

Edward Barker, the man who bought the Offington estate from Thomas West in 1597, shortly afterwards sold it on to John Alford, and the estate remained in the Alford family for almost 130 years. Then, in 1726, it was sold to William Whitebread, on whose death twenty years later it passed to his nephew John Margesson.

It was probably John Margesson who pulled down the old Tudor mansion and built the Georgian house that stood on the estate for two hundred years, for Henfrey Smail dates these events to around 1770. The relatively modest Georgian country house seen in the illustrations was considerably smaller than the house that had stood at Offington from at least as far back as the fifteenth century. An inventory done at the time of the death of the 9th Lord De La Warr in 1554 tells us that at that time the house had sixty-five bedrooms, making it a mansion of almost palace-like proportions.

After John Margesson's death in 1783, the estate was inherited by his son William, who in 1816 sold it to John Theophilus Daubuz. In 1831 it passed to Daubuz's nephew John Baril Daubuz, who between 1854 and 1858 broke up the estate. The consequences of that break up are explored in Section 33, which focuses on Broadwater Hall and the Warren. The house and its parkland were sold to Major Thomas Gaisford, who built the picturesque eastern lodge (see Section 34). Major Gaisford died in 1898 and was succeeded by his son Julian. In 1909, however, Julian inherited from his mother's brother the Howth Castle estate near Dublin with its 9,000 acres of land, and he understandably chose to live there rather than at Offington, which he sold to Lady de Gex (1846–1937) shortly before the First World War.

Lady de Gex, the last private owner of the house, was the widow of Sir John de Gex (1809–87), an eminent Victorian QC, who was over seventy when he married for the first and only time, his wife being thirty-seven years younger. Smail points out that, since Sir John was born in 1809 (when George III was on the throne),

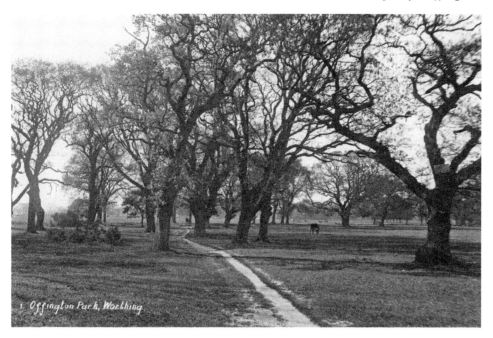

One of the drives through the park at Offington, photographed in 1910. As its reference number '1' indicates, this was the first card in Harold Camburn's long series of cards of the Worthing area.

Another Harold Camburn card from 1910, this time looking west along Shady Lane, as Poulter's Lane was often known at that time. Offington's park is on the right. The stile was located two thirds along from the Broadwater Green end of the lane.

and Lady de Gex died in 1937 (at the start of the reign of George VI), their two lives spanned 128 years and eight reigns. Smail says that Lady de Gex brought to Offington 'something of the grand manner of a departed age'. She used to travel around in an open landau driven by a cockaded coachman, accompanied by two or three King Charles spaniels. She attended Tarring's church every Sunday, where her entrance was marked by 'the expectant rustle and almost perceptible obeisance of the congregation'.

An article by John Simkin on his Spartacus History website tells us that not long after she acquired Offington, Lady de Gex sold much of the parkland to a company called Worthing First Garden City Limited, whose ambitious original intention, as the firm's name suggests, was to build a Garden City there. Minutes from a meeting of Worthing Council held in September 1913 indicate that work was intended to start imminently, but the First World War intervened, and by the time building finally began in earnest in the late 1920s the Garden City Project had been abandoned and the land was used for conventional development.

The two Harold Camburn postcards reproduced on the previous page, which depict Offington's beautiful park before it was built over, have messages on the back that contribute a few brushstrokes to our melancholy canvas. The cards were sent seven years apart by the same person – who signs with initials only – to the same recipient, a Miss Dunolly, who was in Stockton-on-Tees when the first card was sent and in Southampton at the time of the second.

The message on the back of the postcard of the heart of the park, posted in May 1914, includes this: 'This park will soon be cut up for building: so no more shady seats.' The postcard featuring the view of Shady Lane – Poulter's Lane, formerly Poletree Lane, which still runs east from Offington Lane to Broadwater, but looks very different today – was posted in August 1921, and has this on the back: 'Have sent you P. C. of the lane, which is a wide road now, so you must keep it. There's no beauty in it now.'

There is a similar tone of regret in words written in 1939 by a local man called S.G. Carver, which are quoted in John Simkin's article:

> The lodge at the entrance was always a picture, with a pretty garden and the avenue lined with trees ... Poulter's Lane was known as the lovers' walk, being heavily lined with trees which met overhead, and formed a delightful walk on a summer evening. The park was enclosed on all sides with the famous Sussex flint walls.

Carver adds that the property had fallen into the hands of 'a group of speculators' who made a 'deplorable mess' of this 'once charming park'.

Lady de Gex remained at Offington House until 1935 and then moved to Havant, dying in Gosport two years later. The new owner of the house divided it up into flats, but this situation lasted for less than three decades. Finally, and almost inevitably, the old house, which by now had lost almost all the land that had given it context, was demolished in 1963.

SECTION 33

BROADWATER HALL & THE WARREN

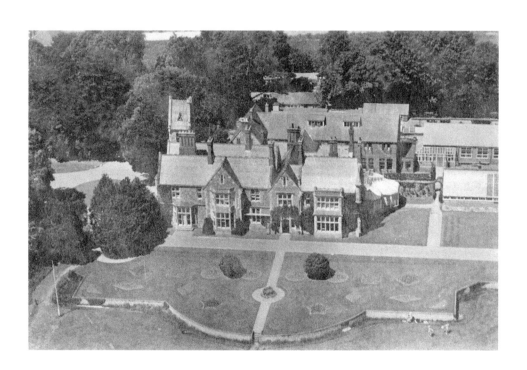

In the mid-nineteenth century, two large houses, South Farm Mansion (later Broadwater Hall) and the Warren – seen on the title page of this section – were constructed on land that had recently been sold out of the Offington estate. They were located just over a mile apart, respectively three-quarters of a mile south-west and three-quarters of a mile north-west of the village of Broadwater. They were built within a decade of each other by the new owners of two former Offington farms who found the existing farmhouses on their land too humble for their households and their aspirations. The histories of the two new houses continued to run in parallel. Both in due course became schools, and they were demolished in the same year; and both, particularly Broadwater Hall, are now all but forgotten.

The Two Farms

At the start of the eighteenth century – as, seemingly, for some two hundred and fifty years prior to that – most of the agricultural land attached to the Offington estate consisted of two separate farms. The northern farm was called Offington Warren Farm, named after a rabbit warren that had been on the land in the fifteenth century. The farm on the southern part of the estate was known as South Farm – hence South Farm Road, which runs from north-west of Broadwater Green to the junction between Tarring Road and Teville Road.

William Margesson (1757–1843), who inherited Offington from his father in 1785, occupied only seventeen acres of his land, most of the remaining 872 acres being let. Then in 1816 he sold the entire estate to John Theophilus Daubuz. Daubuz's main estates were in Essex – at Leyton, Walthamstow and Chingford – and the Offington Estate seems primarily to have been used as an investment. Like Margesson, he leased out most of the land, and in 1819 he built Offington Warren farmhouse for the tenant of the northern of the two farms.

After J. T. Daubuz died in 1831, the Offington estate passed to his nephew James Baril Daubuz (1795–1874). Unlike his uncle, J. B. Daubuz did live at Offington, and indeed he involved himself in Sussex affairs, and in 1846 was High Sheriff of Sussex. Twenty years before his death, Daubuz decided to dispose of the Offington estate, and he maximised his profits by selling it in sections. In 1854 he sold South Farm – which consisted of ninety-five acres – to George Orme (1797–1867), after whom Orme Road, at the southern end of South Farm Road, is named. Then, at some point between then and 1858, he sold Offington Warren Farm to Captain – later Colonel – Thomas Wisden (1835–1904) and a further sixty-one acres of land north of South Farm to Orme. Finally, Offington House and what was left of the estate – effectively just the park – was sold in 1858 to Major Thomas Gaisford (1817–1898).

George Orme

Soon after his purchase of South Farm, George Orme built a fine new house to the south of the existing farmhouse. This house was situated a hundred yards or so to the west of South Farm Road, between Bulkington Avenue and Henty Road. It was certainly in place by the autumn of 1858, for on 16 November of that year a report in the *Sussex Advertiser* of a wedding included the information that 'the second carriage

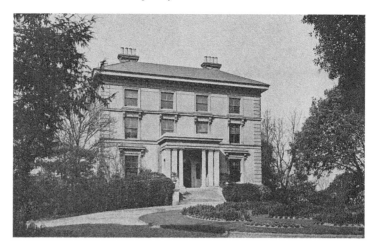

Broadwater Hall, formerly South Farm Mansion.

contained Miss [Maria] Orme, Miss Harriet Orme, and William Orme, Esq. of South Farm Mansion, and Miss Margaret Thomas, of Bognor'. In the 1861 census, the house is again described as South Farm Mansion, but subsequently – probably after George Orme's death in 1867, and certainly by 1891 – it became known as Broadwater Hall.

The Ormes were a well-known London firm of so-called rectifying distillers, and Orme's name appears on the list of subscribers to the Licensed Victuallers School for the period from Lady Day (25 March) 1824 until Lady Day 1825, his address being given as the Unicorn Distillery, Great Surrey Street, Blackfriars Road. Most of the subscribers paid the annual subscription of one guinea, which entitled them to 'one vote for the admission of children', but George Orme had paid ten guineas, a life-subscription that gave him four votes.

At around the same – on 14 January 1824 – George Orme found himself at the Old Bailey to give evidence in the trial of an eighteen-year-old youth called Frederick Turner who had stolen from him a handkerchief worth four shillings. Orme gave the following account of the crime:

> I live at the Unicorn distillery. On 8th of December I was in Cow-lane, between eleven and twelve o'clock in the day, and felt my handkerchief drawn from my pocket. I turned round and saw the prisoner with it in his hand – he ran off; I followed and took him. He had then dropped it, and another person gave it to me.

Turner offered the following somewhat feeble defence: 'The gentleman turned round and said I had his handkerchief. I ran, fearing to be taken, as I had been a long time out of work.' The luckless young man was found guilty, and sentenced to three months in prison.

Broadwater Hall School

Documentary evidence about Broadwater Hall School is hard to come by. Indeed the photograph reproduced here is the only image I have seen of the building, in either its South Farm Mansion or its Broadwater Hall days. The school was certainly in business by 1910, for in that year an advertisement told readers of the *Spectator* that

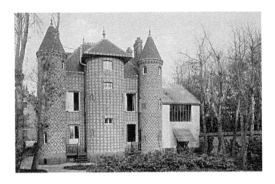

Le Plein Air in Dieppe, the French 'branch' of Broadwater Hall School.

Broadwater Hall, run by the Misses Tritton, offered a 'thorough and consecutive education', with special arrangements available for pupils from abroad. There was also a 'finishing branch' at Le Plein Air in Dieppe.

The following year *Whitaker's Almanack* carried a similar advertisement under the heading 'Twin Seaside School [*sic*] in France and England – Under Joint Management'. Again the 'thorough and consecutive education' on offer was stressed, together with 'a happy home life', 'good air and beautiful surroundings' and 'excellent sanitation'.

The 1911 census tells us that the Misses Tritton that ran the school were three in number: Ethel (1857–1932), the headmistress; Marian (1865–1943); and Rosamond (1867–1940). A fourth sister, Agnes (1859–1933), also worked in education – she was a governess – and it is possible that she subsequently joined the staff of the school, for it was in Worthing that she died. All four Tritton sisters were born in Great Yarmouth, where their father, William, was the minister of the Congregational chapels in Middlegate and King Street.

The other members of the teaching staff at Broadwater Hall School in 1911 were a French governess aged twenty-one and an English teacher aged nineteen. These two teachers were barely older than many of the pupils. On the date of the census there were eleven boarders in residence, nine of them aged between fifteen and seventeen, one aged thirteen and one aged twelve. This was not the school's full complement, for there were probably day pupils as well, the census recording only those who spent the night of 2 April on the premises. The domestic staff in 1911 consisted of Frederick and Anne Pond (the handyman and the cook), and two housemaids aged eighteen and sixteen.

The school seems to have closed around 1930, for in that year the *Journal of Education* carried an advertisement placed by a Miss Tritton – this was presumably Ethel – of Worth Cottage, Worthing for the sale of Le Plein Air which 'has been for years a Finishing School for Girls connected with Broadwater Hall, Worthing'. The price, including furniture, was £3,700.

From around 1908 South Farm and the land around Broadwater Hall had begun to be built over. By 1952 South Farm farmhouse had been demolished and Broadwater Hall divided into flats. Then, in 1972, Broadwater Hall too was demolished, and a modern block of the same name was built on the site.

The Warren School

Soon after he acquired Offington Warren Farm in the late 1850s, Thomas Wisden built (in 1865–67) the Warren house on his land. The respective photographs of

the Warren and Broadwater Hall show that the Warren was by far the grander of the two houses, and indeed Wisden and his family lived there in some style. In 1901, the domestic staff consisted of a cook, a kitchen maid, a scullery maid, four housemaids, a butler, a footman and a groom – although this was fairly typical for a medium-sized country house before the First World War.

After Thomas Wisden's death in 1904, the farmhouse and over five hundred acres of land were leased to Worthing golf club, but the family continued to live at the Warren. Thomas' eldest son, Lyon Wisden, died in 1929 at the early age of forty-five, and his mother three years afterwards. The Warren became a girls' school after Lyon's death, and this remained the case for thirty-five years.

A report in the *Glasgow Herald* of 9 May 1967 tells us that it was in 1966 that the Warren (together with twenty acres of grounds) was sold to the Excess Insurance Company and that by the end of that year the company's motor department was established there, with over two hundred and fifty employees. Sadly, Excess Insurance decided that a modern building would be better suited to its needs, and the Warren was demolished in 1972 – the same year as Broadwater Hall – and replaced by a typically hideous building of the period. The old lodge, however, survived, and still stands today on the north side of the A27, around three hundred yards north-west of the roundabout at the A24 junction.

The new buildings on the Warren site continued to be occupied until 2010 by Excess Insurance and its successor companies: London and Edinburgh Life, which merged with Excess in 1978; Norwich Union, which acquired London and Edinburgh in 1998; and finally Aviva, as Norwich Union became known in 2002. After Aviva withdrew from Worthing in 2010, the site returned to educational use, and in 2013 – almost half a century after the girls' school at the Warren had closed – the new Worthing College campus opened in the same location.

Shirley Cohen

Among the pupils at the Warren School were two notable but very different women.

One was Shirley Cohen, the younger daughter of Jack Cohen, the founder of Tesco. In the 1990s, Shirley Porter, as she was then, was to be at the heart of one of the biggest political corruption scandals of the era. While leader of Westminster City Council between 1983 and 1991, Shirley Porter – who became Dame Shirley in 1991 – was the leading figure in the so-called 'Building Stable Communities' policy, which was in fact a complicated and carefully organised conspiracy to ensure that the Conservatives would retain control of the council by moving people likely to vote for the party into the eight electoral wards that had been the most marginal in the 1986 council elections. This illegal and improper policy came to light and was investigated, and a surcharge of £27 million was levied on Porter and five others in 1996, later raised to £42 million with interest and costs. She eventually settled in 2004, paying a 'full and final settlement' of £12.3 million.

On the outbreak of war in 1939, Shirley and her sister Irene were sent to board at the Warren, which Shirley – who was there for five years – hated. When she heard that the building had been demolished she apparently said 'Good riddance!' A lengthy account of Shirley Cohen's time at the school appears in Andrew Hosken's biography of her, *Nothing Like a Dame* (2006), from which most of the information in the rest of this sub-section derives.

Shirley was at the Warren during the thirty-seven-year headship of the formidable but eccentric Gertrude Ashworth (1870–1950), who was always known as 'GA', pronounced 'Jay'. Something of GA's character can be deduced from the fact that a short history of the school by David A. Cross, published in 2006, was entitled *Churchill in Petticoats: Gertrude Ashworth and the Warren School, Worthing*. Probably born in 1873 (some records have 1874 or 1875), Miss Ashworth became the headmistress of Steyne High School for Girls in 1913. The School moved from the Steyne to Homefield, Lyndhurst Road in 1924 or 1925, and then to the Warren, with Miss Ashworth remaining headmistress until her death in 1950.

GA, like her fellow headmistress, Lottie West of Charmandean (see Section 31), apparently had expensive tastes. She bought herself fine silk blouses and often went up to London to see plays, dining afterwards at the Trocadero. In the classroom, GA was unpredictable. She not only threw blackboard dusters or inkpots at the inattentive, but also on one occasion lit a firework behind a daydreaming girl. Games, as often at schools in those days, were as important as work, and GA was given to such mantras as, 'Now, girls, you want to work hard and play hard and don't get them muddled up.'

Shirley Cohen does not seem not to have fitted in well with the culture at the Warren School, nor to have been popular with the other girls. One contemporary said she 'tended to rub people up the wrong way', unlike Irene, whom everyone liked. Jack Cohen and his wife Cissie bought a bungalow at Elinore Crescent so that they could spend time with their daughters at weekends.

However, Worthing, even with mines and barbed wire all over the beach to deter a German invasion, was not felt to be safe enough for Gertrude Ashworth's girls, and after the fall of France in June 1940 the school was evacuated to a hotel near Land's End. Shirley was in Cornwall for a year, and there she felt even more isolated. All her memories of the period of the school's evacuation were of being cold and hungry.

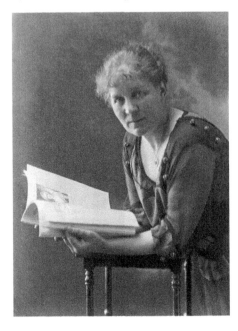

Gertrude Ashworth, headmistress of the Warren School (formerly Steyne High School) from 1913 to 1950. This photograph was taken around 1925. (© www.westsussexpast.org.uk)

Steyne High School's Fifth Form during the second half of the 1920s, when the school was located at Homefield House in Lyndhurst Road. The school, which had started life in 1888 in the Steyne, moved to the Warren in 1929 and took the name of its new location. The aerial view of the Warren on the title page of this section probably dates from the end of the 1930s.

One reason for Shirley's unhappiness was that in those days there was what Andrew Hosken describes as 'a cultural anti-semitism which was widespread in England and elsewhere in Europe'. There were several Jewish girls at the Warren, most of whose parents had fled to England to escape Nazi persecution, and they became a clique. Shirley Cohen's sense of her Jewishness made her feel self-conscious and, although there were doubtless real slights, some were imagined. She later wrote, for example, that she was passed over for the post of Head Girl because of her Jewishness. However, contemporaries have no memory of her having been suitable for the position, and indeed she did not remain at the school long enough to be eligible, since her father withdrew her from the school when she was fifteen or so. She then went to a finishing school in Switzerland, which she also disliked, leaving after seven months; and in 1949, at the age of only eighteen, she married Leslie Porter, a man ten years her senior.

Pam St Clement

The experience at the Warren School of the actress Pam St Clement (born Pam Clements) – best known for playing Pat Butcher in the BBC soap opera *EastEnders* from 1986 until 2012 – was more positive. In her 2015 autobiography, *The End of an Earring*, she paints a vivid picture of her time at the Warren in the fifties. She started at the Red House, the Warren's junior school, located two-thirds of a mile away, in Ashacre Lane. She says that she took to boarding-school life in Worthing

'like a duck to water'. She was there for what she calls 'seven fulfilling years', and, coming as she did from what she describes as 'a chaotic parental background' – her mother died soon after she was born, and she was put into foster care when her father remarried – she enjoyed the sense of structure and stability the school gave her. She even liked the school song, whose first two verses went:

> Oh may the school we love forever flourish
> And be the better for our passing though,
> For we upholders of an old tradition
> Are builders of a new.
> So in our school we crave a healthy outlook
> A quickened interest in all we find
> That we may never know the sin of boredom
> Or listlessness of mind.

As for many people, Pam's memories of school food are vivid. The main constituent of breakfast at the Warren was a slimy porridge that called to mind the gruel in *Oliver Twist*. Lunch might consist of a gristly stew, boiled potatoes and overcooked greens, followed by blancmange or milky rice pudding with skin on top. After games in the afternoon, there was a mug of tea and two slices of bread, the topping depending on what day of the week it was: jam on Monday, Marmite on Tuesday, sandwich spread (which Pam hated) on Wednesday, chocolate spread on Thursday, and Shippam's bloater paste (which she hated even more) on Friday. Supper was insubstantial.

Although Pam liked school, she was by her own admission very naughty. At the lower end of the scale, this consisted of listening under the bedclothes to Elvis Presley and Tommy Steele on Radio Luxembourg, but she also remembers cycling with other girls round Broadwater Green at dead of night, with coats over their pyjamas. They chatted to boys on the adjacent golf course, and indulged in a certain amount of voyeurism, spying on courting couples on the downs. She says that the various areas of amenity land near the school were 'a magnet for every flasher in Sussex', and that one flasher who regularly visited the school copse 'became quite an attraction'. Puzzled prefects used to come across 'groups of girls giggling to the point of weeping'. When, in due course, the police were called, Pam was very embarrassed to have to explain to the male police officer what she had seen.

As we saw in the account of Shirley Cohen's schooldays, games and outdoor activities were important at the Warren. Pam disliked cricket and golf, but enjoyed archery and, in particular, riding. The school had its own stables, run by the eccentric Captain Willy, who was uncomfortable in the presence of teenage girls. Most important for Pam, however, was the fact that it was at the Warren that she developed her passion for acting, and she became the president of the Drama Society – although what she describes as her 'physicality' meant that she often played male roles, including Joss Sedley in *Vanity Fair* and Mr Bennet in *Pride and Prejudice*.

SECTION 34

The Lodges at Offington

At various times in the nineteenth and twentieth centuries, there were no fewer than four lodges on the Offington estate; a fifth was in due course built to serve Broadwater Hall; and there was a sixth lodge that may or may not have been associated with Offington. All but the lodge for Broadwater Hall are marked on the map of Offington that is reproduced on page 252.

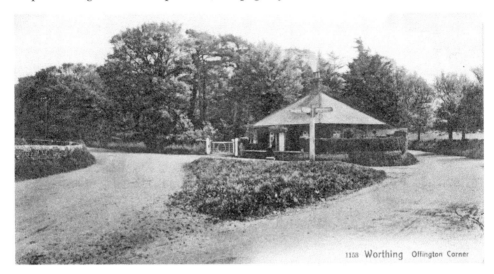

The lodge at Offington Corner, photographed from the north. The official name of this lodge was originally North-West Lodge, then North Lodge, and later Offington House Lodge, Durrington. The road to the left, halfway up the picture, is the road to Worthing (today the A24), and the road leading straight ahead on the right of the picture is Offington Lane.

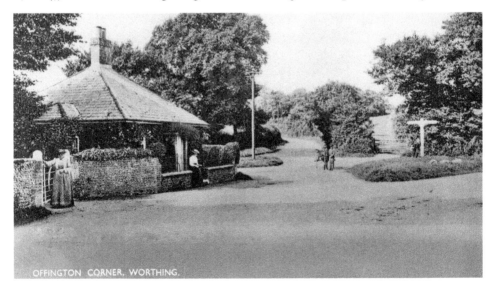

This time the lodge at Offington Corner is seen from the east, with the road to Arundel straight ahead, the road to London on the right, and Offington Lane leading off to the left just past the lodge.

The best known of the Offington lodges was the one built at the north-west of Broadwater Green by Major Thomas Gaisford, who bought the house and the park in 1858. It was often known locally as Major Gaisford's lodge. This section is therefore an appropriate place to set down a brief account of the fortunes of the distinguished Gaisford family, who owned Offington for around half a century.

The Gaisfords

During his career as a regular soldier in the 79th Highlanders, Thomas Gaisford (1816–98), who bought Offington in 1858, reached only the rank of captain. His rank of major related to his time with the 2nd Sussex Battalion of volunteers, in effect the local territorial army of its day. (The material in this sub-section comes mainly from old census records and from two websites: www.gaisfordfamily.com and www.thepeerage.com.)

Major Gaisford's father, also Thomas (1779–1855), was a cleric and scholar. From 1812 until his death – therefore for over forty years – he was Regius Professor of Greek at the University of Oxford, and from 1831 onwards also Dean of Christ Church. Although Major Gaisford had five half-siblings by his father's second wife – the eldest of them eleven years younger than him – he had only one full sibling, his brother William, who drowned in tragic circumstances in 1843, at the age of only twenty-one.

William got into difficulties while swimming at Sandford Lock, just south of Oxford. His friend, Richard Phillimore, son of Joseph Phillimore, Regius Professor of Civil Law at the university, tried to save him, but both young men drowned. They are buried in Christ Church Cathedral and commemorated by an obelisk at Sandford. In 1921, the same location was to claim the life of Michael Llewelyn Davies – the adopted son of J. M. Barrie and the inspiration for Peter Pan – in almost identical circumstances, although Llewelyn Davies's intention may have been to kill himself. Either way, he and a close friend who followed him into the water both drowned.

We do not know how Major Gaisford acquired the wealth and social position that enabled him to buy Offington and to move – and indeed to marry – in such elevated circles as he did. It is unlikely that any wealth passed down from his mother, Helen, who was the daughter of a country vicar. However, it is telling that one Christmas Day Gaisford's father preached a sermon in Christ Church Cathedral that included the following rather un-Christmassy sentiment: 'Nor can I do better, in conclusion, than impress upon you the study of Greek literature – which not only elevates above the vulgar herd, but leads not infrequently to positions of considerable emolument.'

Perhaps being a professor of Greek at Oxford was more financially rewarding than we might suppose. It is unlikely to have been a coincidence that it was three years after Major Gaisford's father died in 1855 that the major bought Offington for £12,000 (over £1 million in today's money). Before he moved in, he spent a further £5,000 on improvements and additions, including a new wing, a chapel for (Catholic) worship, and a library to house his father's vast book collection, which, when it was sold at auction in 1890, realised around £12,000. The new lodge at the north-west of Broadwater Green was another enhancement to the estate.

Thomas Gaisford married three times, and each of his wives was the daughter – or, in the first case, the granddaughter – of a nobleman.

Gaisford's first wife, Horatia Feilding, was the daughter of Rear-Admiral Charles Feilding and Lady Elizabeth Fox-Strangways, granddaughter of Henry Fox-Strangways, 2nd Earl of Ilchester. She married Gaisford on 1 January 1850, but died only nineteen months later, on 8 August 1851, probably during or after the birth of their only child, Horace, since he was born (on an unknown date) in that year. All this, of course, was before Gaisford owned Offington. Horace Gaisford became a Lieutenant in the Grenadier Guards and was killed in action in 1879 during the Second Anglo-Afghan War.

Gaisford's second wife, whom he married in 1859, was Lady Emily St Lawrence (1830–68), the eldest daughter of the 3rd Earl of Howth. They had seven children, though the eldest of these, Cyril, died in infancy. Lady Emily died on 6 November 1868, after only nine years of marriage, and again in all probability the death was during or after childbirth, since it was in that year that her youngest child, Philip, was born.

Some sense of the elevated social life that Major Gaisford and Lady Emily lived at Offington can be gauged from the fact that, on the day of the 1891 census, four noble guests were staying at Offington – the Countess of Cork, Sir Robert Brownrigg, and the wife and daughter of Lord Dormer. In addition to the Gaisfords' own nine servants, there were three visiting servants at Offington on that day, two of them lady's maids (presumably those of the Countess of Cork and Lady Dormer) and the third – mysteriously – a 'fishman'. As we saw in Section 33, Julian, Major Gaisford's eldest surviving son with Lady Emily, inherited the Howth Castle estate near Dublin when his uncle, Lady Emily's brother, William St Lawrence, 4th Earl of Howth, died unmarried in 1909. Julian added his mother's surname to his, probably as a condition of his inheritance, and the Gaisford-St Lawrence family own the Howth estate to this day.

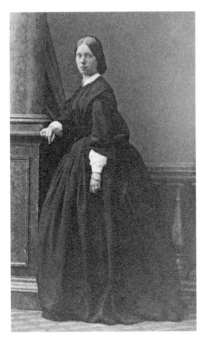

Lady Alice Kerr, photographed in 1860, ten years before she became Major Thomas Gaisford's third wife. Photograph by Disdéri. (© National Portrait Gallery, London)

In June 1870, less than two years after Emily's death, Gaisford married for the third and final time. His new bride was Lady Alice Mary Kerr (1837–92), the daughter of the 7th Marquess of Lothian. She was more than twenty years younger than the major. They had two sons, the elder of whom, Lieutenant Colonel Walter Gaisford, was killed during the First World War, on the first day of the Battle of Loos on 25 September 1915, while he was commanding the 7th Battalion of the Seaforth Highlanders.

The Gaisfords are commemorated in the names of two streets in Worthing – Gaisford Road and Gaisford Close – though these were built on land west of South Farm Road that was never in the ownership of the family, having been sold out of the Offington Estate in the 1850s before Major Gaisford bought it.

The Lodges at Offington

It is from the Ordnance Survey map of 1879 and original handwritten census records from between 1861 and 1901 that we learn that there were five lodges on the 'extended' Offington estate (we use that term because, as we saw in Section 32, the Warren Farm and South Farm had been sold out of the estate in the 1850s) – and not just the two well-known lodges familiar from old photographs and postcards.

Confusingly, four of the lodges went under at least two different names during their existence. Establishing which lodge had what name at which period is not always

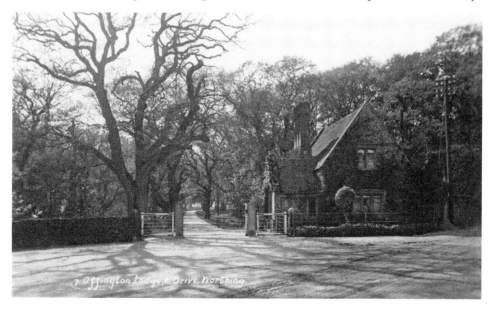

The most substantial and often photographed of the lodges that served the Offington estate was built by Major Gaisford in 1858 after he bought Offington. For many years its official name was East Lodge, but by the start of the twentieth century it was known as Offington House Lodge. In the photograph of this lodge on the title page of this section, the road straight ahead is the road to Offington Corner, Findon and London, today the A24. This Harold Camburn postcard from 1910 is of the rarely photographed view up the drive.

as straightforward as might be supposed, because nineteenth-century censuses of scattered rural dwellings were often conducted in a very unmethodical manner. In the case of the Broadwater and Offington area, the enumerators for a new census did not return to the 'template' of ten years earlier, but instead started again from scratch, following new and sometimes fairly haphazard geographical sequences.

It does not help that dwellings are often not given proper addresses or locators, so the sometimes illogical geographical sequencing is our only guide. In addition, the 1881 census is useless for our purposes, because that year the enumerator for the relevant area did not bother to include any addresses or the names of any buildings. All that appears is a list of the names of individuals living in the Broadwater and Offington area in 1881.

The only one of the Offington lodges proper that survives today is the lodge named on the 1861 and 1871 censuses as North Lodge. This was the lodge that served Offington Warren Farm and then the Warren. Although Offington Warren Farm was sold out of the estate in the mid-1850s, no one initially saw any need to rename the lodge. As already indicated, the 1881 census is no help to us, so we do not know what the lodge was called in that year. By 1891, there had been a rationalisation of the nomenclature of the various lodges at Offington, and the lodge that served the Warren was now no longer called North Lodge but is listed as 'Lodge, The Warren'.

The lodge on the west side of the estate was situated on the east side of Offington Lane, just north of the Ashacre Lane / Offington Avenue crossroads, and was the nearest lodge to Offington House, which stood roughly where Hall Close now is. In the 1861 census this lodge is named as Grove Lodge; in 1871 as West Lodge, The Grove; and by 1891, following the rationalisation of names, as simply West Lodge. There was a further renaming process at some point between 1891 and 1901 – probably conducted by Julian Gaisford after his father died in 1898 – and this resulted in the removal of geographical names and West Lodge reverting to its former name of Grove Lodge.

The single-storey lodge of which there are two photographs on page 236 was located at Offington Corner, which is now the busy roundabout just south-east of Durrington cemetery, at the junction of the A27 and the A24. In the 1861 and 1871 censuses this is named as North-West Lodge, but by 1891 it had become simply North Lodge, that name no longer being in use for the lodge that served the Warren. Then, when the geographical names were removed at some point between 1891 and 1901, North Lodge (formerly North-West Lodge) became Offington House Lodge, Durrington, and the much-photographed eastern lodge became Offington House Lodge.

The eastern lodge stood to the north-west of Broadwater Green, where what is today Offington Avenue bends sharply south. It was at the other end of Warren Road from – and three-quarters of a mile south-east of – the lodge at Offington Corner. A number of early postcard publishers, however, confused the locations of the two best-known lodges on the estate and incorrectly added the words 'Offington Corner' to the captions of postcards of the eastern lodge.

The eastern lodge, which had been built in 1858 as part of Major Gaisford's programme of improvements before he moved into Offington, was, as already mentioned, often referred to as Major Gaisford's Lodge, but this conversational name did not appear on the censuses. In the 1861 census it has the logical name East Lodge, and this seems to have been its name until at least 1891. Then, after

the removal of the geographical markers in the lodge names by 1901, it was, as we have seen, called Offington House Lodge. According to Robert Ellery's *A Millennium Encyclopedia of Worthing History* (1998), this lodge was demolished in 1959, so it stood for almost exactly a hundred years. During the Edwardian era the eastern lodge was a particular magnet for postcard photographers, partly because it was a notable landmark for those driving to and from Worthing on the London road, and at least twenty different postcard views of it were published.

As well as the lodges on the western side of the park, at Offington Corner, and north-west of Broadwater Green, there was a fourth lodge – South Lodge – that also served the house at Offington (thus, leaving aside the lodge that served the Warren Farm). The Ordnance Survey map of 1879 shows that South Lodge was located along Poulter's Lane – at that time known as Poletree Lane – about a third of the way between Broadwater Green and Offington Lane, and that a diagonal drive connected it to West Lodge.

Just as the owners of the Warren farm and the Warren house had their own lodge, so in due course did the new owners of South Farm, which was also sold out of the Offington estate in the 1850s – and Broadwater Hall Lodge, serving Broadwater Hall (formerly South Farm Mansion), was in existence by 1891. This lodge was located at the entrance to the short drive to Broadwater Hall, on the west side of South Farm Road, just north of Henty Road.

There was yet another lodge immediately adjacent to the Offington estate, a building that still stands, just south-east of the junction of the A24 and the A27 and only a few yards to the east of where Major Gaisford's Lodge used to be. This building, which was – and is – called Grove Lodge, is today occupied by the Grove Lodge Vetinerary Hospital. Confusingly, 'Grove Lodge' was also, as we have seen, the name that was used at various times for the lodge on the western side of the Offington estate. The 'eastern' Grove Lodge, which was the wrong side of the main road to serve as an entrance to Offington, may not have been part of the estate, and indeed it did not stand at the entrance to a private drive to any other house. It may therefore have been a lodge in name only.

The Monerys

The lodges almost always housed employees of the estate. In 1861 West Lodge (at that time known as Grove Lodge) was occupied by a young woman called Maria Habgood who, although she is described as a sailor's wife, was probably employed at Offington. In 1871 a coachman, Thomas Callcutt, was living there, and by 1891 it was the home of a domestic servant named George Dullen. The lodge at Offington Corner (North-West Lodge, later North Lodge, and by 1901 Offington House Lodge, Durrington) had a more consistent occupancy pattern, since an estate gardener seems always to have lived there. In 1861 this was Charles Leggett, between at least 1871 and 1891 it was Richard Monery, and in 1901 it was John West.

On 25 November 1882, Richard Monery's second son, Frederick, placed this advertisement in *Gardeners' Chronicle*: 'To Nurserymen – Wanted, a situation to work in the houses [that is, greenhouses]. Two and a half years' experience in a nursery. Age 17; good character. – F. M., Offington Lodge, near Worthing.'

The address he gives seems oddly imprecise, in view of the fact that the eastern lodge laid at least equal claim to that name.

Frederick was born in 1866 and so was actually no older than sixteen at the time. He added a year to his age for the purposes of the advertisement, presumably to make himself a more mature and tempting prospect. Since *Gardeners' Chronicle* was a national publication, Frederick may have been happy to work elsewhere in the country if necessary. Either way, he probably hoped to escape from the crowded little lodge which he shared with his parents, two brothers and a sister.

In the event, he remained in the area, and by 1891 was married with two small children. His first wife, Millicent, was probably, like Major Gaisford's first two wives, a casualty of what at that time was the dangerous activity of childbirth, for she died in 1901. Frederick remarried the following year, and in 1911 he was living at No. 78 Cranworth Road – a modest but charming terraced house with a forecourt, which still stands just east of Worthing Hospital – with his second wife, Margaret, their four-year-old daughter May, and twenty-two-year-old Ellen, his daughter with his first wife. His occupation is listed as 'Gardener – Fruit Grower'.

In those days few men of any social class seem to have remained unmarried for long after their wives died, and the same applied in the case of Frederick Monery's father, Richard, a man as fertile as his employer, Major Gaisford. In 1871, Richard was living at North-West Lodge with his first wife Fanny and four children. Fanny died in 1881, once again probably in childbirth, since her youngest child Theresa was born the same year. The following year Richard married Cecilia Tribe, a woman nineteen years younger than him, and in 1891 the pair were living at the tiny lodge with five children, none of whom were the children who had shared the lodge with Richard twenty years earlier. The children there in 1891 were his two youngest children with Fanny, and three he had had with Cecilia. The fecund Richard Monery died in Worthing in 1918, at the age of seventy-nine.

In the 20 February 1892 issue of *Cycling* magazine, the second Mrs Monery is described as 'the cyclers' friend at Offington Lodge', so she presumably offered refreshment to cyclists who paused at Offington Corner, the important junction where the road from London to Worthing crossed the Chichester to Brighton road.

SECTION 35

THE COTTAGES AT GORING CROSSWAYS

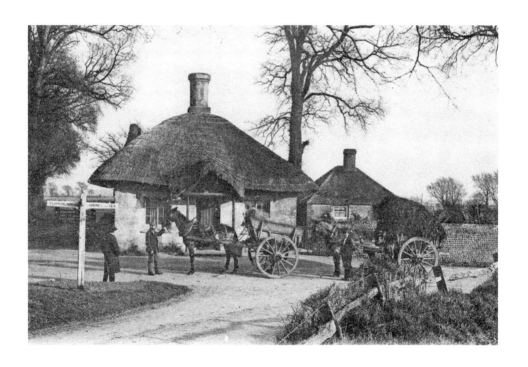

Just as the lodges at Offington Corner and at the north-east of Broadwater Green were landmarks for those entering Worthing from the north, two tiny cottages that stood at the junction that used to be known as Goring Crossways served the same purpose for those travelling from the west. This location is now the busy roundabout at the junction of the A2700 (Titnore Lane), the A2032 (to Worthing), and the A259 (from Littlehampton to Goring).

Goring Crossways can be seen near the bottom left-hand corner of the extract from the 1879 Ordnance Survey map that appears on the title page of the map section of this book (page 247). This map shows what a rural and indeed isolated location this was a century and a half ago, consisting mainly of a few scattered farmsteads.

The cottage that stood on the south-east corner of the crossroads, which had a postbox in its north-facing wall, is sometimes referred to as a toll house, but it cannot have served this purpose, since the road that ran west out of Worthing to Littlehampton was never a turnpike road.

The cottage was demolished in 1938, and today its site lies under the roundabout. Most photographs of the scene suggest that the cottage stood alone, but the two east-facing views (on the title page of this section and on page 246) demonstrate that the more familiar cottage was in fact one of a pair, the second being very close to it, but set slightly further back from the road.

The two cottages were humble farm labourers' cottages, and they originally had no name, although census records suggest that during the latter part of their existence they may have been called Crossways Cottage and Crossways Lodge, though it is not clear which was which. It is possible that they were associated with Northbrook Farm, which by the later years of the nineteenth century had two

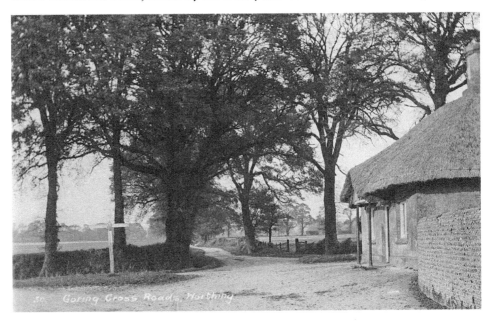

Goring Crossways, looking north up Titnore Lane, with the road to Littlehampton (today the A259) on the left and the road to Worthing (today the A2032) on the right. A Harold Camburn postcard, dating from 1910.

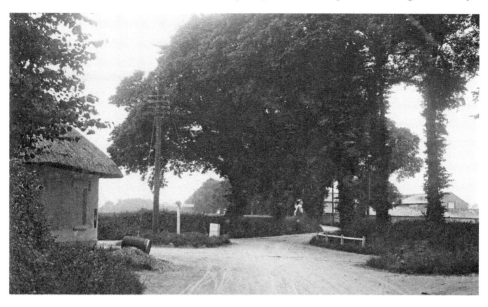

A view from around 1917 of Goring Crossways, looking west towards Littlehampton, with Goring Street leading off to the left. The barn complex on the right of the picture – marked as North Barn on the 1879 map – is today the Swallow's Return pub.

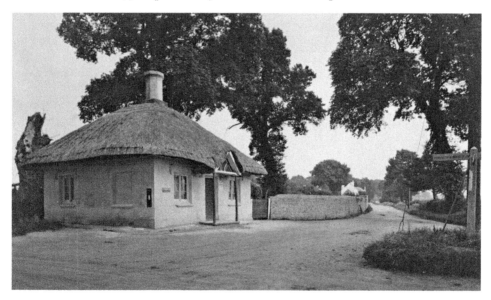

Looking south down Goring Street in the direction of Goring Station.

farmsteads. The lesser of the two, which was known as either Lower Northbrook or simply Northbrook, was about a quarter of a mile to the north-east of Goring Crossways. The larger – and almost certainly later – farmhouse, Upper Northbrook, was about a quarter of a mile to the north of Northbrook, and three hundred yards east of Titnore Lane, along a drive that is today known as Titnore Way.

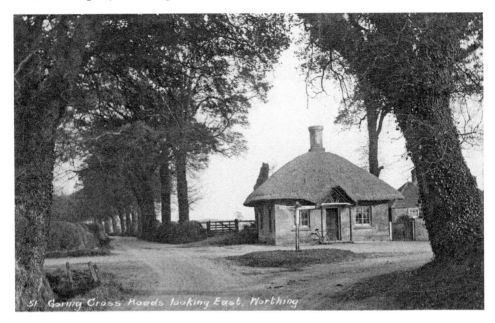

51. Goring Cross Roads looking East. Worthing

Another 1910 Harold Camburn postcard, this time looking east towards Worthing. This, and the photograph on the title page of this section, which dates from around 1904, are two of the very few postcard views of Goring Crossways that include the second cottage.

Titnore Lane, which was an ancient drove road from the coastal plain to the downs, is described in one old document as 'the way which leads from Horsecroft to the Park'. As early as 1682, the name Horsecroft appears at this exact location, and it is possible that the name was associated with these two little cottages and, indeed, that they date back to that period. They are marked on the Ordnance Survey map of 1813 – although, as on later maps, the scale is too small for the cottages to appear as different structures – but they were certainly older than that.

ORDNANCE
SURVEY MAPS
OF 1879

~

The numbers on these extracts from the Ordnance Survey map of 1879 relate to the sections in the book that feature the buildings in question. Where two or more buildings appear in the same section, the section numbers are followed by 'a', 'b', 'c' and so on.

On the first four maps, the numbers on the map are located below the building they refer to, except in the case of the sites of buildings not yet in place in 1879, where the number appears on top of the future building's location.

Map A

Map A – West Worthing and Heene Parade
20 / 21 Heene Parade, later the Beach Hotel

Map B

Map B – From the Coastguard Station to Montague Place
17. The Royal Baths, later known as Marlborough House
18. Augusta House, later known as the Stanhoe Hotel
19. The Thomas Banting Memorial Home, later part of the Parade Wine Lodge

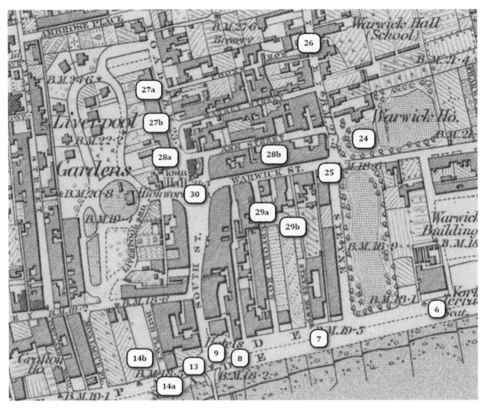

Map C

Map C – Central Worthing
6. York Terrace, later Warne's Hotel
7. Stafford's Library and Rebecca House
8. The Wellington Inn, later known as the Pier Hotel
9. The Marine Hotel
13. The Royal Sea House Hotel
14a. The New Parisian Baths, later known as the County Club
14b. Site of the New Assembly Rooms (built in 1884), later known as the New Theatre Royal
24. Warwick House
25. The Colonnade
26. The High Street
27a. Cook's Row
27b. Market Street
28a. Ann Street
28b. The Old Theatre
29a. Lane's House, later known as Bedford House
29b. Stanford's Cottage
30. The Town Hall

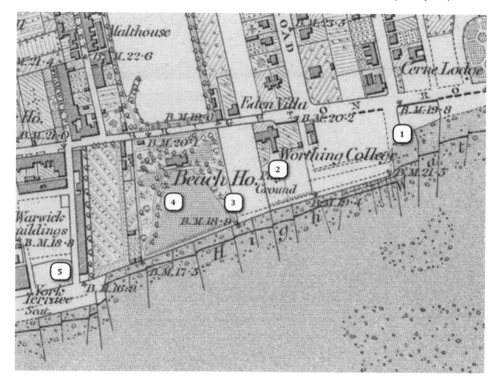

Map D

Map D – Beach House and Worthing College
1. Site of the Esplanade (built *c.* 1881)
2. Worthing College, later known as Beachfield and the Catherine Marsh Convalescent Home
3. Site of the Children's Play Areas (laid out between 1937 and 1951)
4. The Gardens of Beach House
5. Site of Eardley House (the terrace was built in 1868)

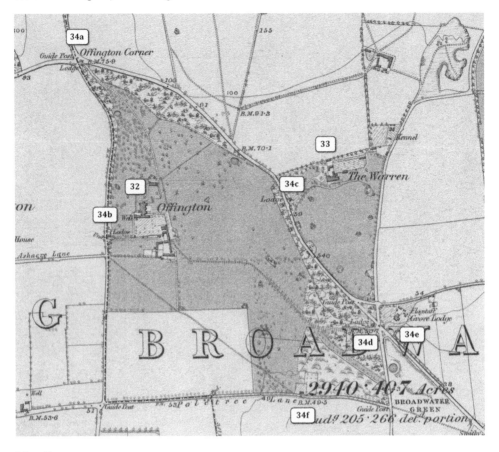

Map E

Map E - Offington

32. Offington House
33. The Warren
34a. North-West Lodge, later known as North Lodge and Offington House Lodge, Durrington
34b. West Lodge, at various times known as Grove Lodge
34c. North Lodge, later known as the Warren Lodge
34d. East Lodge or Major Gaisford's Lodge, later known as Offington House Lodge
34e. Grove Lodge
34f. South Lodge

Note that the names 'North Lodge' and 'Grove Lodge' were at different times used for two different lodges (see Section 34).

In the case of this map, in order to preserve the integrity of the markings as far as possible, the numbers on the top half of the map are located above the building in question, and the numbers on the bottom half are located below the relevant building.

These six extracts from the Ordnance Survey Map of 1879 are reproduced by permission of the National Library of Scotland.

INDEX OF PEOPLE

~

Where a person's name is printed in bold type, at least one of the accompanying page references includes either a sub-section about that person or an anecdote in which he or she makes an appearance. Names printed in standard type are of people referred to only in passing.